Nomads of the Serengeti

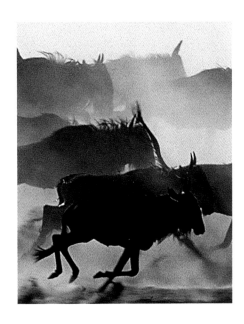

ROBYN STEWART

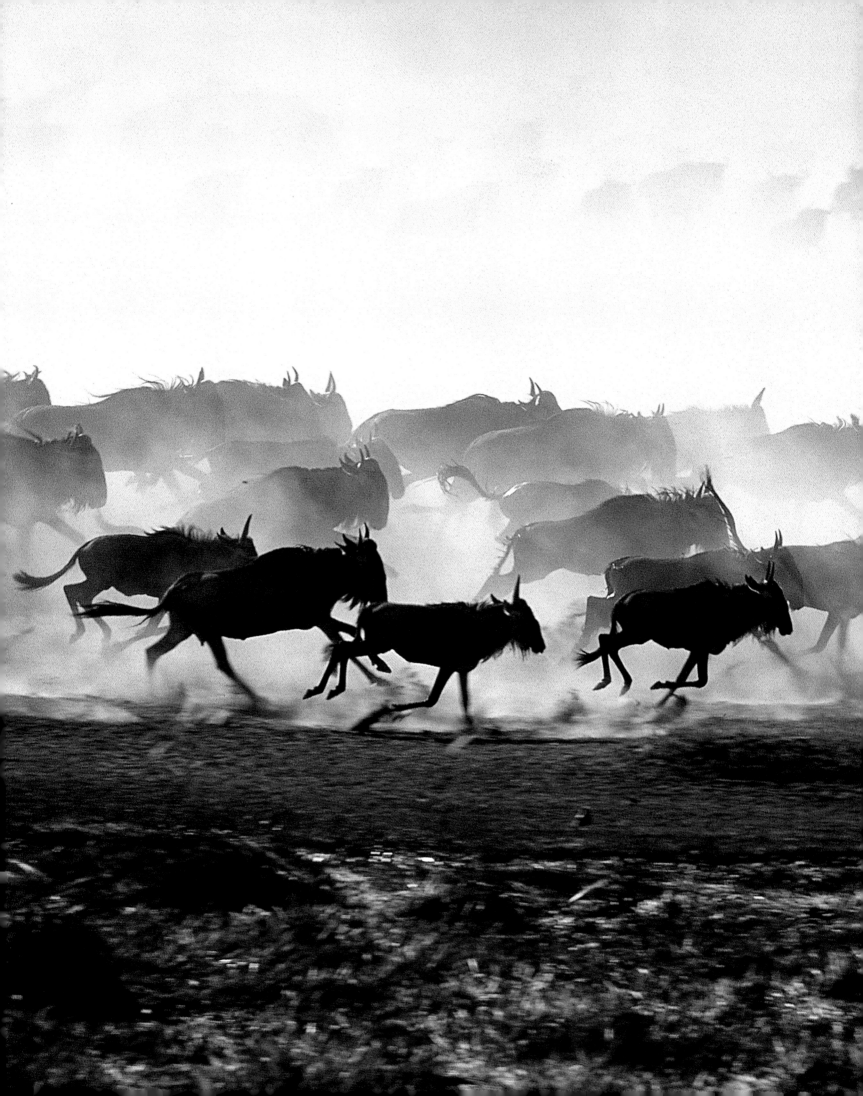

Struik Publishers
(a division of New Holland Publishing (South Africa) (Pty) Ltd)
Cornelis Struik House
80 McKenzie Street
Cape Town, 8001
South Africa

New Holland Publishing is a member of the Johnnic Publishing Group.
www.struik.co.za
Log on to our photographic website **www.imagesofafrica.co.za** for an African experience.

First published in 2002

1 3 5 7 9 10 8 6 4 2

Publishing manager: Pippa Parker
Managing editor: Helen de Villiers
Editor: Katharina von Gerhardt
Design director: Janice Evans
Designer: Lesley Mitchell
Proofreader: Tessa Kennedy

Reproduction by Hirt & Carter Cape (Pty) Ltd
Printed and bound by Tien Wah Press (Pte) Ltd, Singapore

ISBN 1 86872 762 9

CONTENTS

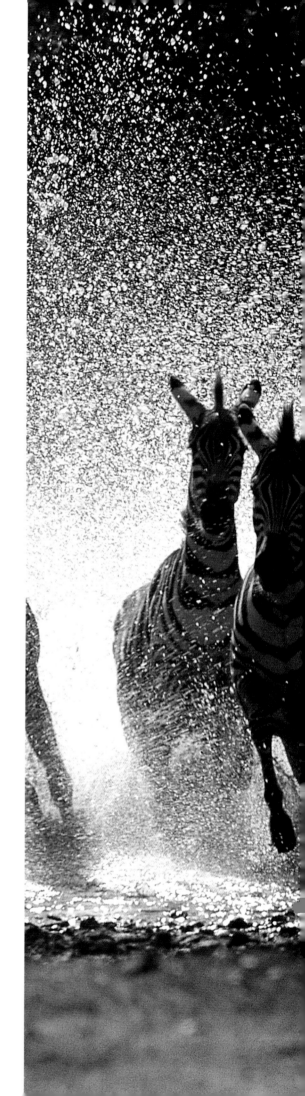

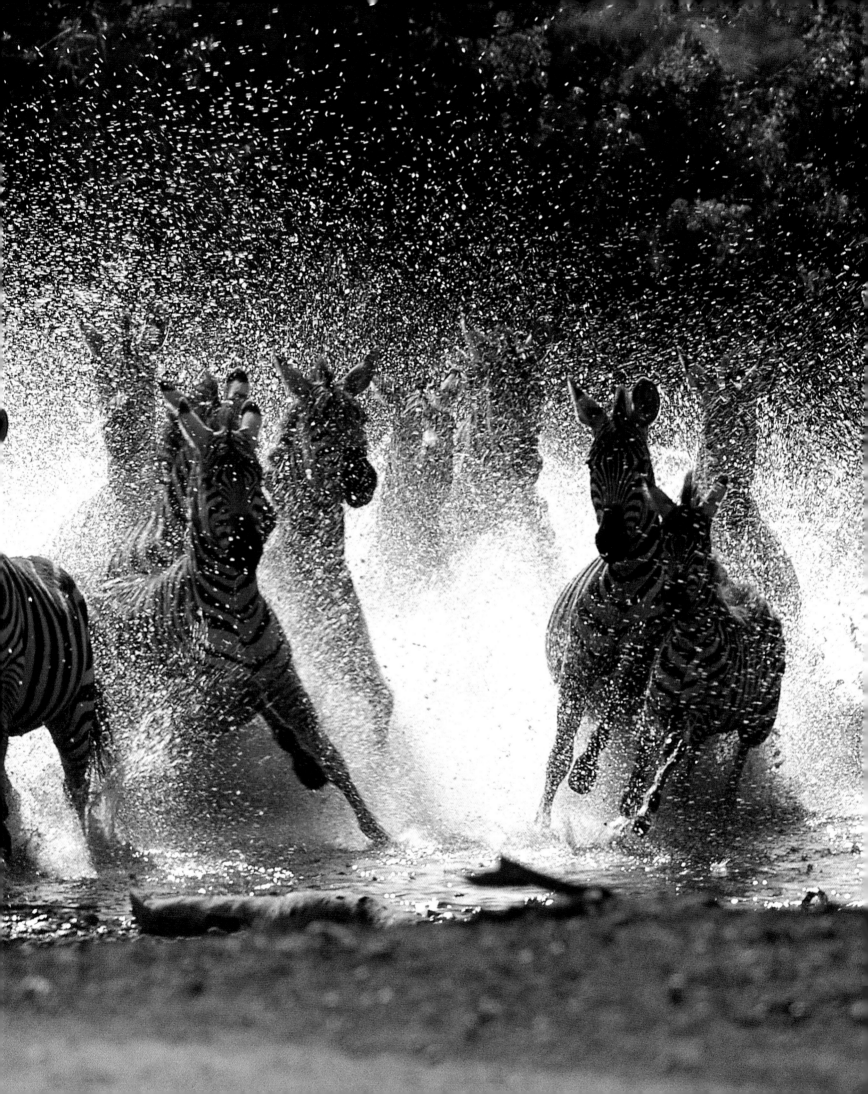

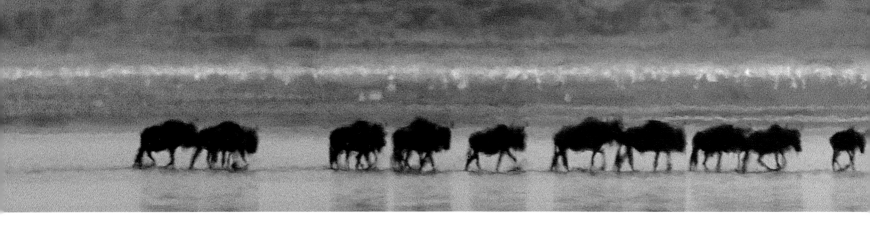

INTRODUCTION

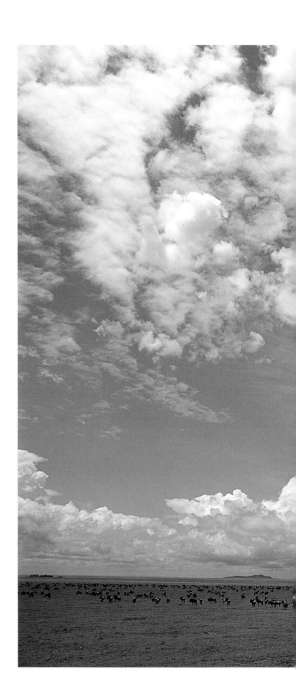

The continent of Africa once supported an array of wildlife that was astonishing in its diversity and breathtaking in its magnitude. The first mammals emerged on the continent 180 million years ago and by the time *Homo sapiens* appeared, perhaps as many as 100 million mammals wandered the continent. Today, despite the continuing decrease in wildlife numbers due to human expansion and resource utilisation, more than 1 150 mammalian species still exist in Africa.

Twenty-five million years ago, the great continental land masses of Africa and Eurasia collided violently, cracking the earth's crust in a line extending from the Dead Sea to Mozambique. In eastern Africa, this crack resulted in a double rift, creating two chains of valleys, lakes and volcanic mountains. The Great Rift Valley in Kenya and Tanzania, as the eastern rift came to be known, cradled the genesis of some of our first upright ancestors in a climate and landscape little different from today.

Here, between the lakes and volcanoes, a migration of animals began that has continued for more than a thousand millennia (as fossils from Olduvai Gorge indicate). In an annual cycle, huge herds of wildebeest sweep from their calving grounds in the short grass plains of the southern Serengeti to fresher pastures further north, and return with the onset of the seasonal rains. This ancient landscape was smoothed over by eruptions from volcanoes of the Crater Highlands in the Rift Valley around three million years ago. Vast amounts of dust and debris were blown westward to settle over the land, forming what the Maasai call 'serenget', meaning 'endless plain'.

This endless plain is now known as Serengeti. Spread like a carpet in the rain shadow of the Ngorongoro Crater Highlands, the plains stretch eastward to the distant Gol Mountains, and west to the Itonjo Hills and to Sukumaland beyond. Bulbous granite outcrops, known as 'koppies', provide footholds for wild figs and euphorbias, as

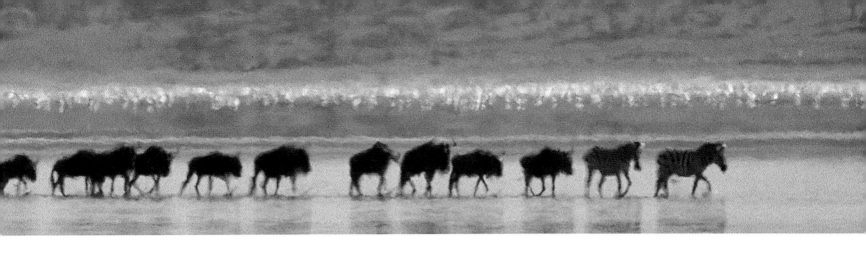

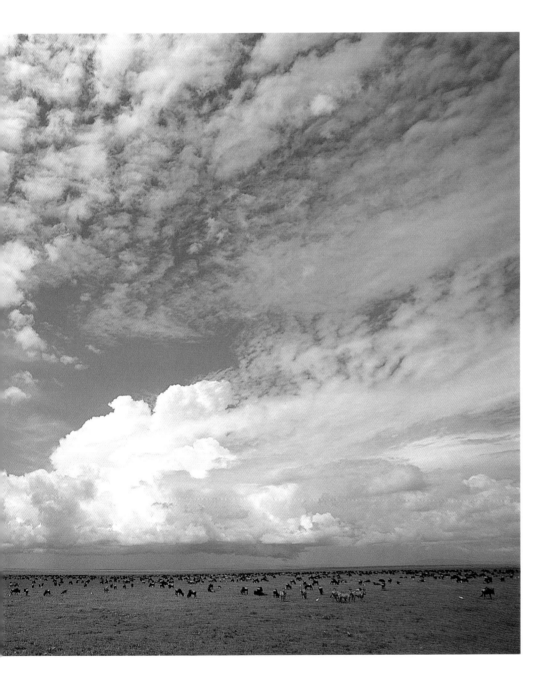

well as rocky refuges for elusive animals. To the north, the plains dissolve into undulating savanna and acacia woodland that extend into the Kenyan Maasai Mara. The Grumeti and Mbalageti rivers dissect the hilly ranges of the west that reach almost to Speke Gulf in Lake Victoria.

The Serengeti National Park is carved out of the larger Serengeti-Mara ecosystem, and is dominated by the migration of its immense population of common wildebeest. Their grazing patterns, fodder selection, habitat preferences, migratory routes and their sheer numbers have shaped the fabric of this environment.

THE HISTORY

Before the arrival of Europeans, the area encompassing the Serengeti was a wilderness. The fearless Maasai, the 'wild sons of the steppe', used the Serengeti grassland to graze their cattle, around which their existence revolved.

As their culture forbade the consumption of game meat, they coexisted harmoniously with the wildlife.

In the 1890s, disaster struck the Maasai, their cattle and the wild animal populations as a result of the introduction of rinderpest. This disease was introduced to Africa by infected cattle from India, imported by colonists into Ethiopia. Rinderpest is a highly infectious viral disease that affects cloven-hoofed animals, causing high mortality in those animals with no immunity to the disease. The disease exterminated 95 per cent of the indigenous cattle in East Africa and quickly spread to the wild animal populations, particularly wildebeest and buffalo. Within a few years, much of the wildlife had disappeared. With little natural prey left to hunt, lions were forced to prey on humans in order to survive. Humans very quickly deserted the lion-infested country, leaving formerly grazed land to revert to woodland.

Over the next decade, ungulates that had developed immunity to rinderpest became more numerous. This enabled the local blood-sucking tsetse flies, to which wild ungulates are normally host, to expand their range into the woodlands. Tsetse flies transmit the deadly parasitic disease Trypanosomiasis (sleeping sickness) to humans and livestock. However, having developed a degree of immunity over millennia, wild animals normally do not succumb to the disease. Further human retreat to the west, forced by the tsetse fly invasion, continued until the 1930s, when mechanical bush-clearing methods were introduced in order to reduce the fly's habitat. Part of what is now southern and eastern Serengeti was set aside as a game reserve in 1929, and given Protected Area status in 1940. Although by this time certain wild animal species had gained

a measure of immunity to rinderpest, the disease periodically reappeared in wild ruminants, causing high death rates in yearlings. In the 1950s, a concerted campaign of cattle vaccination was mounted in the surrounding areas, which eventually rid wild animal populations of the disease. Wildebeest and buffalo regained a foothold, and in the following decade and a half, wildebeest numbers increased six-fold. This was particularly fortunate for the large carnivores, whose numbers increased rapidly in response.

A national park, encompassing the southern part of the present-day Serengeti and the Ngorongoro highlands, was established in 1951. The Maasai were allowed to continue using the park's pasture until the mid-1950s, when it was decided that their tenure in the park was not compatible with wildlife conservation.

The Serengeti National Park lies in northern Tanzania

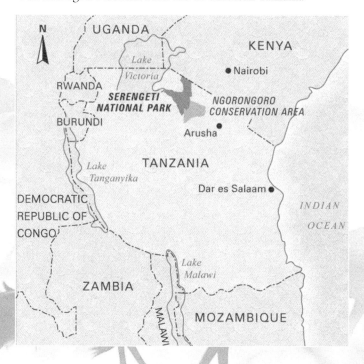

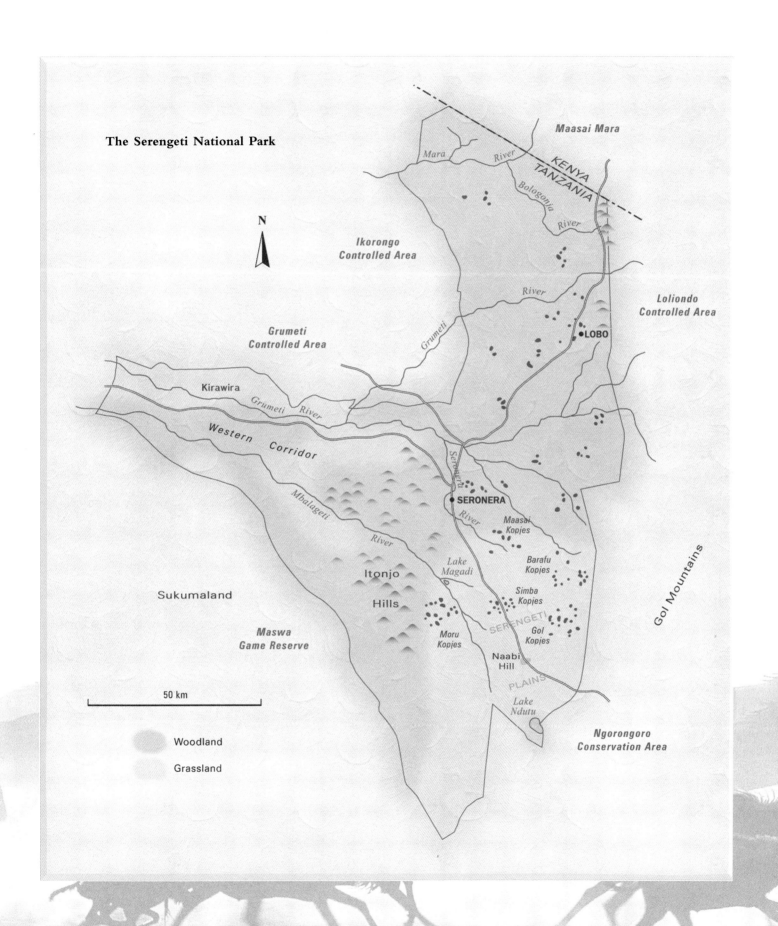

The Serengeti National Park

N

Maasai Mara

Mara River KENYA
TANZANIA

Bologonja
River

Ikorongo
Controlled Area

River

Loliondo
Controlled Area

Grumeti
Controlled Area

Grumeti

•LOBO

Kirawira

Grumeti River

Western Corridor

Serengeti

Mbalageti

SERONERA

River

Maasai
Kopjes

Gol Mountains

Lake
Magadi

Barafu
Kopjes

Itonjo

Simba
Kopjes

Sukumaland

Hills

Moru
Kopjes

SERENGETI
Gol
Kopjes

Maswa
Game Reserve

Naabi
Hill

PLAINS

50 km

Lake
Ndutu

Ngorongoro
Conservation Area

Woodland

Grassland

At that time two German naturalists, Bernard Grzimek and his son Michael, undertook the first aerial study of the Serengeti. Until then, no scientific research into the ecology of the ecosystem had been undertaken. The Grzimeks collected information on animal numbers and movements, using an aeroplane they bought and learnt to fly specially for the task. They felt it was imperative to protect the wildebeest's full migratory range from human development and were passionate in their desire to preserve what they believed was a unique natural habitat. Tragically, Michael gave his life for the cause, plunging to his death in their zebra-striped aircraft after colliding with a vulture over the Salai Plains. The data he and his father collected played a significant part in the inclusion of the area north of Seronera, up to the Kenyan border, into the Serengeti National Park when the park boundaries were realigned in 1959. The Ngorongoro Crater Highlands and the eastern portion of the plains were excised from the park and given Conservation Area status, which allowed for the accommodation of Maasai pastoralists' needs.

Tanganyika, as Tanzania was then known, experienced political and economic troubles following independence in 1961. The Serengeti National Park, along with most of the country's protected areas, fell into decline. Throughout the 1970s and 1980s, in the absence of proper anti-poaching methods and equipment, poaching decimated the elephant and rhino populations. The situation improved in the late 1980s, when the country's economy began to recover. Infusions of donor money enabled park authorities to rebuild park infrastructure and invest in the improvement of anti-poaching strategies and equipment. The world-wide ivory ban in 1989 finally halted the pressure on the park's elephants, and those that had escaped the slaughter by fleeing to Kenya slowly started to return. Sadly, since then, the park's African wild dogs have disappeared; the last of the remaining animals were possibly killed by rabies, spread to them by domestic dogs. The Serengeti-Mara ecosystem is recognised as one of the most important wildlife areas in the world, and the network of parks and reserves established to protect it is remarkable. Serengeti National Park was declared a World Heritage Site by UNESCO and a World Biosphere Reserve in 1981.

THE MIGRATION

The wildebeest migration has been described as one of the greatest wildlife spectacles on Earth. The sight of tens of thousands of animals advancing in a giant wave across the grasslands, or trudging in columns tens of kilometres long, is unrivalled. Their nomadism traces the ephemeral pattern of grass regrowth, which is determined by seasonal rains, and at times takes them beyond the boundaries of the 14 750 square kilometre national park.

The seasons in Serengeti are determined by a large-scale weather system associated with the movements of the sun across the equator. The sun's southward movement brings relatively dry north-easterly winds, which reach the Serengeti in late October or early November, and produce the first short rains – known as the 'short wet' – after the dry season. Wetter, south-easterly winds from the Indian Ocean, following the northward movement of the sun, produce the long rains – known as the 'long wet' – that last from March until May. This weather pattern is further influenced by the Ngorongoro Crater Highlands, which rise to over 3 000 metres in the south-east, casting a rain shadow over the Serengeti plains and creating a hot, dry season devoid of rain from June to October. Beyond the rain shadow to the north and west, nearby Lake

Victoria, which creates its own convergence zone, produces some precipitation during the dry season, resulting in a more consistent weather pattern. Migrating herbivores searching for green grass are therefore more likely to find it in the north-west.

The 'short wet' draws the nomads to the grass plains of the southern Serengeti and Ngorongoro. Here they remain for several months, grazing, giving birth and fattening up. Between November and February there is little rain, but within weeks of the wildebeest calving in February, the 'long wet' begins. For almost three months, heavy rains regularly deluge the plains and days are kept cool by heavy cloud cover.

The 'long wet' encourages new grasses to sprout, which the animals crop short. The Serengeti plains consist of three distinct grass types: short grass plains hug the lee of the highlands in the south-east and merge into intermediate and then long grasses in the northern plains. It is the short grass plains that are important to the nomads. Their teeth are designed for nipping off soft grass shoots, and the high density of herbivores that graze the plains maintains the type of pasture that wildebeest prefer. Yet even though the southern plains are still a lush green at the end of the 'long wet', the wildebeest know they must move on before the dry season appropriates their water, and shallow-rooted grasses stop growing.

At the end of May, they begin a long and hazardous journey in search of pasture that will sustain them during the dry season. Their destination is the Mara region, an area straddling the Tanzanian border with Kenya, some 200 kilometres to the north. Their route detours north-west through the hills and plains astride the Mbalageti River until they reach the Grumeti River in the Western Corridor. Some herds travel north to Seronera, where umbrella acacias provide shade from the hot midday sun, and water is plentiful.

The plains of the Western Corridor consist of sticky black cotton soil (so named as it has the texture of wet cotton during the wet season), patched with groves of whistling thorn trees and surrounded by woodland. These plains set a perfect stage for the grand theatre of the rut, when wildebeest bulls devote all their energies to attracting and mating with a harem of females. They reach this area in June, when the dry season has begun. At this time of year, the Grumeti River is still flowing with run-off from the rocky hills that loom over the Rift Valley to the east.

After watering, mating and resting by the Grumeti River for a week or two, the wildebeest head north-east. Leaving the security of the national park, most travel beyond park boundaries through the Grumeti and Ikorongo controlled areas, which act as buffer zones between the park and settled areas. They reach the Mara in the far north of the park towards the end of July and the beginning of August. Unlike the southern part of the park, the north is softly undulating and clothed in savanna dotted with numerous rocky outcrops and patches of woodland. Although it is now the hot, dry season that desiccates the land from June to October, they are sustained here by perennial water from the Mara River and by the fresh grass generated by occasional rain.

At the first hint of the 'short wet' in October, the nomads desert the Mara and swing south again. Most of the adult females are pregnant, and as they reach the southern plains, there will be plenty of forage to nourish them and their offspring.

More than 1,2 million wildebeest and 200 000 zebras embark on this extraordinary trek. Along the way, these nomads are threatened not only by malnutrition and disease, but by predation by the 2 500 lions, 7 500 spotted hyaenas and more than 200 cheetahs that are among the residents of the Serengeti.

SOUTHERN
SERENGETI

In 1911, the German visitor F. Jaeger wrote of the Serengeti plains: 'And all this a sea of grass, grass, grass, and grass. One looks around and sees only grass and sky.' These vast plains cover some 5 200 square kilometres of grass.

This is the Africa of the imagination. Vast and deceptively silent, the broad landscape seems flattened by sky. On cloudless, hazy, dry-season mornings, a fiery sun rises over the horizon and tips pink-gold light across the grassland. As the sun climbs higher, heat haze stipples the distant hills and pours phantom lakes onto the steppe. Woven into this landscape is the greatest concentration of wildlife on Earth.

In the Serengeti, the cycles of birth, death and regeneration are governed by the seasonal rains, which have defined the climate for millions of years. The short rains in November foster the sprouting of fresh new grasses, and soon afterwards, the southern plains are tattooed with more than one million wildebeest, as well as zebra, Thomson's gazelle (Tommies), Grant's gazelle, topi, hartebeest, eland – and their predators. Before the onset of the long wet season, almost all the wildebeest cows give birth during a few weeks in February.

The wildebeest remain on these southern plains throughout the wet season, which lasts from March until May. The new-born calves grow and thrive on the tender green shoots, which also supply essential nutrients for the lactating mothers, while bulls build the strength and muscle mass to see them through the coming rut. It is a time of feasting for the large predators too, who gorge themselves on the plentiful calves.

At the end of May, warm breezes herald the end of the rains and the beginning of the world's most spectacular single movement of wildlife. The wildebeest migration defines fat times – and lean times – for the large predators. Hundreds of thousands of zebras and their calves share the plains with the wildebeest, and migrate with them. Though they are out-numbered by the wildebeest six-to-one, their relatively high density means they must keep on the move in order to find pasture. As the grasses turn to the colour of oats, Thomson's gazelle move steadily west into the woodlands. While the plains are filled with potential prey, hunting is easy and predators grow fat, but as the plains gradually empty, predators must change their hunting strategies in order to survive. With the larger prey gone, predators focus on smaller prey such as Tommies, warthogs, and hares. Unable to follow the nomads with their young offspring, the lions of the southern plains move to the few remaining perennial water sources, such as the swamps of the Mbalagati River, to catch the remaining prey that comes to drink. Cheetahs follow the migratory movements of Thomson's gazelles as they move towards the woodland, and hyaenas escape the feast-famine cycle by commuting between their territories and the nearest migratory herds on hunting forays.

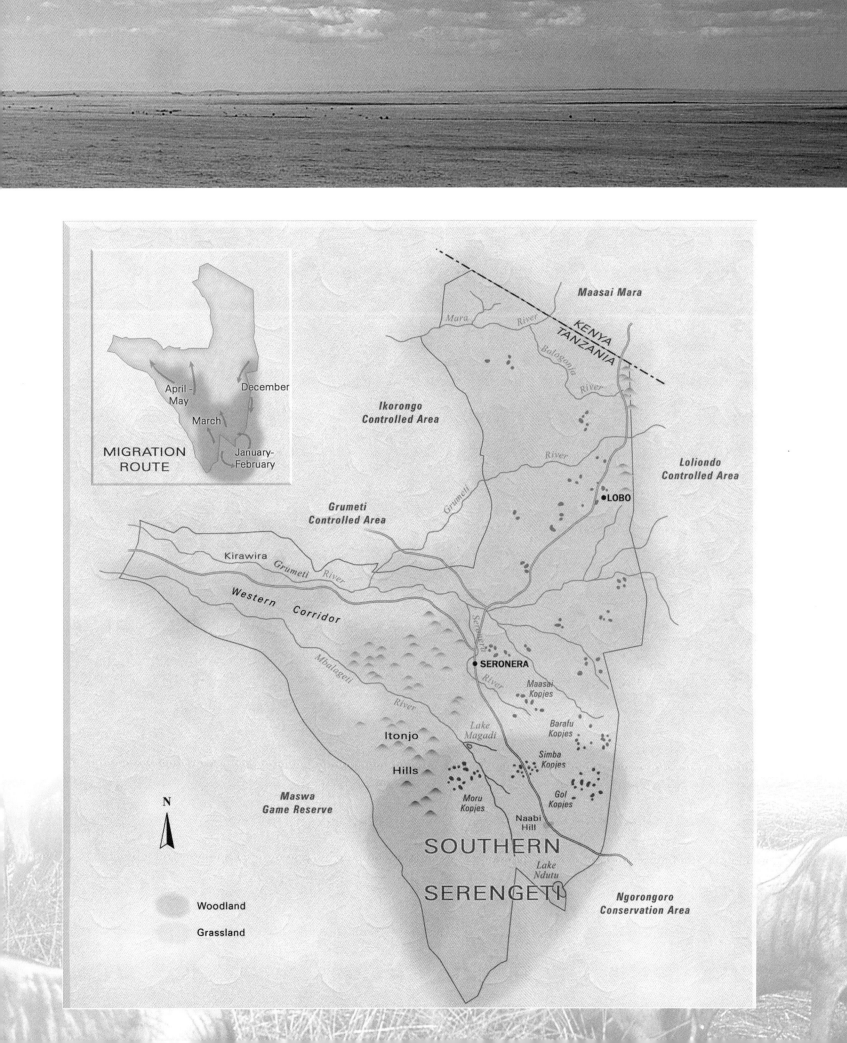

MIGRATION
ROUTE

April - May December

March

January-
February

Maasai Mara

KENYA
TANZANIA

Mara River

Bologonia

River

Ikorongo
Controlled Area

River

Loliondo
Controlled Area

Grumeti

●LOBO

Grumeti
Controlled Area

Kirawira Grumeti River

Western Corridor

Seronera

Mbalageti

●SERONERA

Maasai
Kopjes

River

Barafu
Kopjes

Lake
Magadi

Itonjo

Simba
Kopjes

Hills

Gol
Kopjes

Maswa
Game Reserve

Moru
Kopjes

Naabi
Hill

N

SOUTHERN

Lake
Ndutu

SERENGETI

Ngorongoro
Conservation Area

Woodland

Grassland

The Serengeti plains rerpesent a type of ecosystem once widespread throughout Africa, Eurasia and North America. These plains are now one of the few remaining fragments of a naturally operating grazing system, whereby the feeding strategies of grazers promote the types of pasture they require. Heavy grazing stimulates the production of new leaves, and this ability of grazers to crop grassland to increase yields is a consequence of selection for grazing resistance in Serengeti grasses. The vast numbers of herbivores that graze the plains thus not only maintain the stability of the ecosystem, but maintain plant diversity by selecting different plant species in accordance with their feeding preferences.

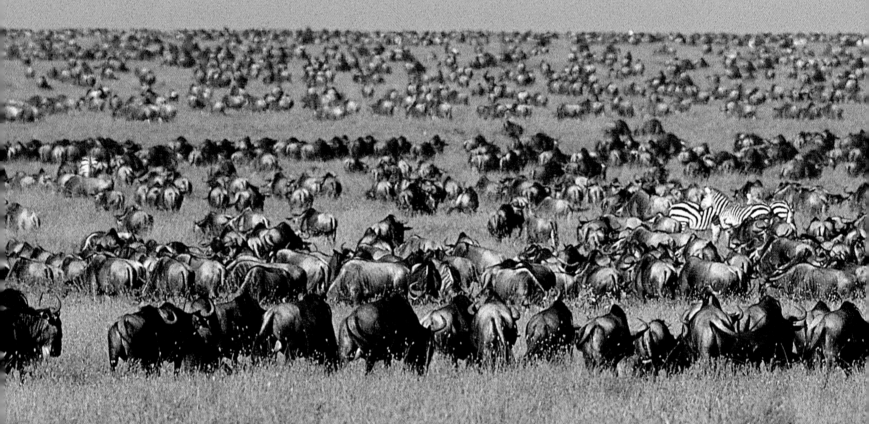

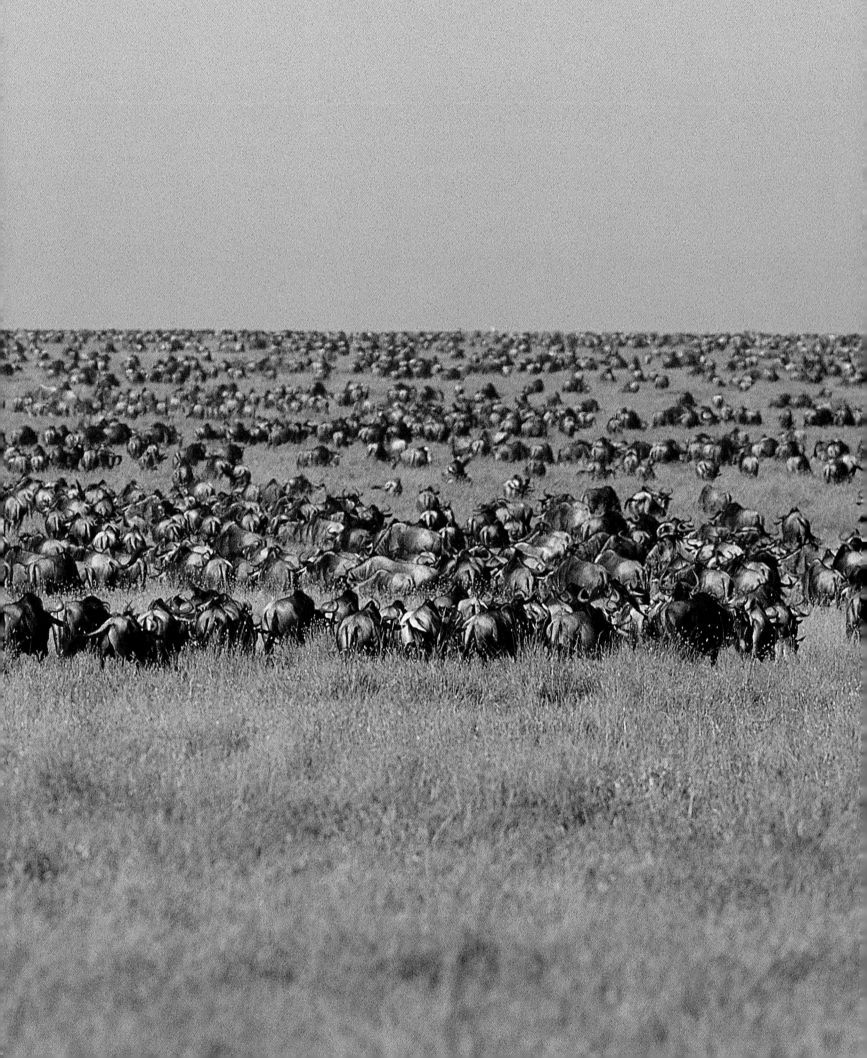

Wild fig trees cling to a crevice in a smooth granite boulder, one of a cluster named the Simba Koppies in the south.

OPPOSITE Lichen-stained rocks protrude from the plains that stretch in all directions. At the height of the wet season, nearly two million animals inhabit these plains.

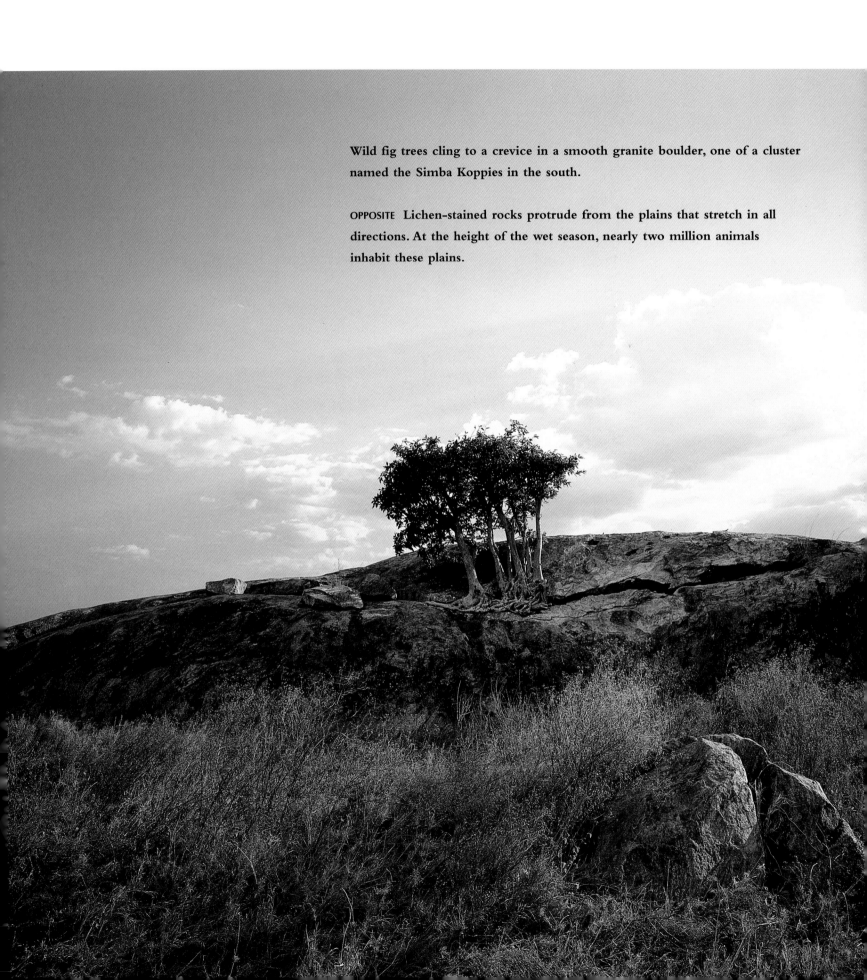

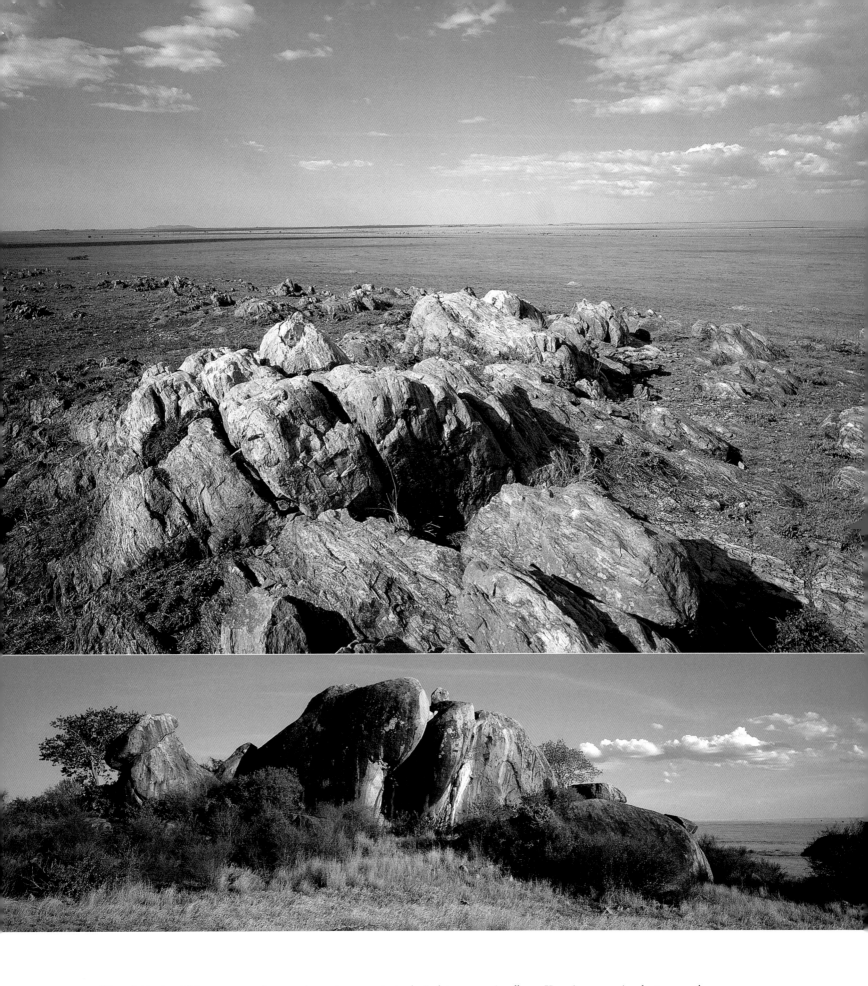

ABOVE 'Koppie' is the Afrikaans name for a rocky outcrop or, in technical terms, an inselberg. Koppies occur in clusters on these plains, providing shade and shelter for hyraxes and porcupines, as well as nesting sites for birds of prey.

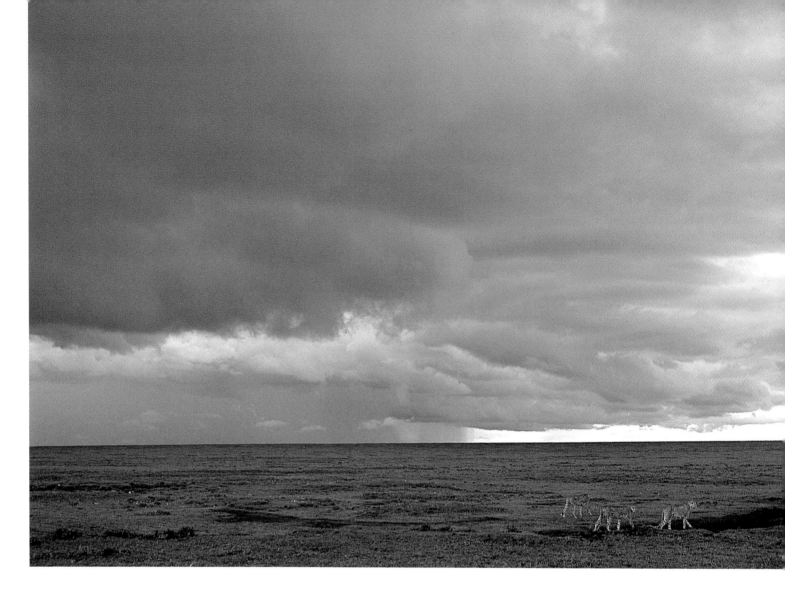

ABOVE Thunderstorms roll daily across the plains in the wet season.

RIGHT Like all cats, young cheetahs dislike getting wet. Young siblings huddle together for warmth in a deluge that severely restricts visibility and interrupts their search for prey.

Young cheetahs need practice to perfect their hunting techniques, and their mother will often bring them a crippled animal, which the young cheetahs use to practise their hunting skills, including pouncing, dragging and suffocating. Although hunting is instinctive, prey choice and the avoidance of predators are not, and cubs learn these by watching their mother. Some 95 per cent of cubs do not survive to independence, mainly as a result of the Serengeti lion's unexplained predilection for killing cubs. Cheetahs are an endangered species as their habitat is being drastically reduced. Nevertheless there are still more cheetahs per square kilometre in the Serengeti than anywhere else in Africa, and when lion numbers drop there is a corresponding increase in cheetah numbers.

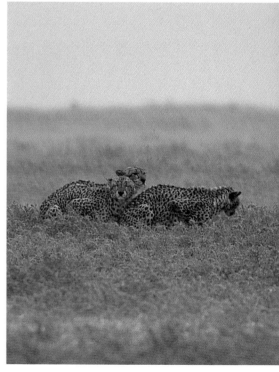

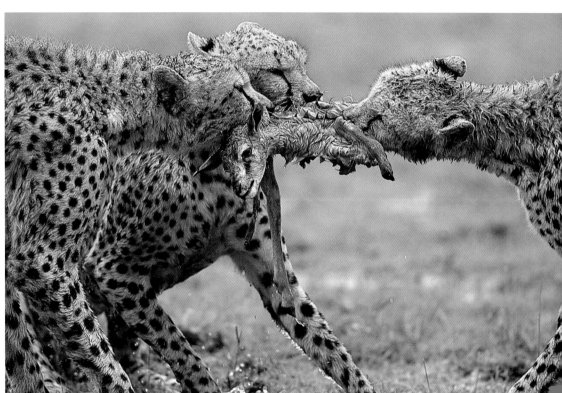

ABOVE A Tommy fawn provides a mere snack for three ravenous cats, and precipitates a tug-of-war over the small prize.

Cheetah cubs leave their mothers at around 18 months, and at first find it difficult to feed themselves. Although they have been taught the theory, prey seems more elusive than it was when their mother did the hunting. Hares and fawns constitute the major part of their diet until their hunting skills are honed and they can catch something larger.

No other animal can sprint as fast as a cheetah. Its sleek body is designed for speed. It has a light build, small head, slender limbs, a hollowed undercarriage to allow the hind legs maximum forward reach, and a long tail for balance – but it lacks stamina, and must run down its prey within 300 metres.

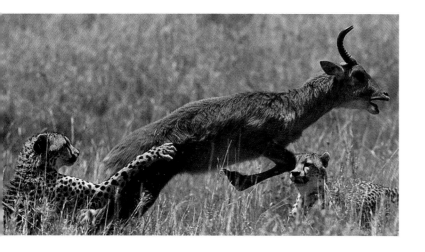

LEFT Prey is difficult to see when the grasses are long, but a pair of cheetahs spots a reedbuck that has strayed too far from its usual habitat in dense reeds. Hunting co-operatively, they catch it easily. They also eat co-operatively: one keeps watch for danger while the other eats, then they swap places. Very few solitary male cheetahs survive beyond four years of age, but if they form a coalition with another male, their prospects increase dramatically. Coalitions are usually, but not always, between brothers.

RIGHT After feeding alone on a kill, a cheetah returns to her cubs and climbs a termite mound to scan for danger. At just four weeks of age, the cubs have ventured out of their den in a nearby koppie for the first time. Before sunset the mother will return to the koppie to hide her cubs from night's marauding predators.

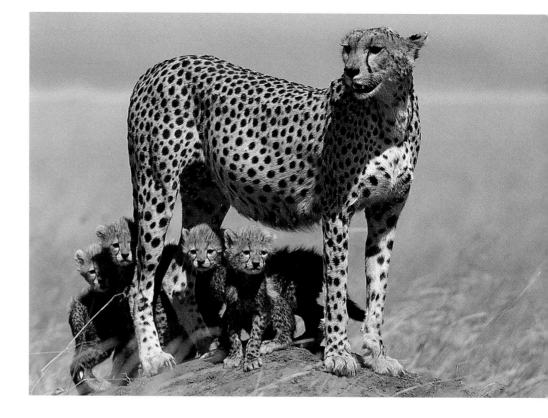

BELOW Caught in the act of giving birth, a Tommy stands no chance of escaping a hungry cheetah. This unusually large litter of cheetah cubs will be increasingly difficult to raise if they survive infancy. As they grow larger, their mother will need to hunt two or three times a day to keep them fed.

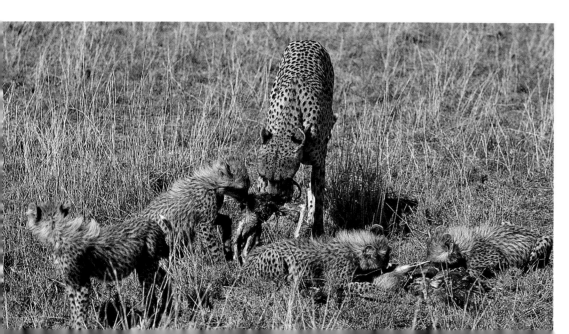

OPPOSITE Male Tommies are more vulnerable to predation than females as the males often stand alone guarding their territory. One benefit of group living is that the increased number of eyes on the look-out decreases the chances of an individual being surprised by a predator.

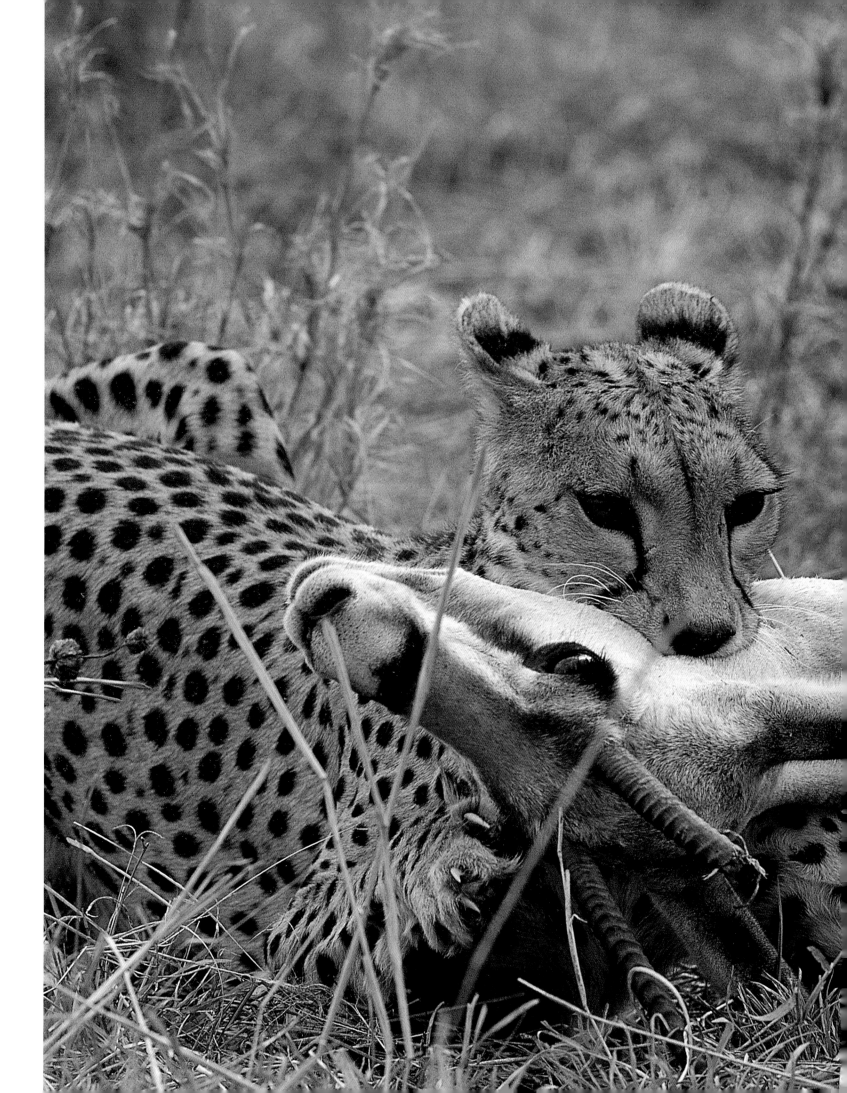

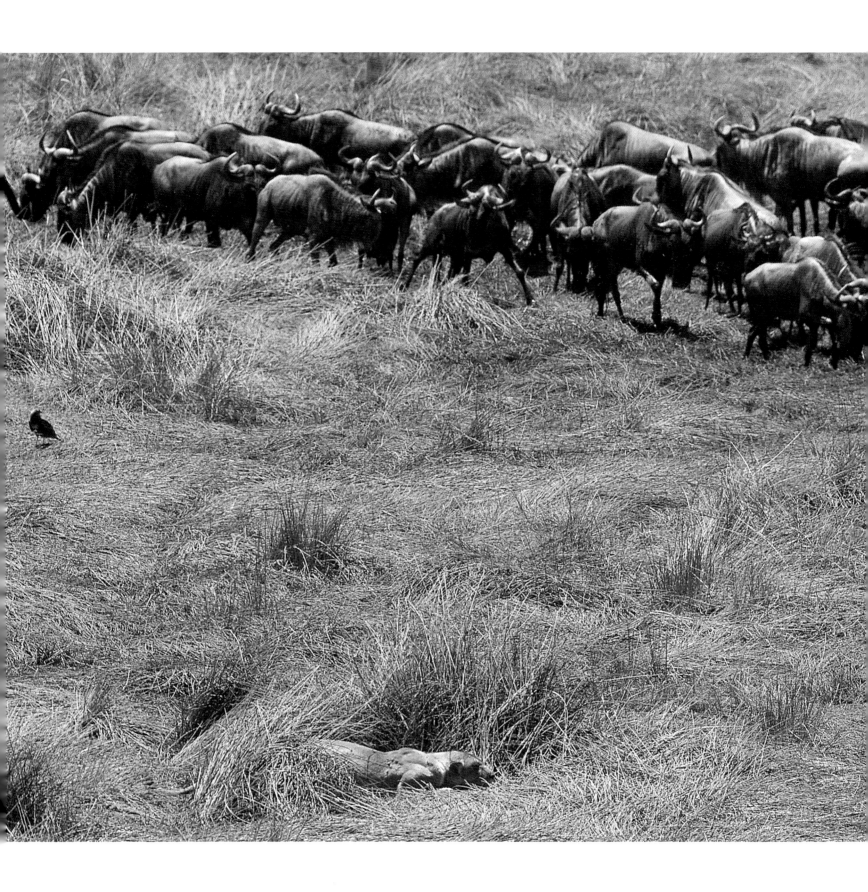

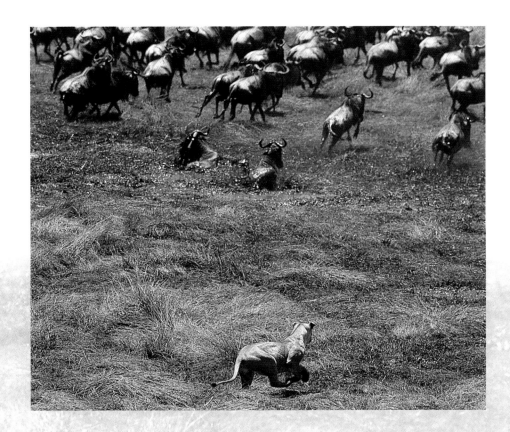

Thirsty herds frequent a string of marshes near Lake Ndutu. A lioness flattens herself in the long reeds, waiting for the right moment to pounce. When she explodes from cover, the wildebeest scatter, and amid the ensuing pande-monium two animals slip and become stuck in the mud. Fearing the same fate, the lioness abandons her chase and watches as the animals finally struggle to their feet and flee. Fewer than one in four lion chases are successful.

BELOW Zebras and wildebeest filter out of the woodland that encloses the marshes and plunge headlong into the pool of water to drink. When animals are drinking, they are at their most vulnerable. With heads down, their vision is restricted, and a quick escape is unlikely as the wildebeest are hindered by those animals pushing from behind, trying to get to the water's edge.

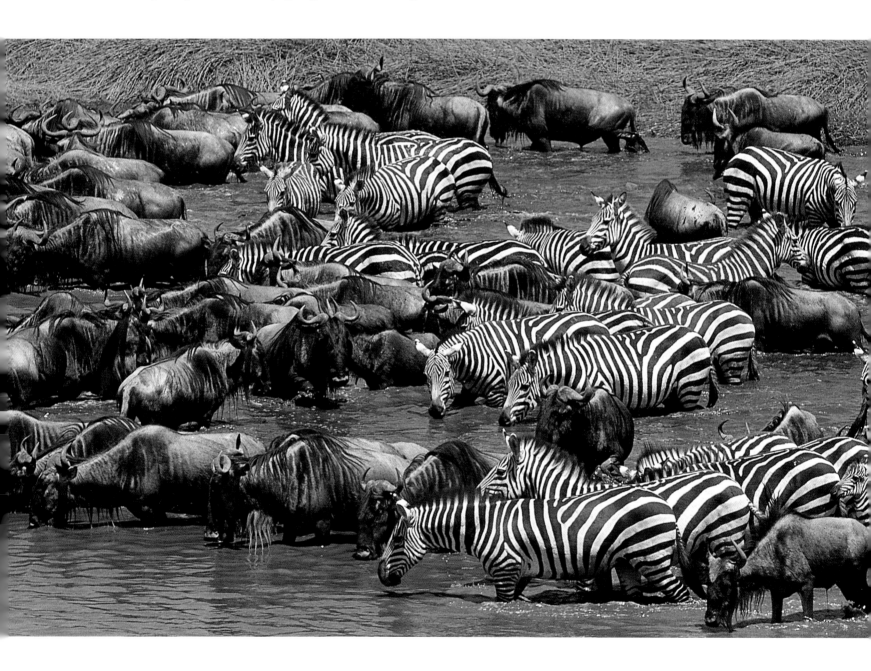

RIGHT Hunting is less challenging for lions in the wet season due to the abundance of calves – they need only wait near water for the animals to arrive. As calves require less effort to catch than fully grown animals, they are the preferred prey.

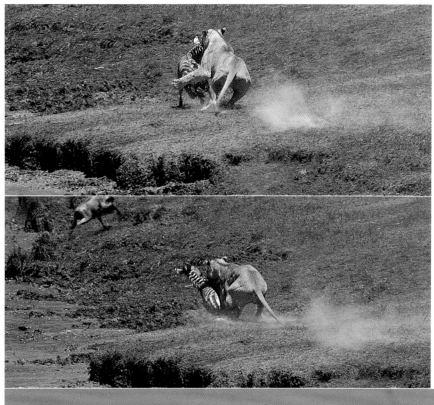

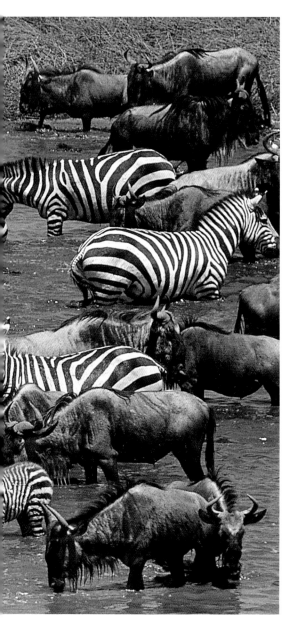

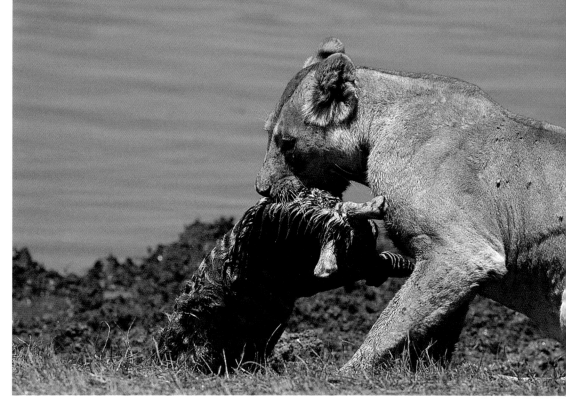

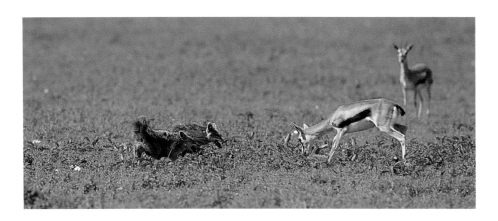

Black-backed jackals relentlessly pursue a Tommy fawn, while its mother weaves in front of them in a valiant attempt to drive them away. The Tommies zigzag at high speed across the plain until the jackals finally catch up with their quarry. One of them cripples the fawn by biting its soft underbelly so that it cannot escape, while the other tackles the mother, who is still trying to defend her fawn. However, her efforts are to no avail.

Jackals hunt together and pair for life, breeding at the time when gazelle fawns are abundant. When pairs go out hunting, pups are left in the care of an older sibling. Upon the parents' return, the pups rush to the parents to beg for food in a ritualised greeting ceremony that elicits regurgitation by the well-fed parents.

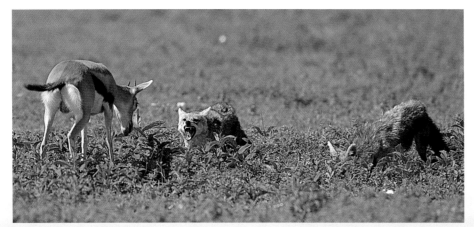

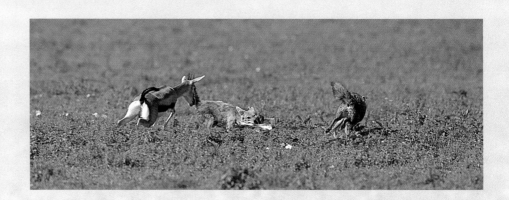

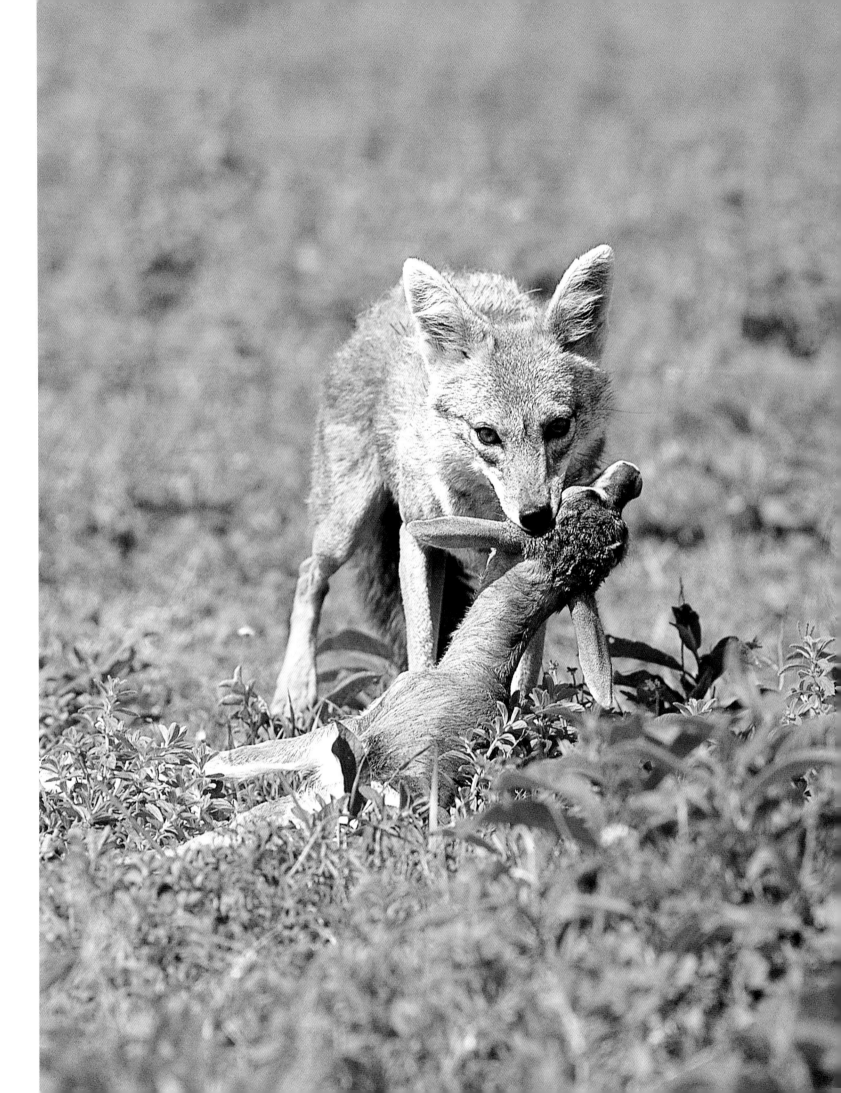

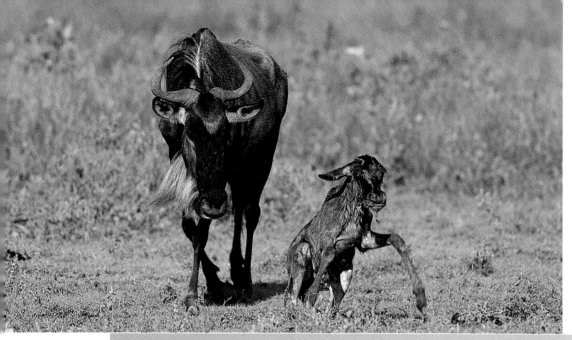

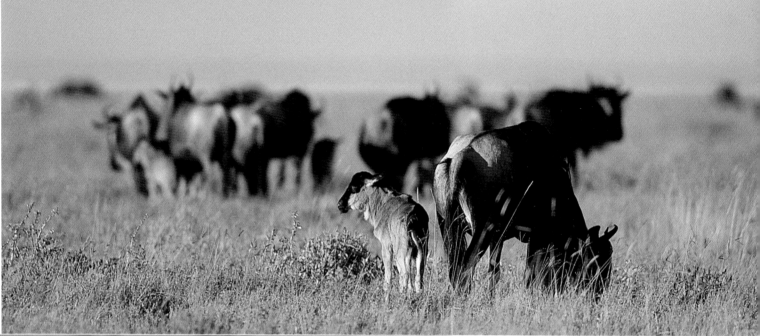

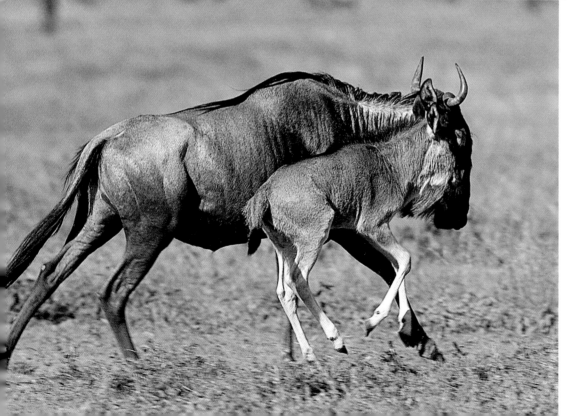

THIS PAGE A wildebeest calf struggles to its feet moments after birth and within minutes, the calf is able to run with its mother. As its fur dries, it assumes the familiar buff colouring.

All wildebeest calves are born within a few weeks during February, exactly eight months after the rut. By this time the animals have massed on the open plains where they are safest. This coincides with the time that grasses have their highest protein content.

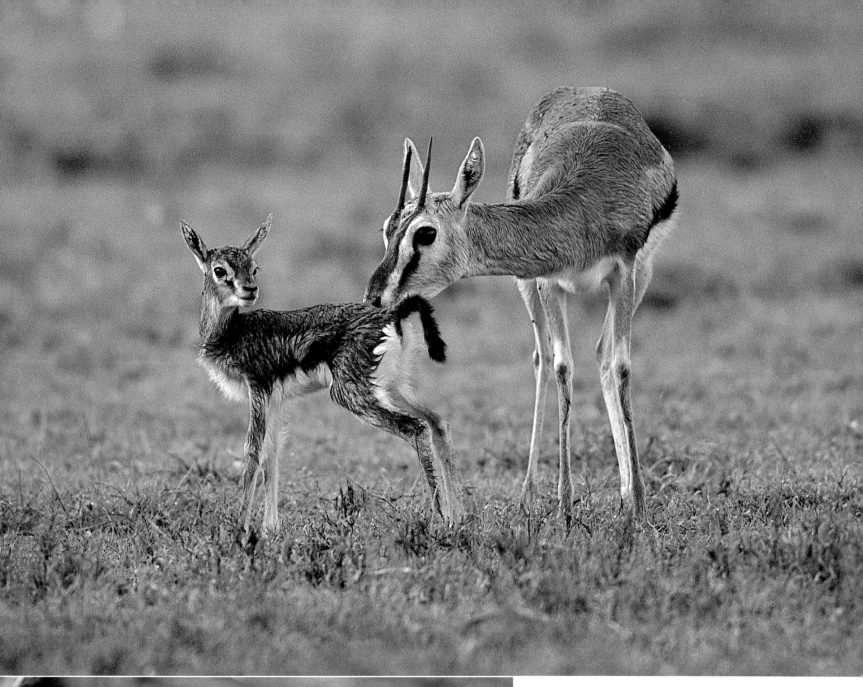

ABOVE AND LEFT Thomson's gazelles move to the short grass plains to give birth in February, which coincides with the wildebeest birthing period. The fawns graze on the short grass where they learn to recognise danger from a safe distance. Fawns are extremely vulnerable to predators, and rather than attempting to flee when in danger, they hide by dropping to the ground and curling up. Although their colouring provides good camouflage, lions, cheetahs, hyaenas, jackals and eagles have an easy meal when they stumble across a defenceless fawn.

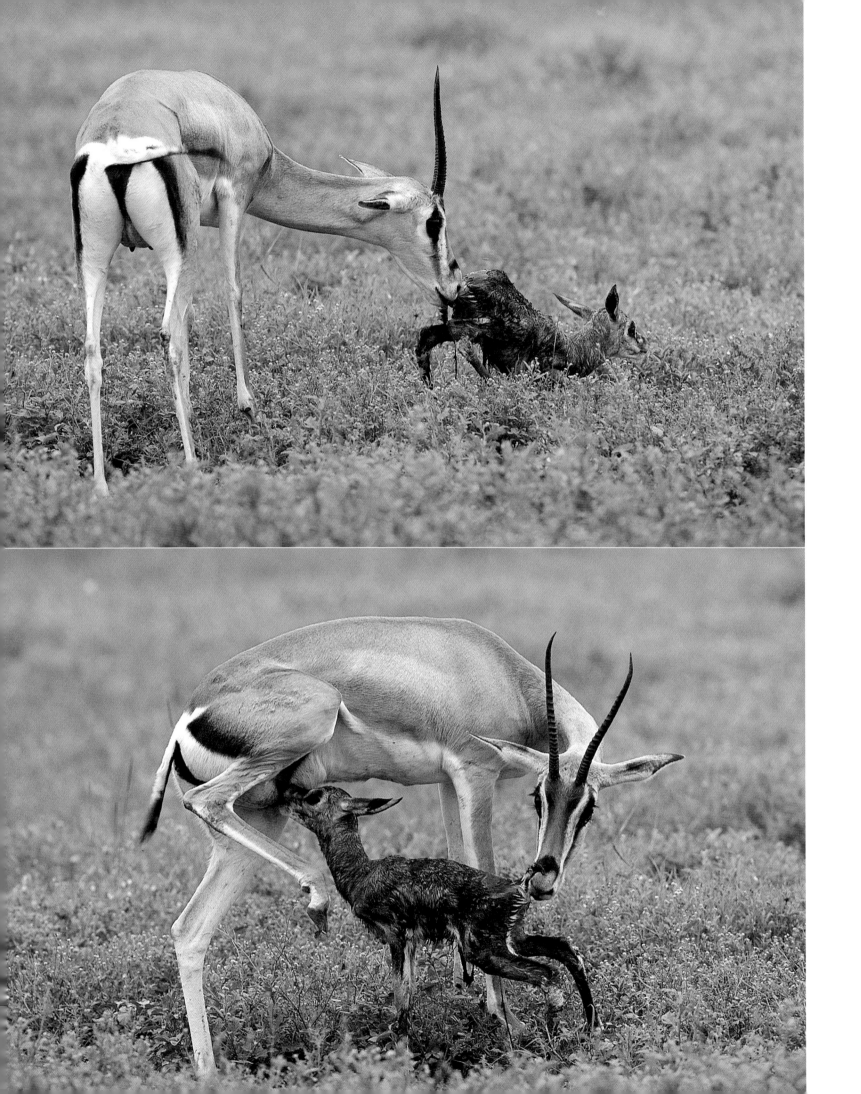

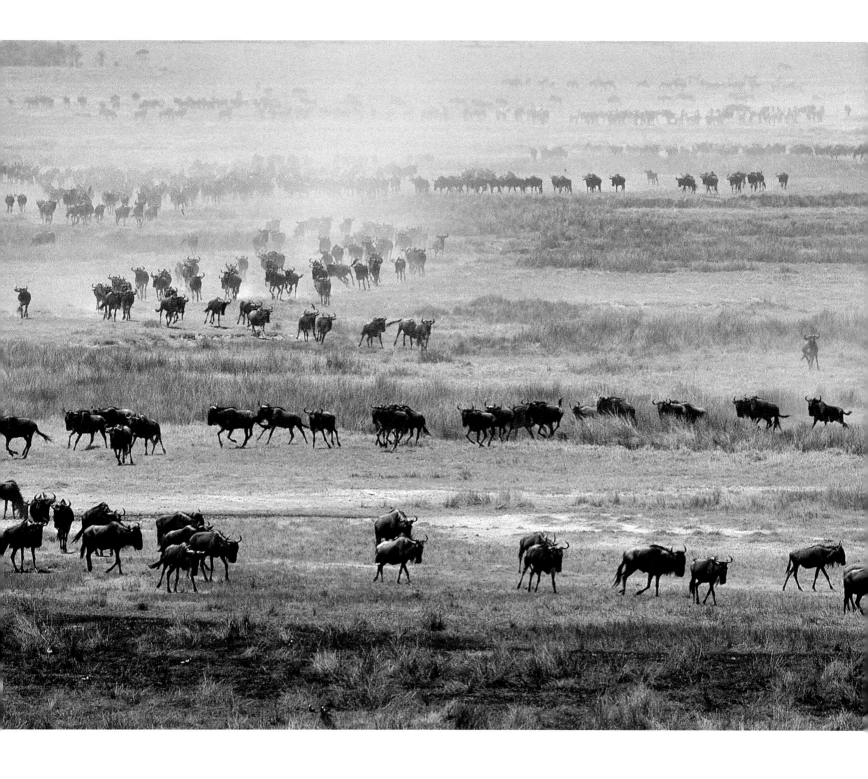

OPPOSITE Grant's gazelles, the larger cousins of Thomson's gazelles, give birth simultaneously with the wildebeest. Grant's gazelles' propensity to defend themselves vigorously with their large horns means that they are more difficult to catch than other prey, so they are generally ignored by the large predators. But like those of Thomson's gazelles, their fawns are extremely vulnerable to predation by both black-backed and golden jackals.

ABOVE Permanent water is scarce in the southern plains, but fresh water seeping from the ground in the depression that cradles Lake Ndutu maintains marshes, which remain green throughout the year. During the dry spell between rains, pools of fresh water edging the marshes are a magnet to the large herds, which file in from the surrounding plains each morning to drink.

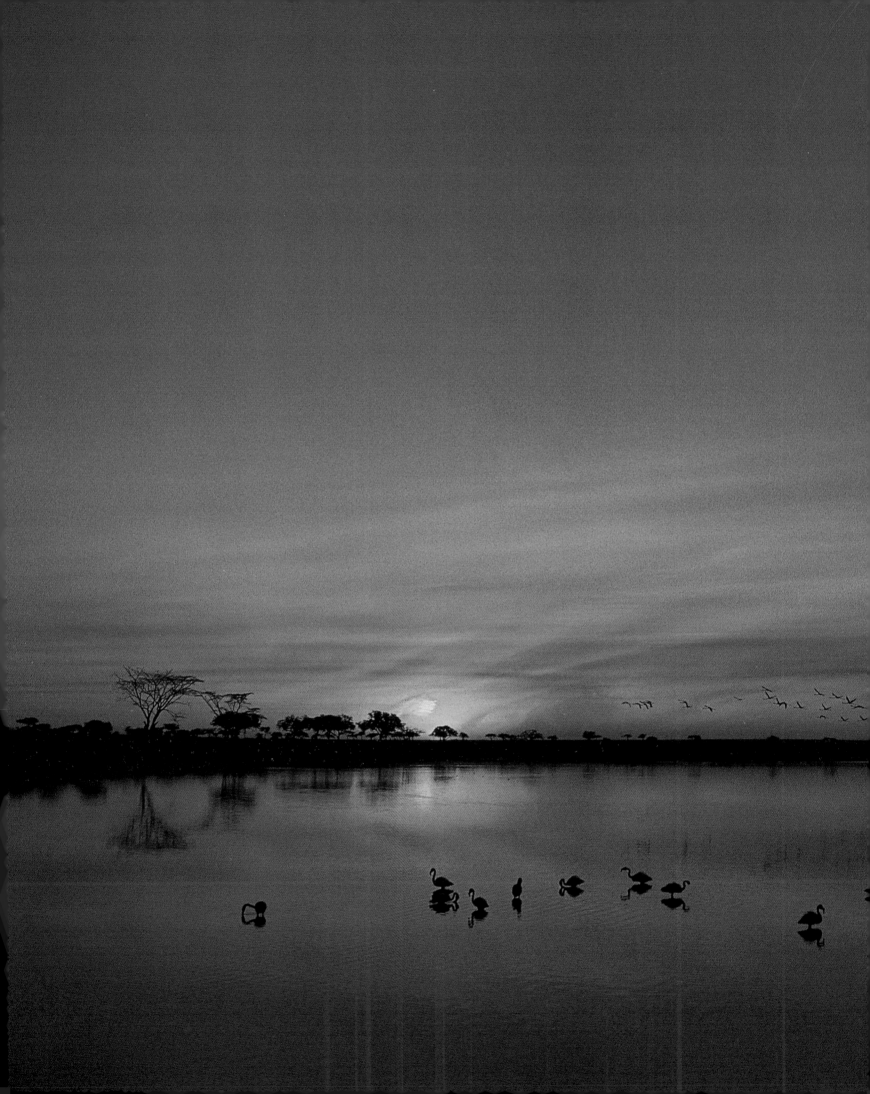

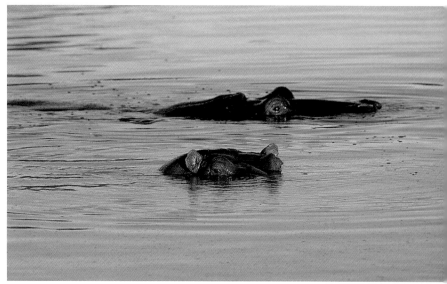

ABOVE Hippos occasionally stray from the nearby Mbalageti River to Lake Magadi, a small soda lake at the edge of the grassland. The alkalinity of the lake water makes it unfit for drinking. Hippos spend most of the day wallowing in shallow water and come out to graze at night. They are entirely herbivorous and sometimes wander several kilometres from their daytime haunts to graze by night.

OPPOSITE Lake Magadi mirrors the hues of day's beginning.

RIGHT Before an early breeze ruffles the water, an avocet skims the surface of the lake. The lake attracts a variety of waterbirds in the coolness of early morning. In dry seasons, the lake gradually shrinks, until all that is left is a soda crust imprinted with animal tracks.

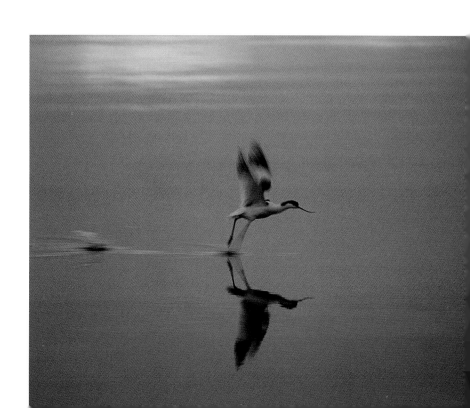

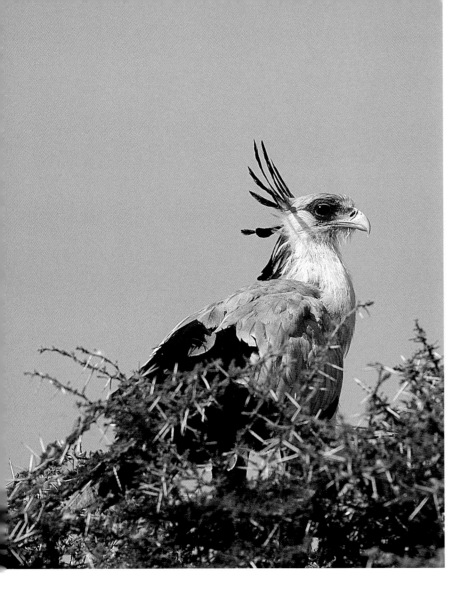

LEFT The acacias on Naabi Hill are favoured nesting sites for Secretary Birds, which range across the surrounding grassland in search of snakes and large insects that are the staples of their diet. The long-legged Secretary Bird earned its name from its crest feathers, which resemble the writing quills once carried behind the ear by office clerks.

BELOW The Black-shouldered Kite is a common plains resident, scouring the grassland for prey with its eerie blood-coloured eyes. It hunts almost exclusively for rodents, hovering above its prey before dropping on it like a stone.

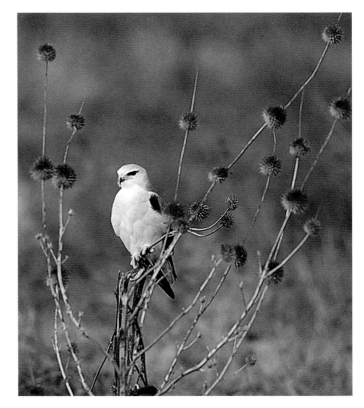

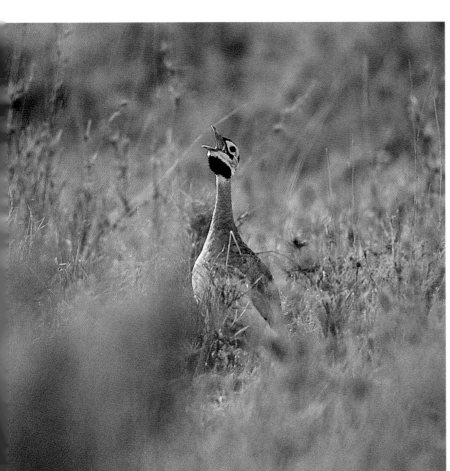

LEFT The first breath of dawn stirs a White-bellied Bustard, which fills the air with its staccato call. Rarely taking to the air, it spends most of its time stalking the open grassland where its streaked, buff-coloured feathers camouflage it well.

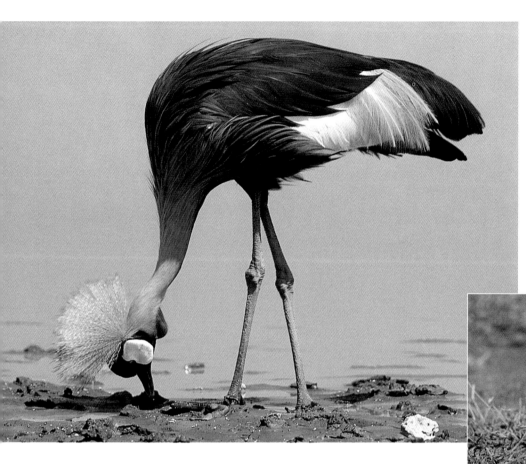

LEFT The elegant Crowned Crane searches the grassland near a seasonal waterhole in its constant quest for frogs and insects.

RIGHT A Lilac-breasted Roller pauses for a moment in its task of making breakfast digestible. It repeatedly slaps the frog it has caught against the ground to break up its bones, before tossing it down in a single gulp. This beautiful bird is common in the lightly wooded savanna that edges the plains.

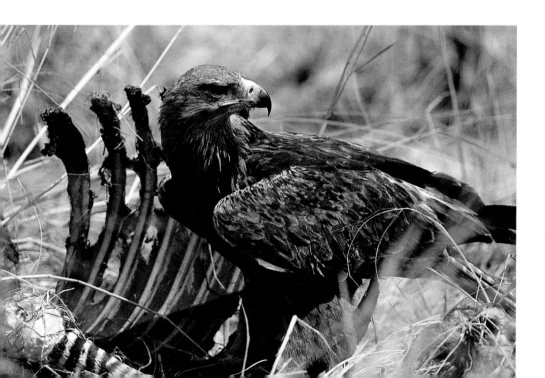

LEFT While the Tawny Eagle is an efficient predator, capable of catching a mammal the size of a dik-dik, it is not averse to scavenging on kills when the opportunity arises.

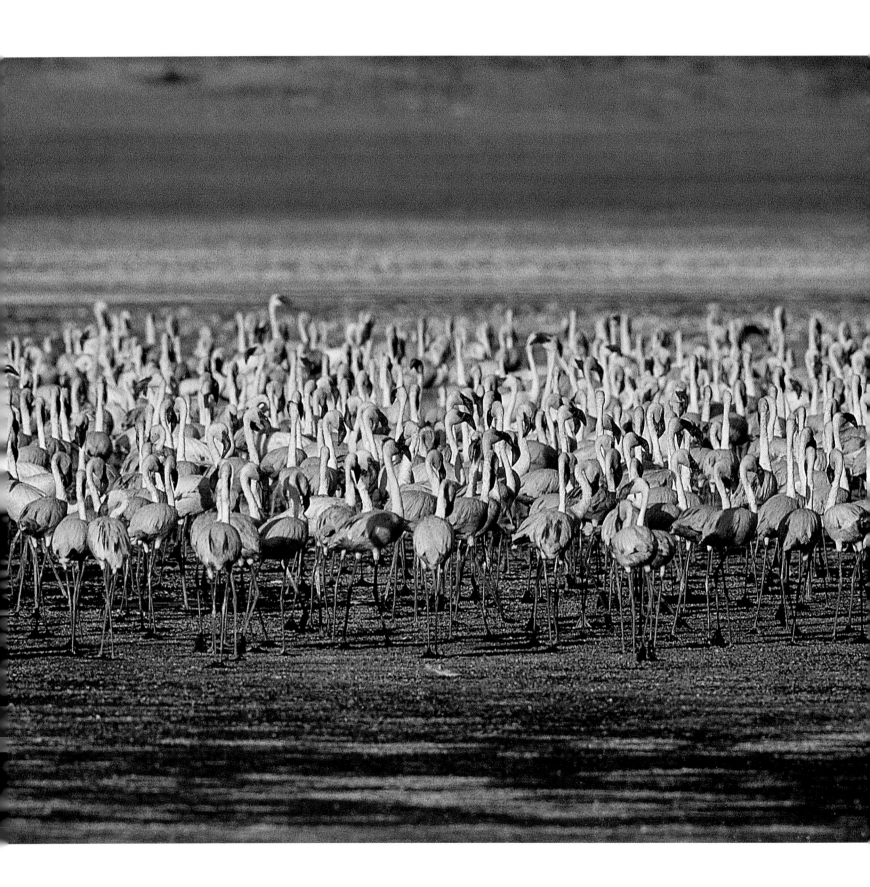

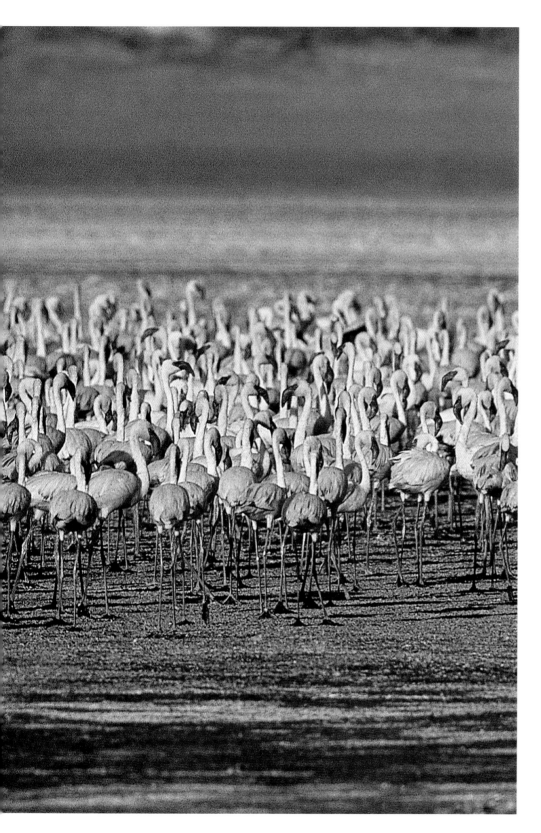

LEFT AND TOP At high water Lake Ndutu is pink-edged with flamingos, which fly from lake to lake along the Great Rift Valley. Along with Lake Masek, which lies on the Ngorongoro side of the park boundary, Lake Ndutu is cupped in a small depression enveloped in woodland in the south. Although Lake Ndutu is very shallow, the hard pan that underlies the plains prevents the lake's water from seeping away. Large numbers of waterbirds, such as Knob-billed Ducks, stilts, terns and sandpipers congregate there to feed on organisms that thrive in the alkaline water.

ABOVE The male Knob-billed Duck, a resident at Lake Ndutu, develops a large swelling on his upper beak during the breeding season.

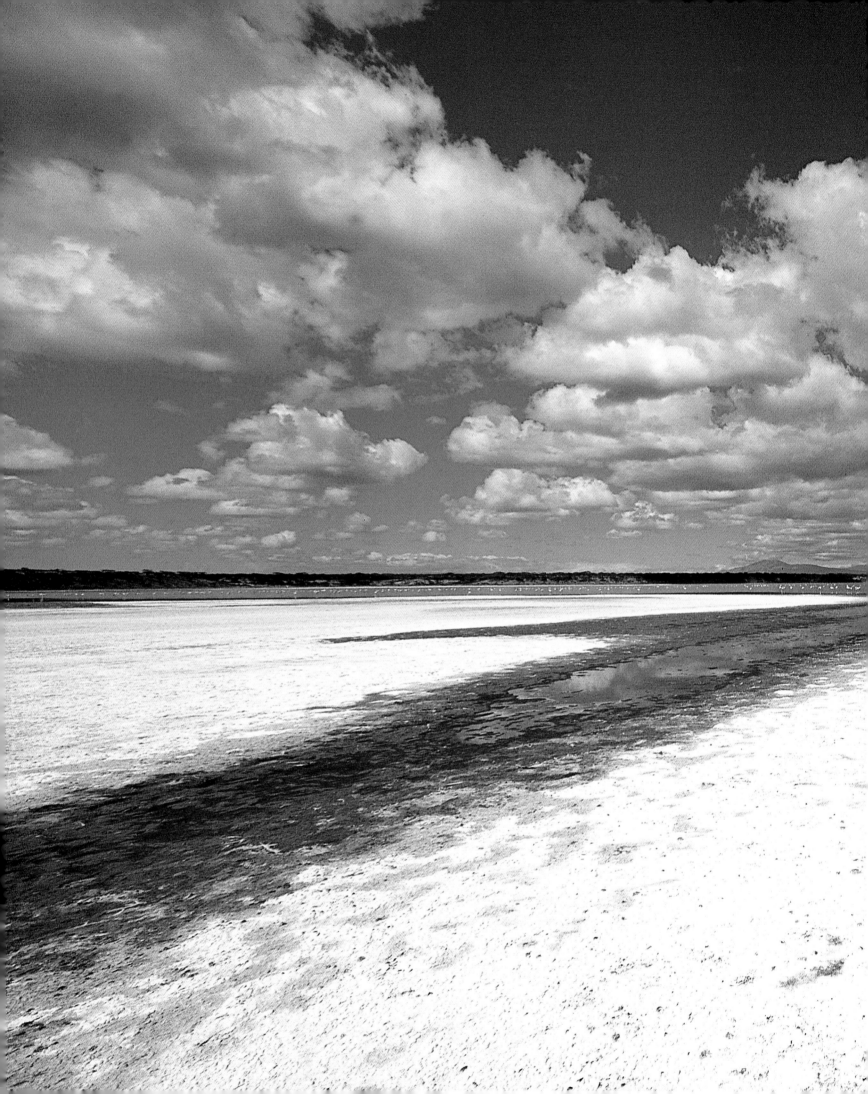

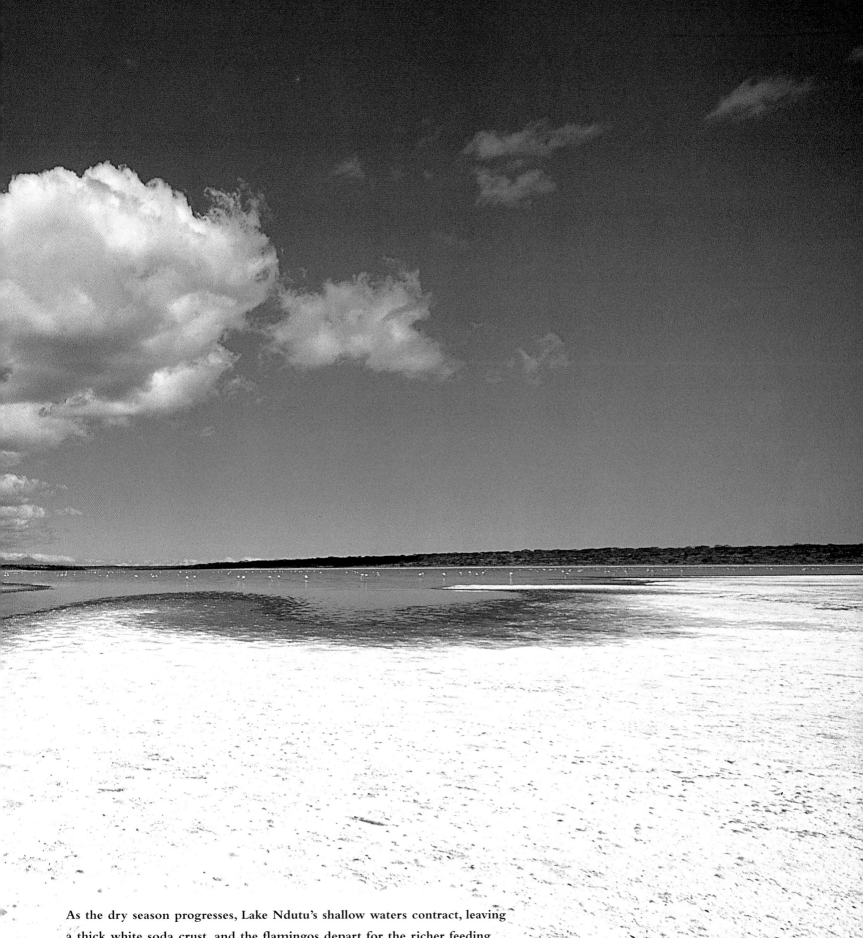

As the dry season progresses, Lake Ndutu's shallow waters contract, leaving a thick white soda crust, and the flamingos depart for the richer feeding grounds of the larger lakes in the Great Rift Valley.

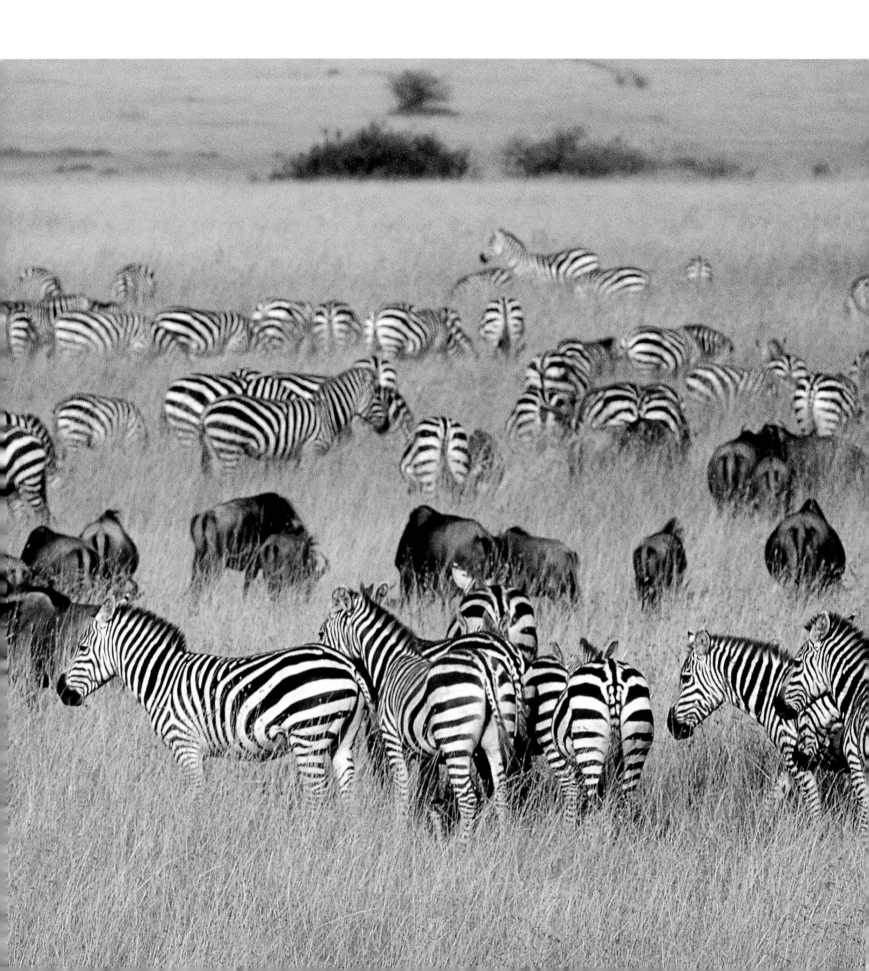

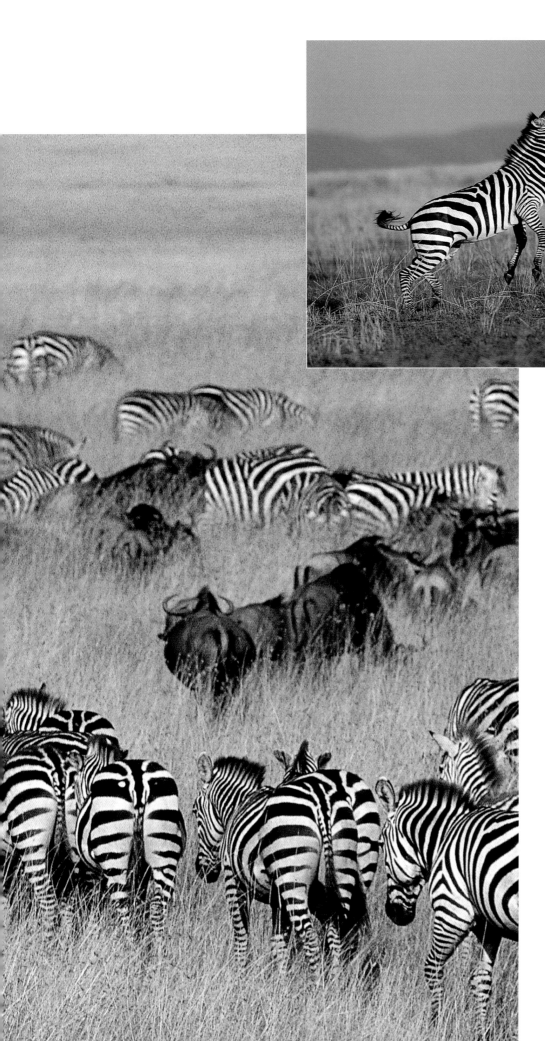

LEFT First to move into areas of long grass, zebras graze down the coarser, nutritionally poorer and less digestible grasses, leaving shorter, leafy green swards. Wildebeest in turn eat these exposed grasses, giving Tommies access to high-protein herbs normally hidden among the longer grasses.

ABOVE With teeth bared, a zebra stallion vigorously defends his position as family head. Fights almost always revolve around access to oestrus females, and usually involve neck-biting and wrestling.

To gather his own harem, a male must first abduct a filly from her family, and then defend her from rival stallions until he can impregnate her. A stallion uses his noisy, rasping bark to call the herd members to him in times of danger.

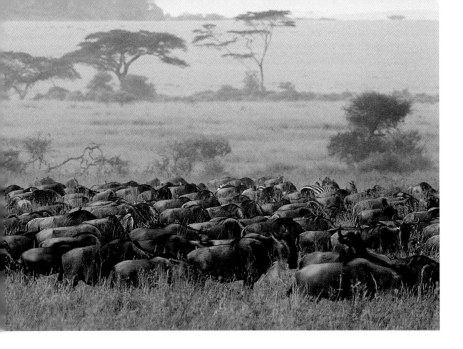

ABOVE Under a haze of smoke, the wildebeest begin moving north. Planned burning is carried out soon after the end of the wet season, when grasses still contain enough moisture to ensure a cool burn. Planned grassland burns benefit grazers by promoting the growth of palatable grass species and removing tough, woody plants, but unplanned fires wreak havoc in woodlands, which shelter small animals and reptiles that are unable to escape the flames.

BELOW Despite a nasty scorching that char-grilled its nose, a leopard tortoise survives the fire.

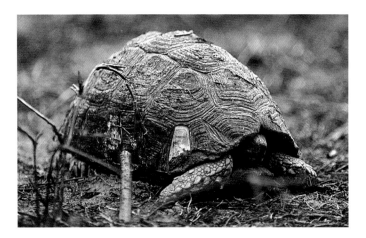

RIGHT A fire in the adjacent Ngorongoro Conservation Area, probably started by Maasai herders to encourage new grass growth and kill off ticks, quickly spreads to the woodland at Ndutu.

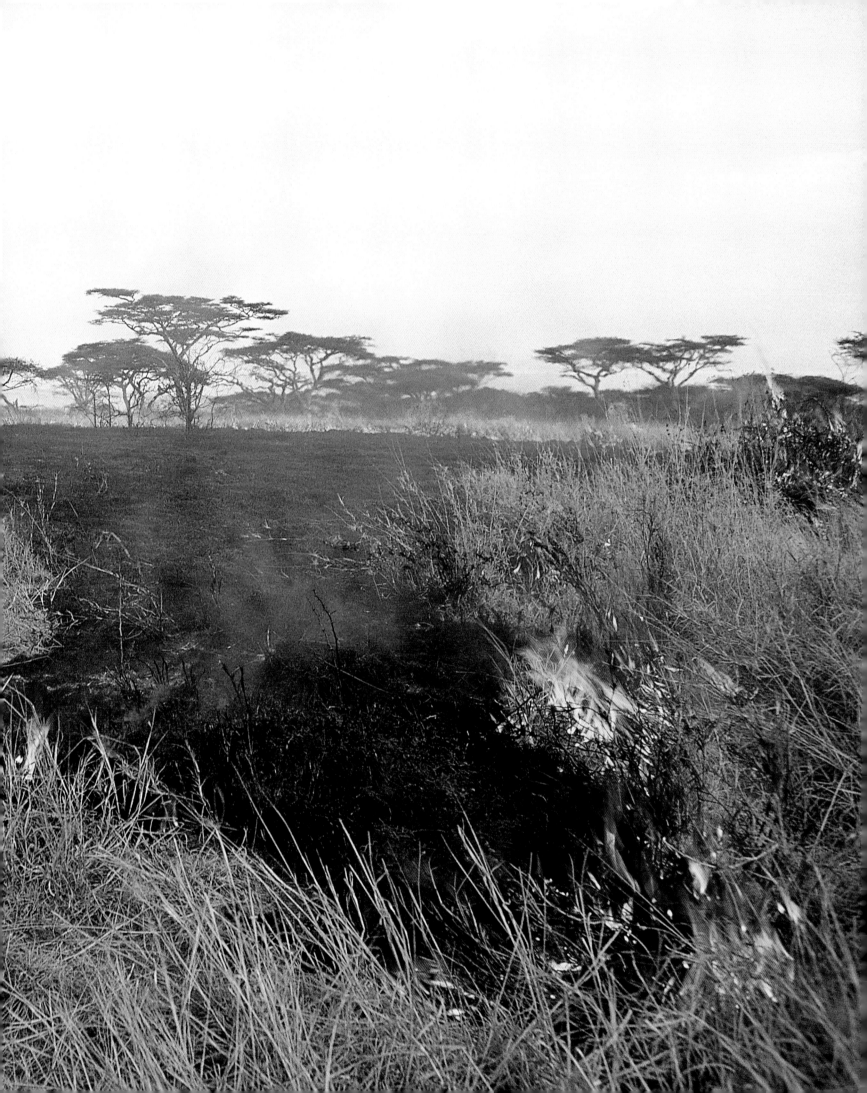

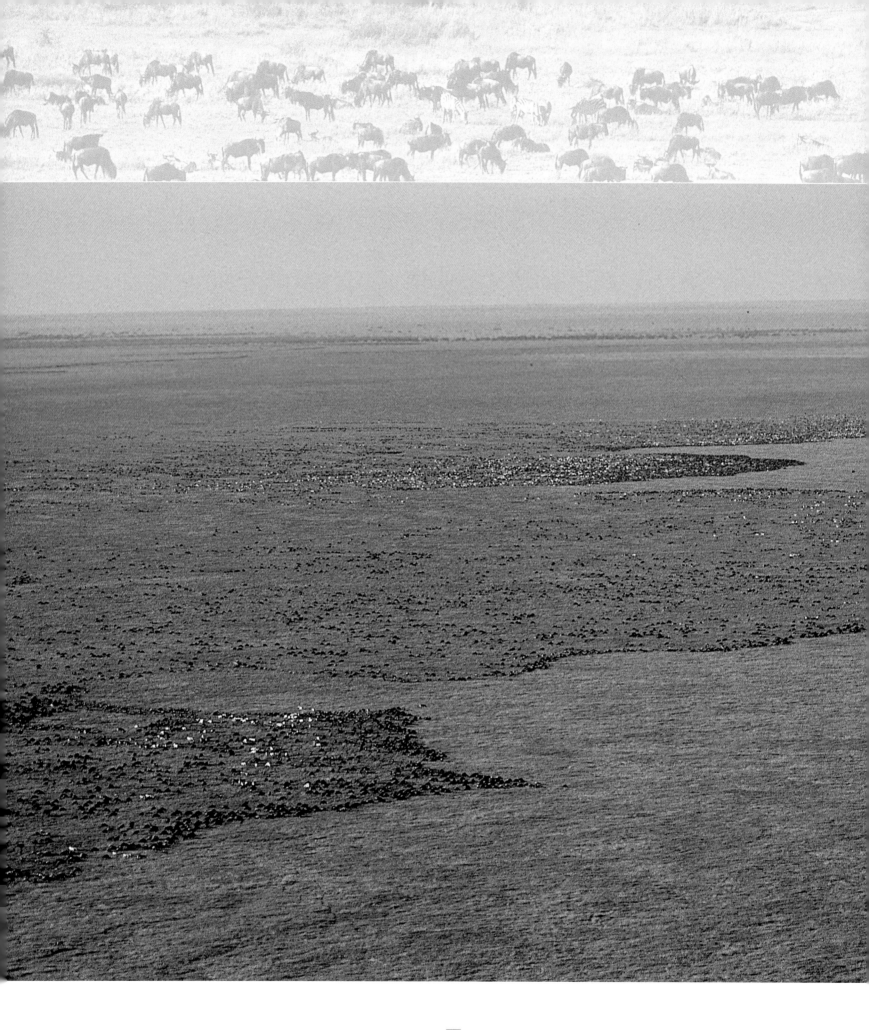

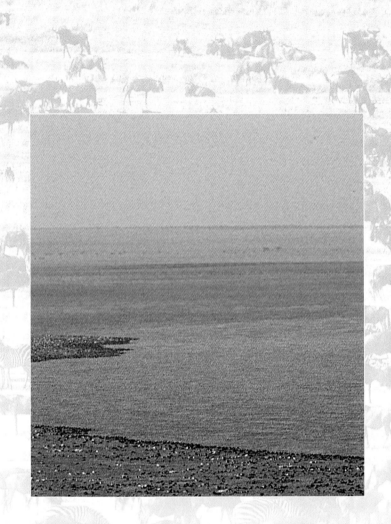

Even when the plains are flush with new green grass, the restless nomads are continuously on the move in search of the most palatable grass species. Wildebeest densities can exceed 1 000 animals per square kilometre. Extensive herding is a strategy that reduces each individual's risk of being attacked by a predator. However, such large aggregations of nomads can denude an area of food, to the detriment of non-migratory species that share the same food preferences.

BELOW Without the tireless efforts of dung beetles, the plains could well be submerged in dung. Attracted to the droppings by their smell, the beetles carefully form dung into a perfect sphere and roll it, backwards, to a place where the soil is soft enough to bury it. Their eggs are laid and incubated in the buried dung ball.

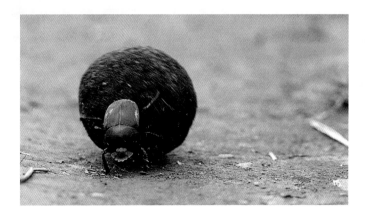

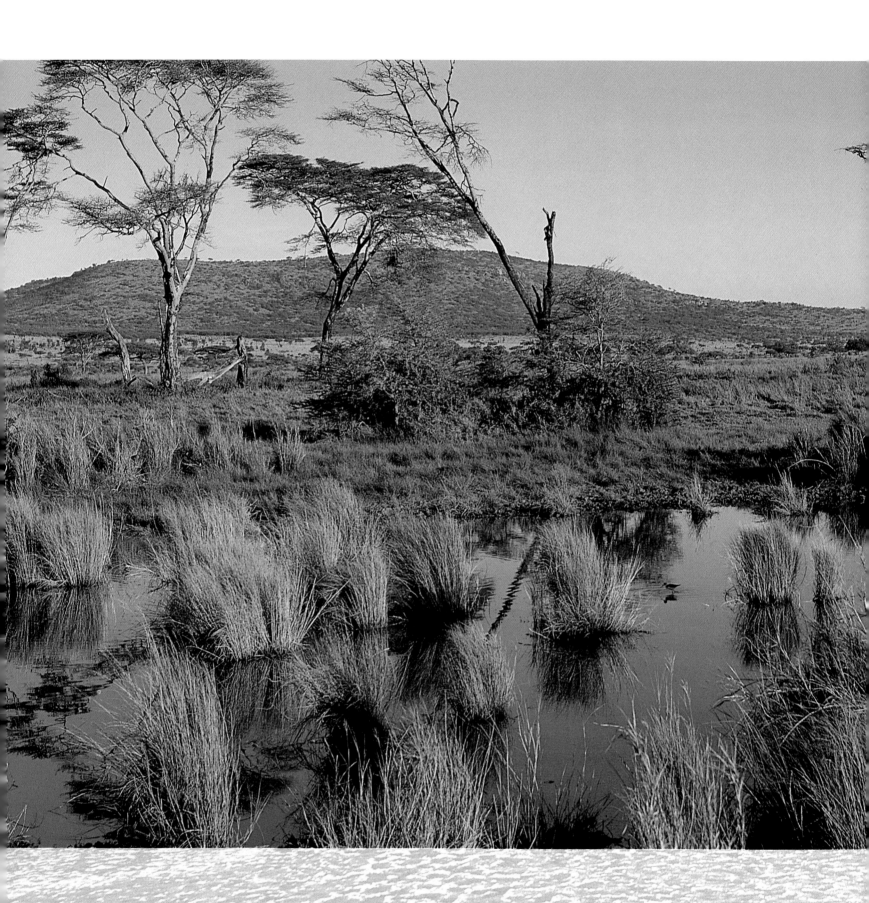

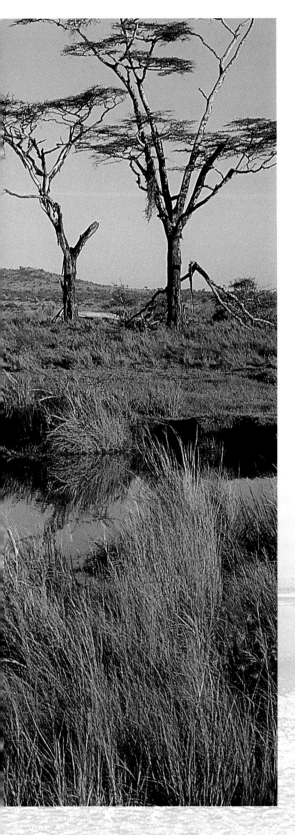

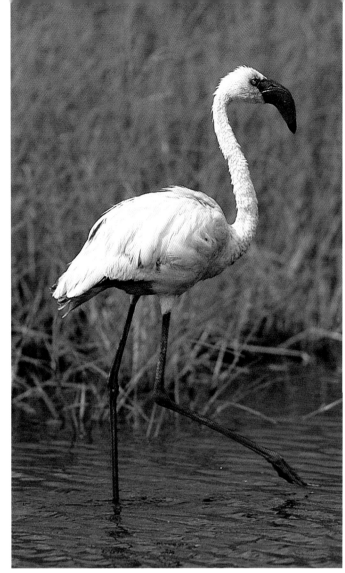

In the dry season the Loiyangalani River, which cuts across the plains to join the Mbalageti River at the western edge, contracts into a string of pools and swamps. It attracts spoonbills (right), Sacred Ibis, pelicans, avocets, stilts and sandpipers, as well as the occasional flamingo (above).

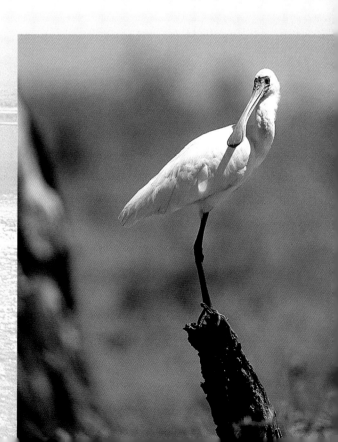

BELOW Lions do not always hunt co-operatively, but doing so increases their chances of catching larger prey. One of their tactics is to fan out and encircle their quarry. No matter in which direction the prey flees, it will more than likely run into one of the lions. As lions do not possess the speed and agility of the cheetah, they must creep as close as possible to their prey before giving chase.

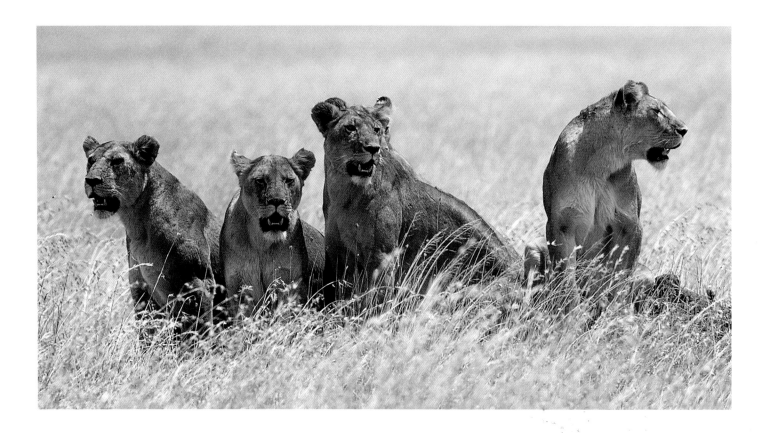

OPPOSITE A pride of lions has moved from its wet season range on the southern plains to a string of swamps, and is finding life tough. The nine pride females have 16 cubs to feed, and prey has become scarce. Where there is little cover in the form of bushes and reeds, lions hunt at night when darkness tips the element of surprise in their favour. As water sources recede, there is not much prey available, and they cannot afford the luxury of choice. Leaving the cubs in the care of one of the mothers, the other females roam all day, sometimes separating, in the search for food.

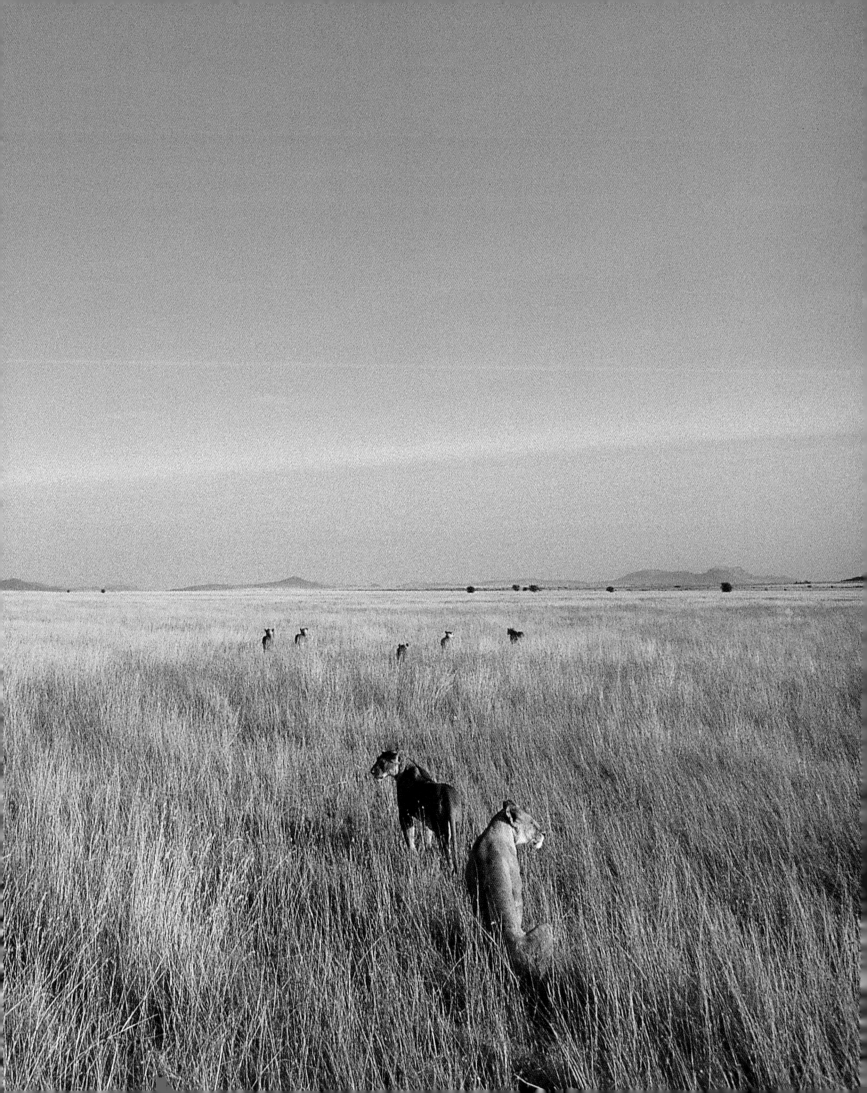

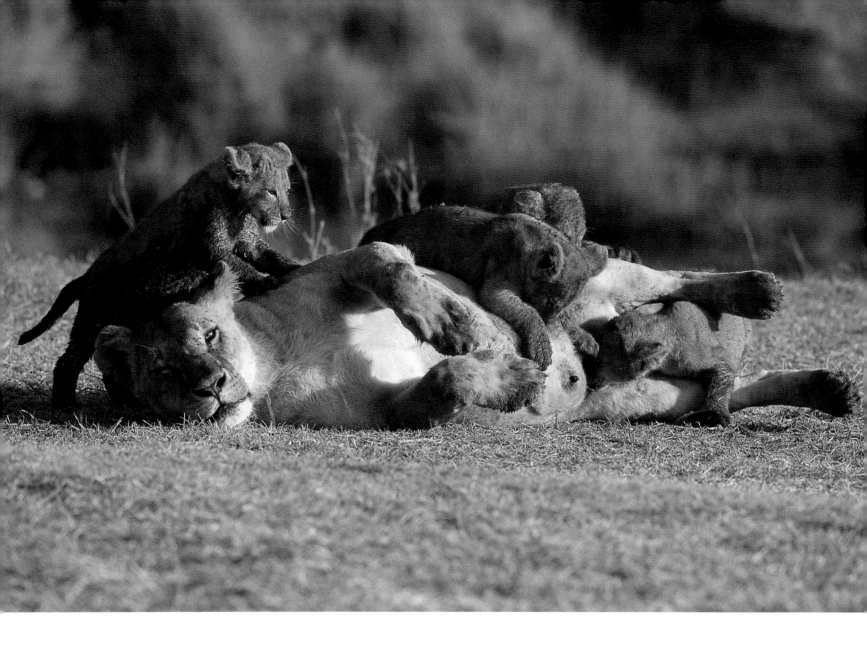

ABOVE Lions frequently engage in physical contact and cubs may suckle as a means of initiating contact. Nursing is a job shared by all mothers in a pride. Although females preferentially nurse their own offspring, cubs can be quite artful in trying to nurse from other lactating females. Non-offspring suckling is more common among closely related lionesses or by females with small litters. However they do so not out of generosity, but because they are too lazy to police who is suckling.

When their bellies are full, cubs are at their most playful. They delight in games of chasing and stalking, pouncing and wrestling, and they like to climb small trees. An adult's tail is also fun to chase and chew, unless it is attached to a male. Males are generally intolerant of the exuberance of cubs and will discourage their attentions by moving away, snarling at them, or even slapping them to display their displeasure.

BELOW The crèche mother is restless and refuses to allow the cubs to suckle, even though they are desperately hungry.

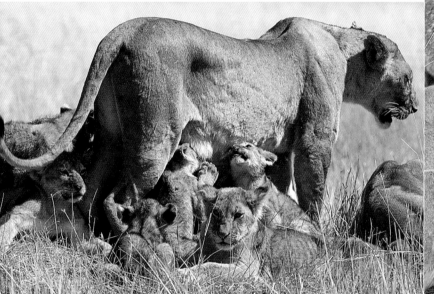

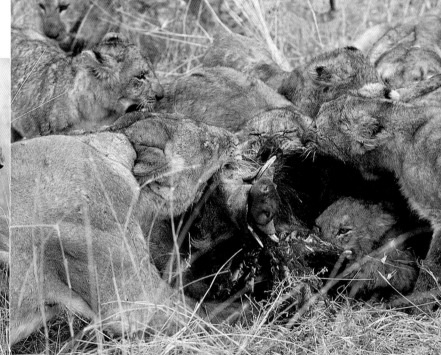

TOP RIGHT After four days without food, one of the females within the pride catches a warthog. Lions find warthog particularly delectable, but it makes a meagre snack when it must be divided among 25 animals.

RIGHT A noisy tug-of-war erupts over the remains of the warthog. Lions are the most social of all cats, but at a kill they are often utterly selfish. Each animal holds on to its morsel for dear life while snarling and growling, and females are known to take meat from their cubs.

Communication is vital to the successful functioning of a society, and a lion's communicative repertoire is well developed. Through vocalisations, facial expressions, scents and postures they signal their moods and intentions to each other.

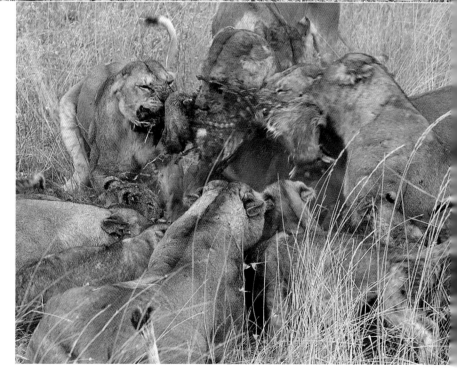

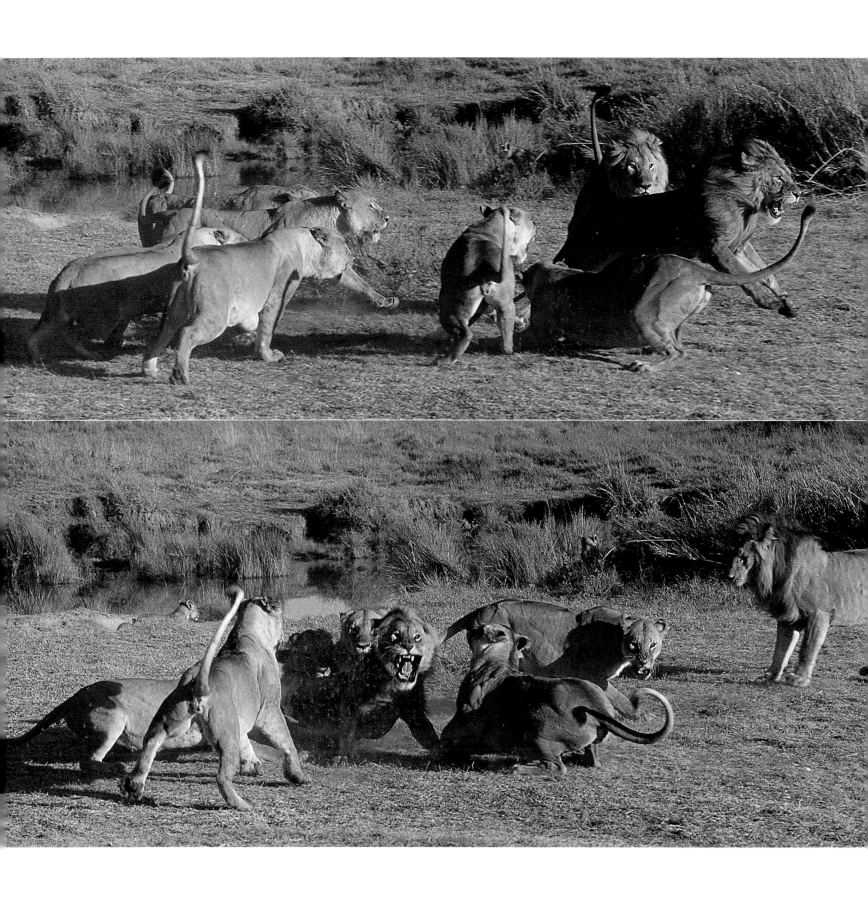

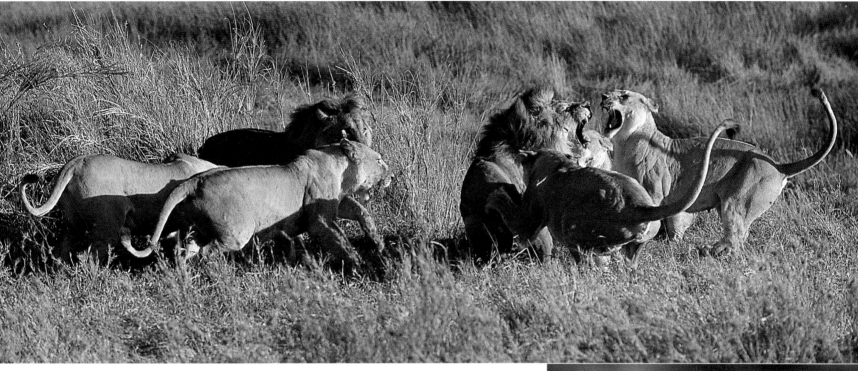

OPPOSITE BOTTOM A pride of females takes exception to the presence of a foreign male. Aggression among lions is usually initiated by females and directed at males that may be harassing them. A roving bachelor poses a grave threat to small cubs – when he takes over a pride, he will kill all the cubs. This is a vital part of his reproductive strategy: a female normally comes into oestrus when her cubs are around 18 months old, but if her litter is lost she will mate again within a few weeks. A male's tenure in a pride may last only two years.

CLOCKWISE FROM OPPOSITE TOP In a gallant show of sisterhood, all the females participate in the attack. Another male takes the opportunity to try and intimidate his rival, yet the tactic backfires on the second male when the females turn on him too. The fracas lasts only a few minutes and the males are only slightly the worse for wear. Occasionally such fights result in serious injury, but lions are amazingly resilient and usually recover well, even from severe wounds.

OVERLEAF Six days have passed since the pride had their last substantial meal. In the depths of the dry season, the outlook is grim for the cubs. Within two months, almost half of them will have died of starvation.

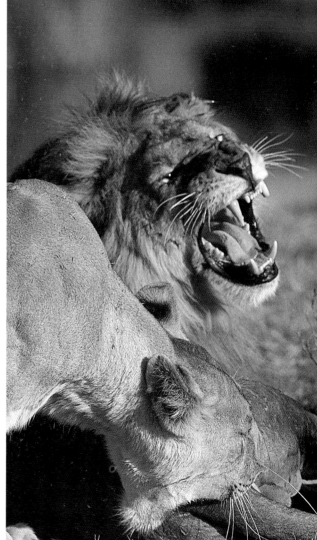

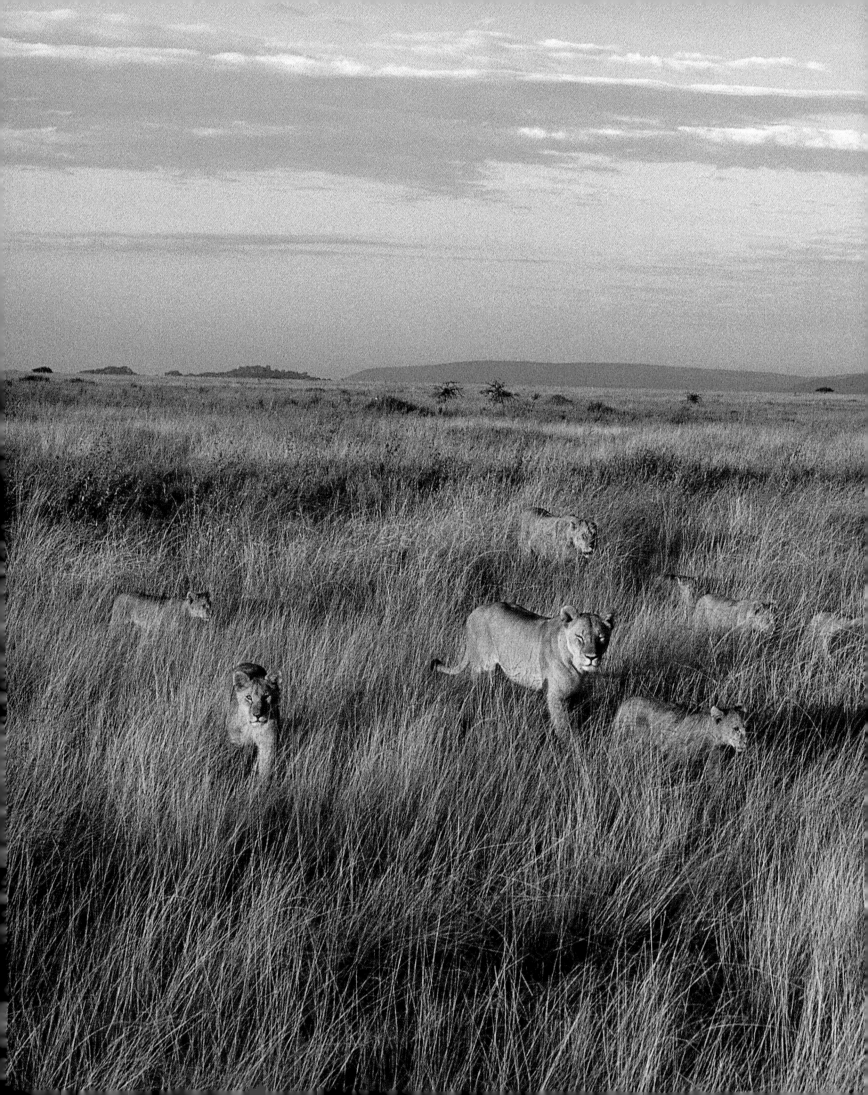

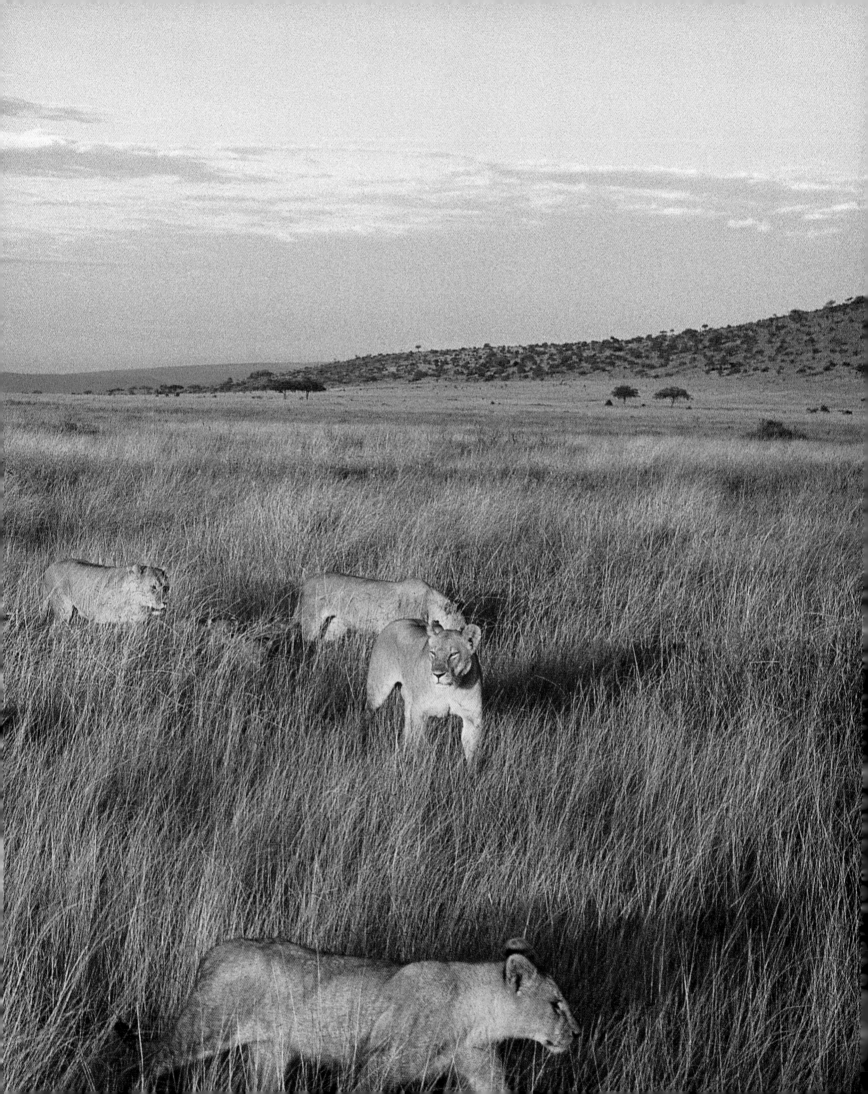

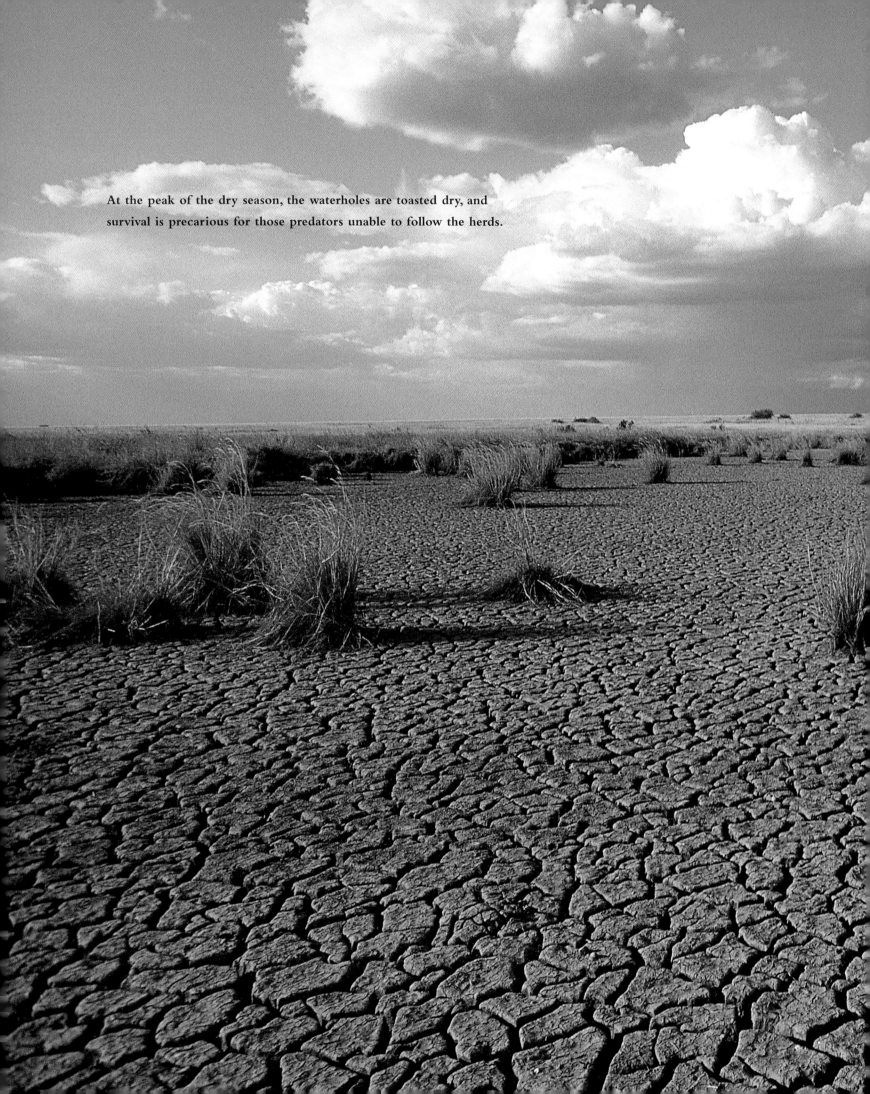

At the peak of the dry season, the waterholes are toasted dry, and survival is precarious for those predators unable to follow the herds.

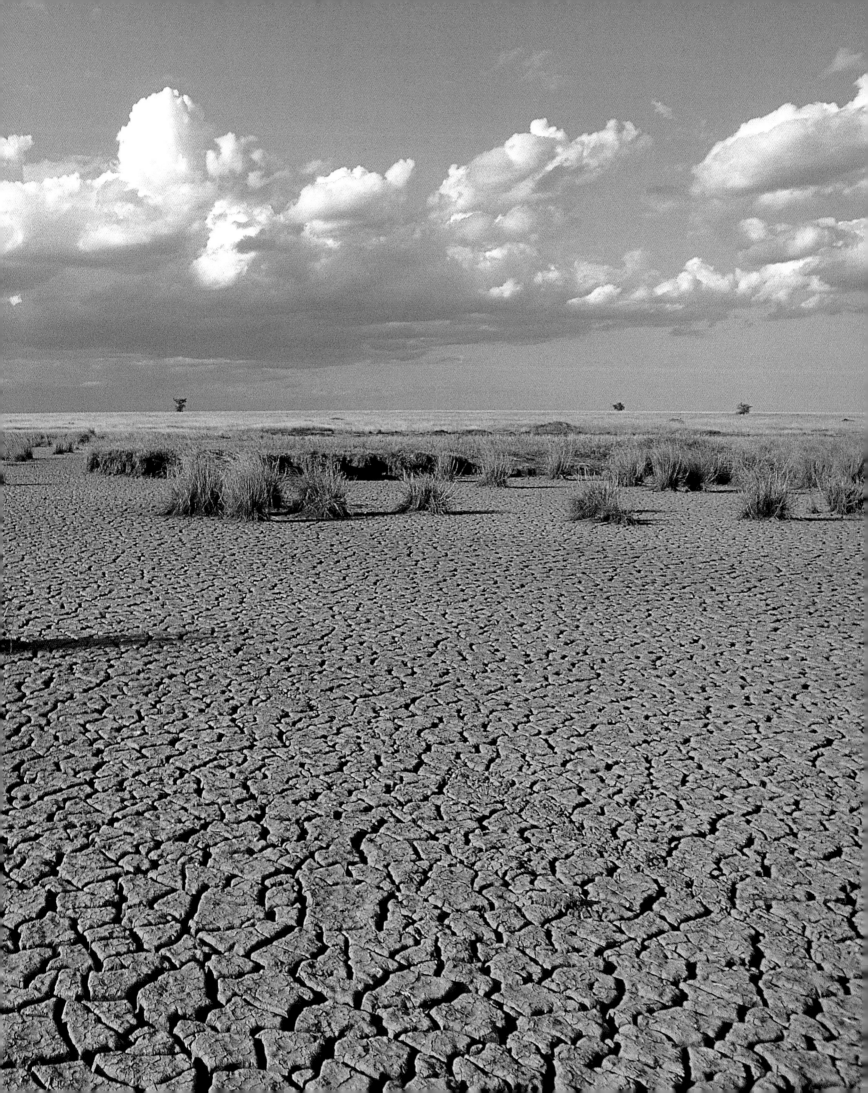

CENTRAL
SERENGETI

Although the Serengeti is most famous for its grassy plains, almost two-thirds of the park consists of savanna and woodland. The shallow hardpan that underlies the plains, sealing off the water table and preventing trees from becoming established, disappears near the edge of the grassland. Towards the centre of the park, plains gently diffuse into woodland studded with koppies and entwined with transient rivers. Trees, mostly thorny acacia species adapted to long periods of drought, moderate the heat and harshness of the dry season, while permanent water sustains a variety of animals and birds.

The first colonists to discover the Seronera River Valley found such an abundance of game, they moved to establish a sanctuary to protect the area and conserve its wildlife, not for posterity but for the exceptional hunting opportunities it presented. When the Serengeti was declared a national park, its headquarters were established at Seronera, in the centre of the park, which remains a vital hub of both tourist and research activity.

As the nomads file off the plains at the end of the 'long wet' and head north-west towards the Western Corridor, some herds drift directly north to the Seronera River valley, where they are assured of ample water. Whether flooding its banks after wet season downpours, or dwindling to a foetid trickle after months without rain, the Seronera River remains the nerve centre of the central Serengeti. Copses of wild date palms, acacias and sausage trees that define its course afford a diverse habitat for herbivores and predators alike.

The predators of the central Serengeti are unable to take advantage of the glut of new calves and fawns born in the south before the wet, but their turn comes when the nomads arrive in the Seronera River valley at the beginning of June. Suddenly food is plentiful and predictable. The wildebeest calves have grown in size and strength and are less vulnerable, but they are nonetheless much easier to catch than the wary resident prey.

The arrival of the herds provides a welcome relief for resident, non-migratory animals. Prides of lions that can enlist the help of a fellow male in hunting frequently prey on buffalo that inhabit the woodland, but when the nomads pass through they switch their attentions to the moving feast. Resident topi, hartebeest, warthogs and gazelles also have a temporary reprieve from lion predation.

Predators do not compete for food as they take different sections of the prey population. Hyaenas hunt by pursuing their prey, taking the slower individuals, while lions ambush and hunt a variety of prey species. Cheetahs mostly hunt Tommies, while leopards prey on impalas and a wide variety of smaller animals.

OVERLEAF River courses defined by sausage trees and yellow-barked acacias demarcate the verge between grassland and woodland of the Central Serengeti

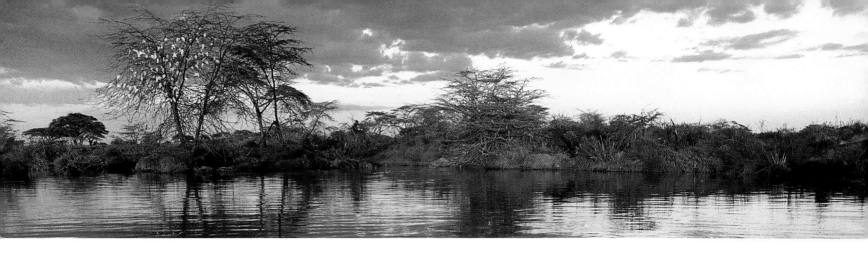

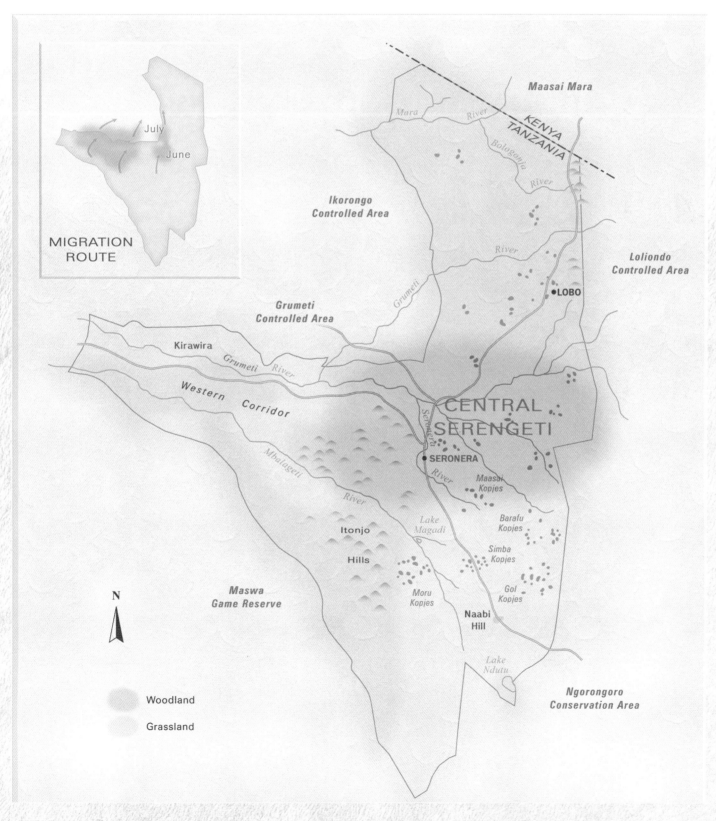

MIGRATION
ROUTE

July

June

Maasai Mara

Mara

River

Bologonja

River

KENYA

TANZANIA

Ikorongo
Controlled Area

Loliondo
Controlled Area

River

Grumeti

•LOBO

Grumeti
Controlled Area

Kirawira

Grumeti River

Western Corridor

CENTRAL
SERENGETI

•SERONERA

Seronera

Mbalageti

River

Maasai
Kopjes

River

Barafu
Kopjes

Itonjo

Lake
Magadi

Simba
Kopjes

Hills

Maswa
Game Reserve

Moru
Kopjes

Gol
Kopjes

Naabi
Hill

N

Lake
Ndutu

Ngorongoro
Conservation Area

Woodland

Grassland

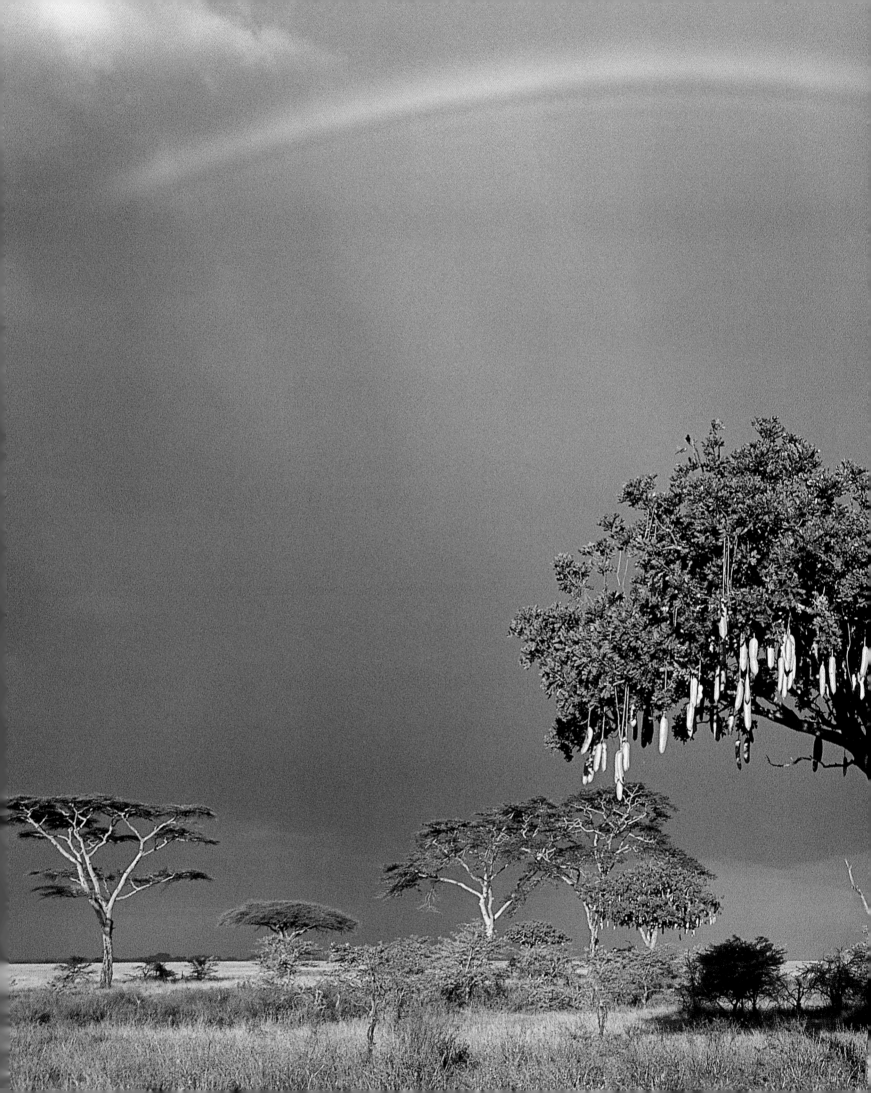

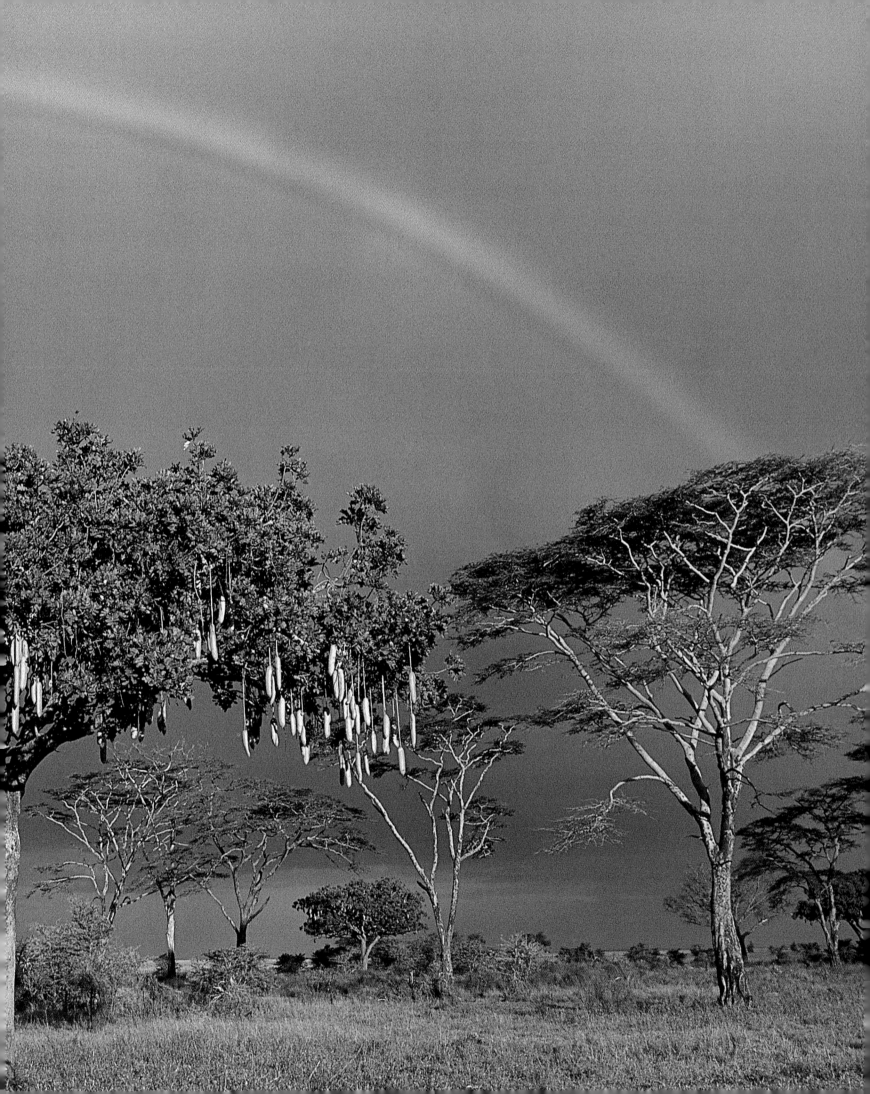

BELOW Groves of yellow-barked acacias, also known as fever trees, hug the Seronera River. It was once thought that these handsome trees harboured malaria, a credible belief in an age when the cause of the disease could only be surmised. The trees flourish in moist or swampy areas, which are ideal breeding grounds for anopheles mosquitoes, the carriers of malaria.

OPPOSITE Woodland koppies are enveloped in thick shrubby undergrowth and succulents, and are often used by the large cats to hide their newborn cubs. Woodland trees are mostly thorny acacias dominated by umbrella acacias, as well as *Commiphora* and *Ballanites* species.

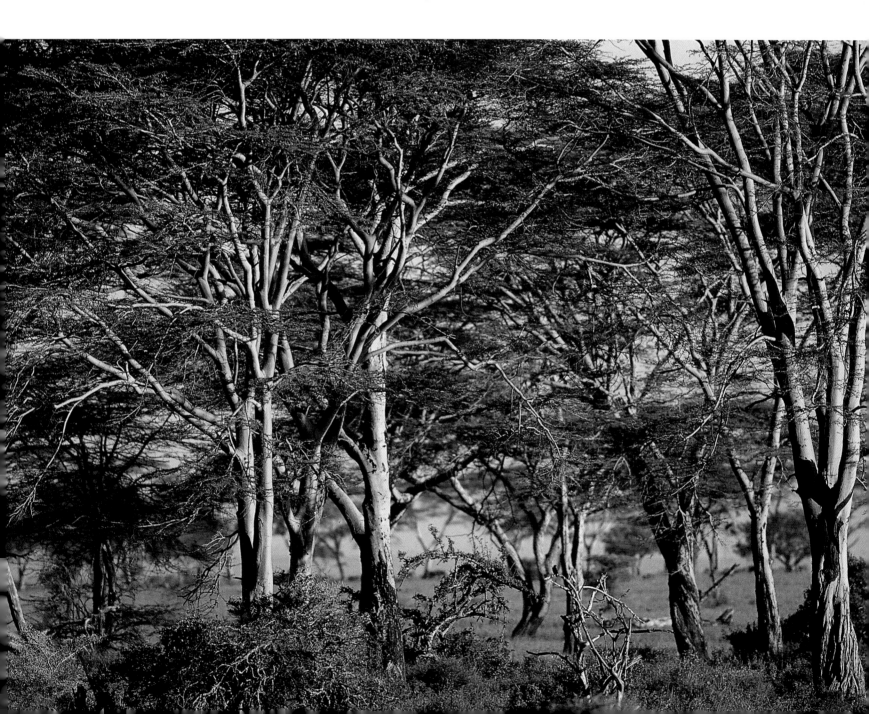

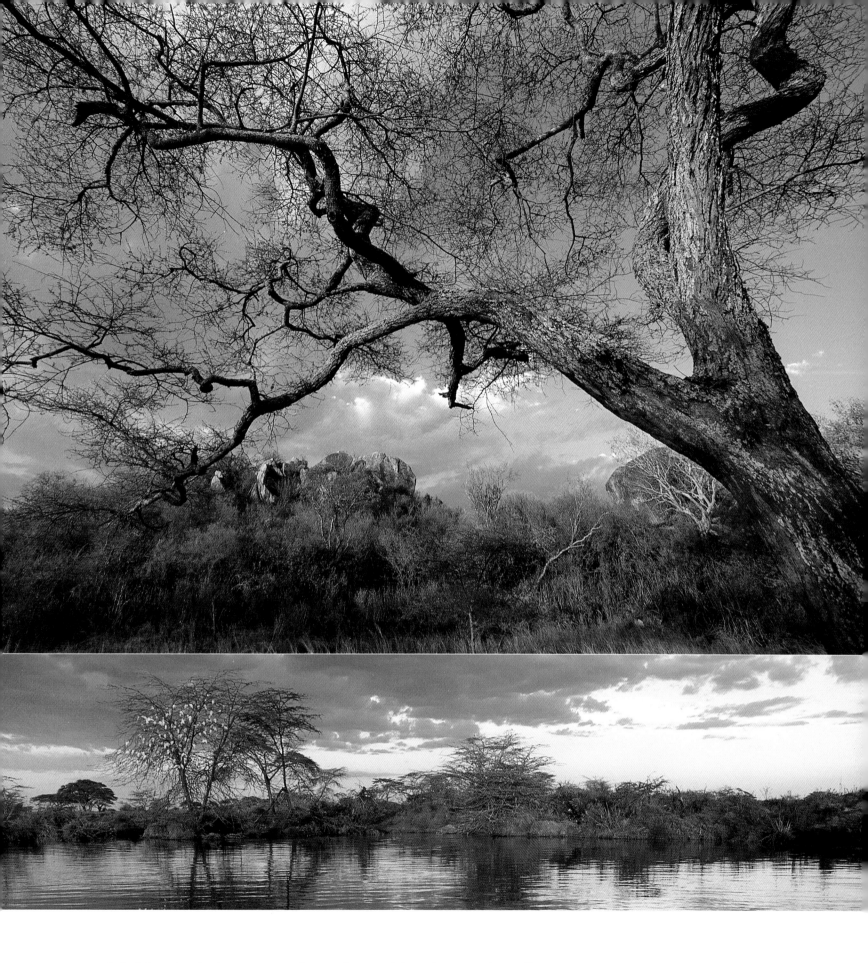

ABOVE A ford damming the Seronera River forms a deep pond that is home to a bevy of hippos.

OVERLEAF Cattle Egrets spend their days feeding on insects stirred from the grass by grazing herds. When they return to roost in their favourite fever tree at dusk, latecomers bicker over the best perches.

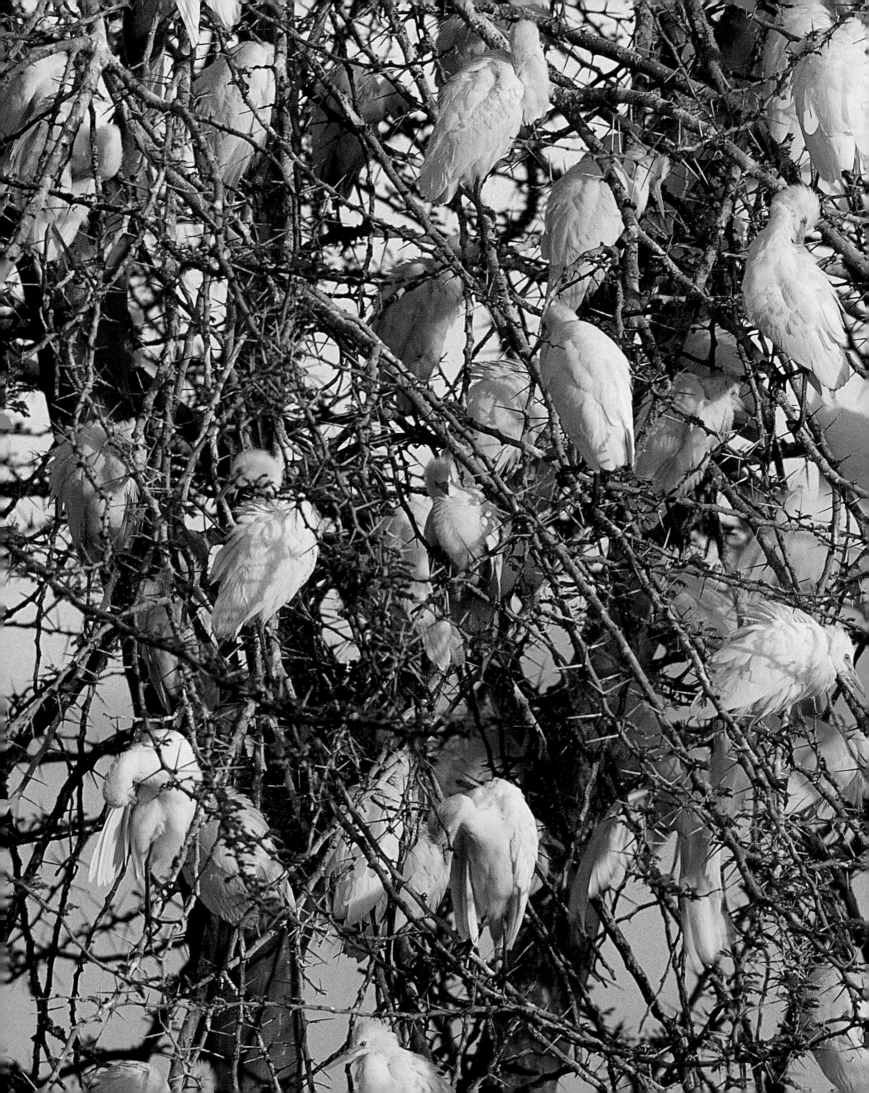

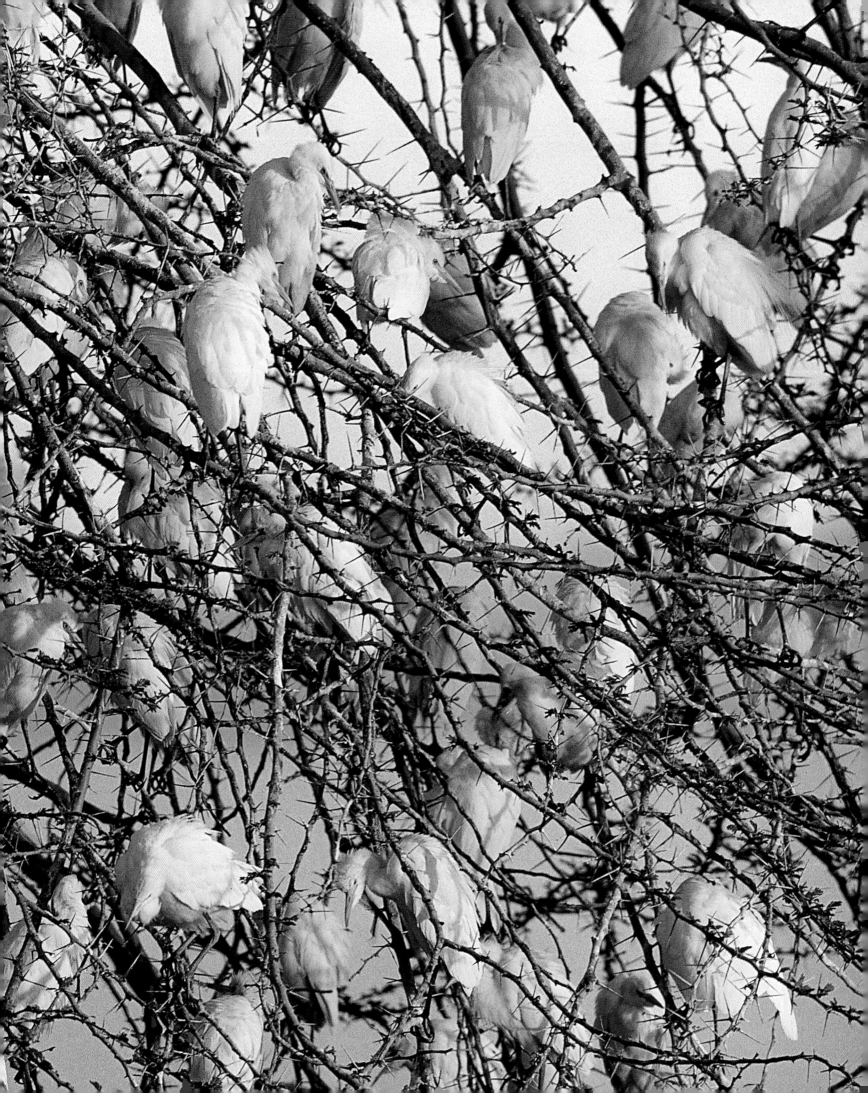

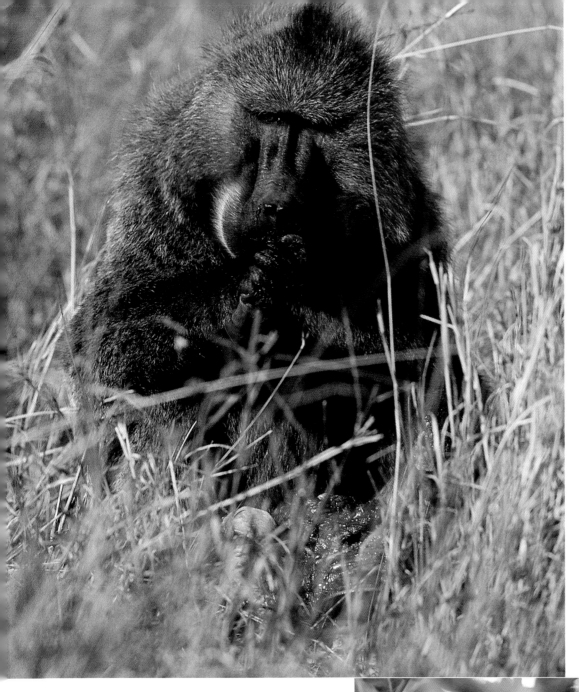

LEFT Baboons are fierce fighters. They are well equipped for battle as they have extremely sharp canine teeth and possess a courageous willingness to challenge predators for their kill.

Here, an olive baboon proved much too fierce an adversary for a cheetah, which reluctantly surrendered the kill to the thief rather than risk an injury that could cripple its ability to hunt. Before the imminent arrival of opportunistic scavengers, the baboon hastily stuffs its cheeks full of meat.

Olive baboons sleep in lofty trees, where they are safely out of reach from nocturnal predators. They are perfectly at home in the riverine areas of the central Serengeti. As soon as danger is detected, the baboons scamper to the security of treetops and bark a loud warning that is universally understood.

RIGHT AND OPPOSITE BOTTOM The rich ruby flowers of the sausage tree develop into tough, fibrous, sausage-shaped seeds relished by baboons, brown parrots and giraffes. By the end of the dry season, very few sausage-shaped seeds remain on the trees.

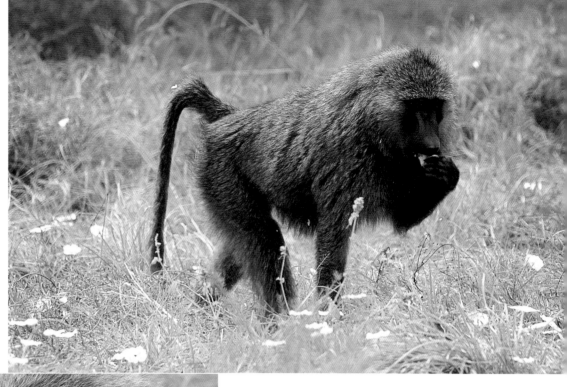

RIGHT Olive baboons are opportunistic feeders, and their strategies and habits, which vary from season to season and from place to place, influence their social organisation. Ipomoea flowers, which appear at the end of the wet season, are a delicacy.

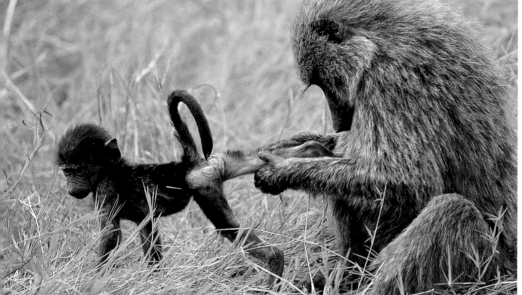

LEFT Like children, young baboons are sometimes reluctant to forfeit playing time for grooming. Grooming is an important means of social bonding within a baboon troop.

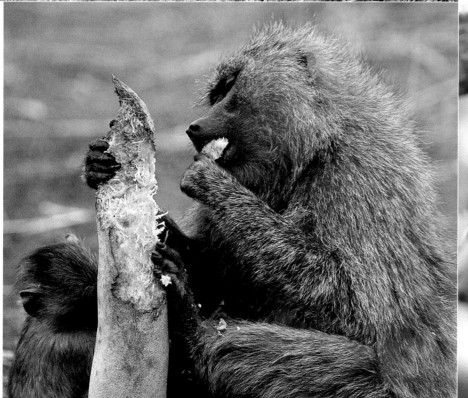

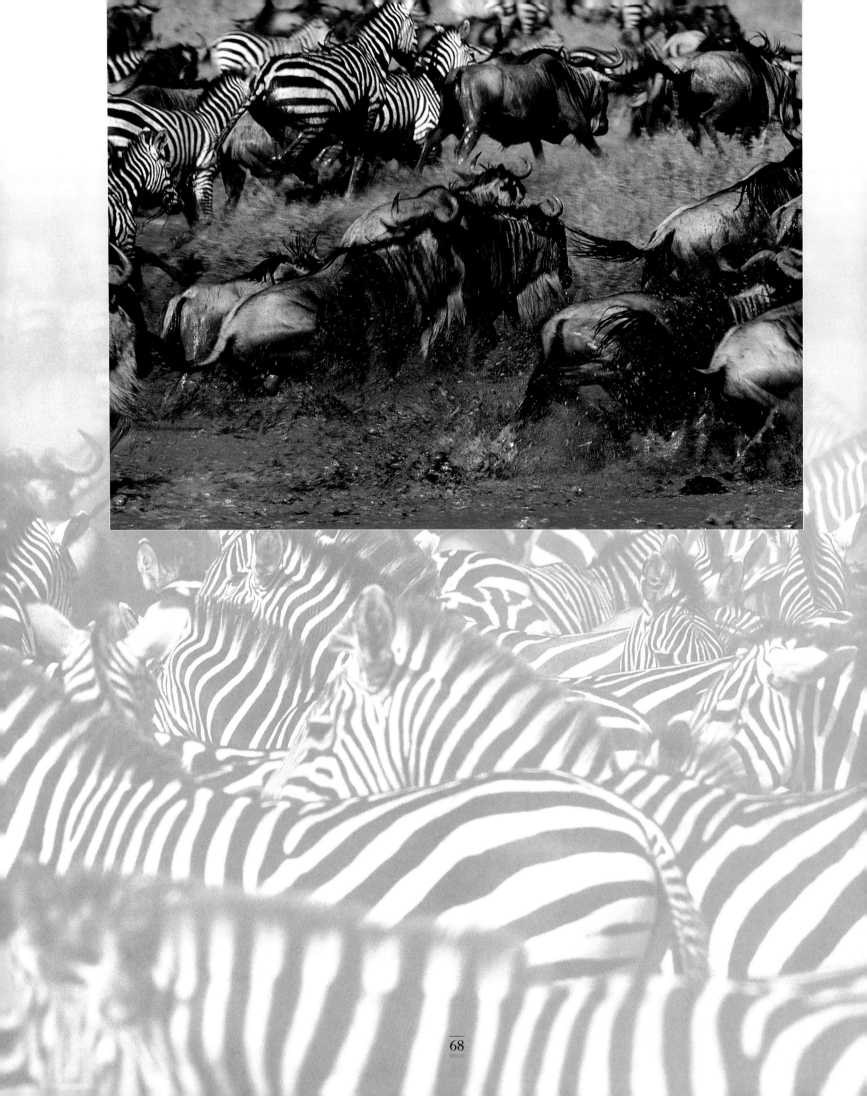

OPPOSITE The slightest noise or movement near a waterhole sparks a stampede of the wary herds.

During the dry season grasses cease to grow in the south, and surface water dries up. Like the wildebeest, zebras too must find new pastures and reliable water in the dry season. Since they are not competing for the same food, and are heading for the same destination, they share the journey.

The zebra's longer gestation period means that births occur throughout the year, providing a continuous source of prey for predators. Zebra herds protect their young from hyaenas by clumping together and hiding the young behind a wall of family members. The stallion actively defends his family and is more than willing to attack hyaenas.

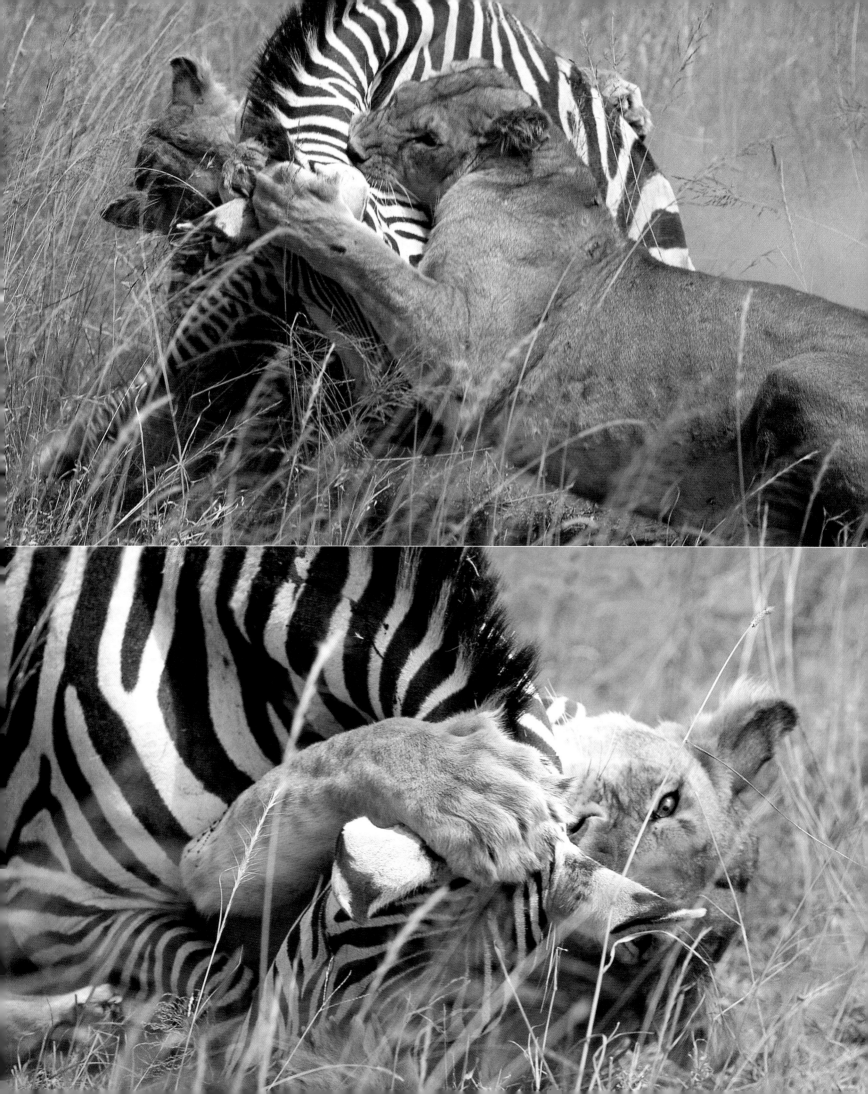

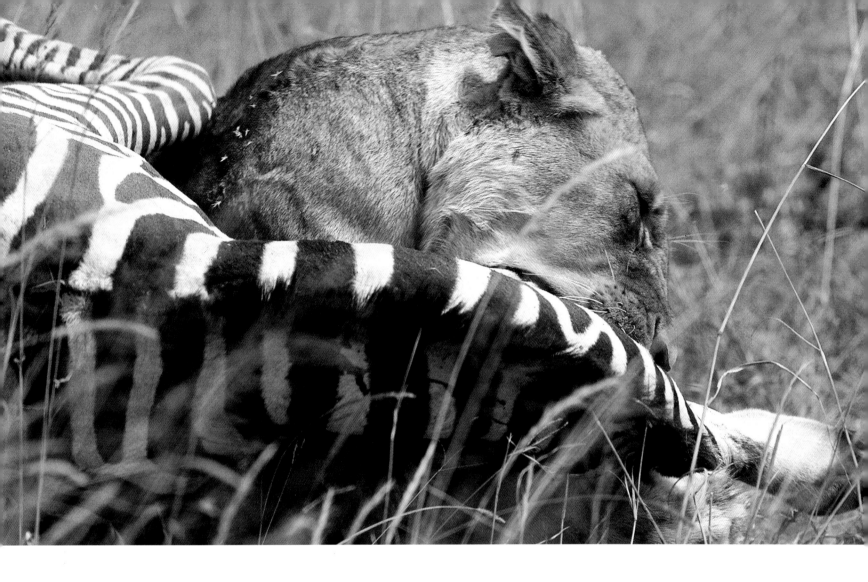

A luckless zebra, one of the last to leave the plains, is ambushed by several members of a lion pride. Two of the lionesses battle to bring it down. Once on its side, the zebra has no hope of escaping.

When lions kill an animal, all parts of the body are eaten, except for the stomach contents and a few indigestible bits such as horns and teeth. When the prey is too large to be dispatched in one sitting, lions will remain with the carcass and feed on it periodically until it is finished. Males may be able to eat as much as 40 kilograms, or a quarter of their body weight, in one meal.

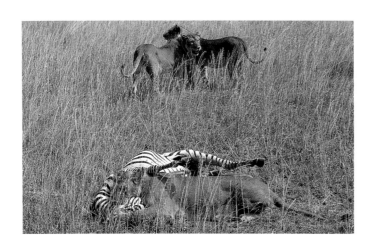

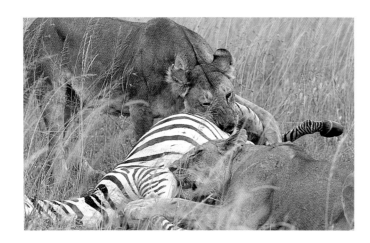

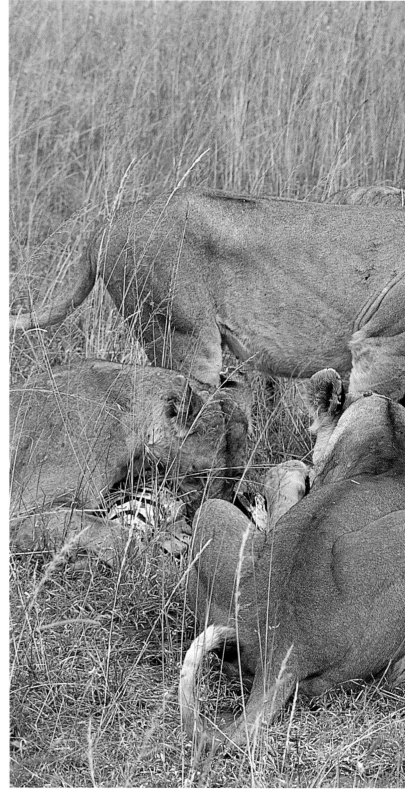

TOP AND ABOVE The third member of the ambush party is greeted with rubs that signal acceptance. While she fetches the other pride members and cubs, which stayed behind during the hunt, the first two lionesses start to eat.

RIGHT When the cubs arrive, they hungrily fall on the carcass. A catch this size is big enough to be shared amicably.

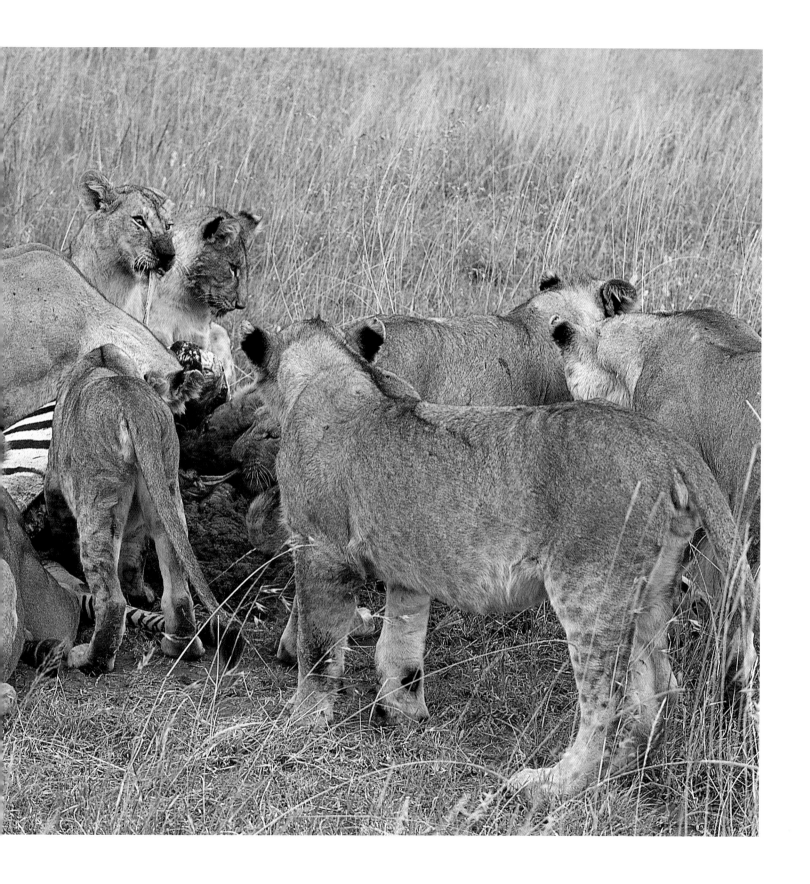

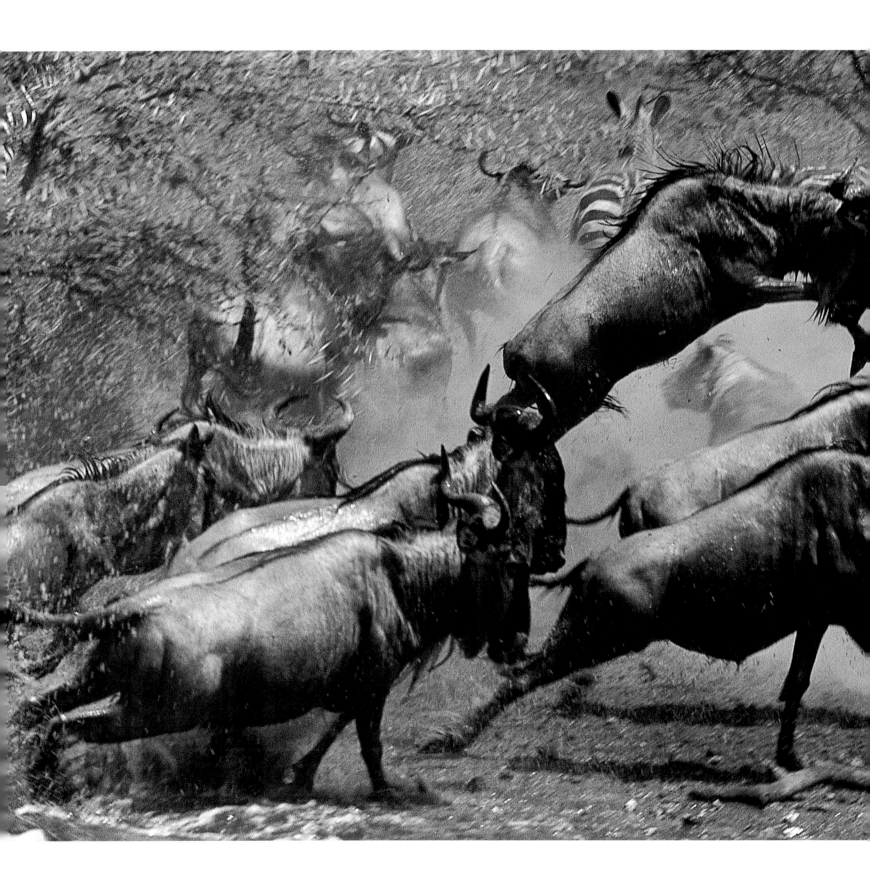

LEFT A lioness has been hiding in the bushes near a favourite watering point on the Seronera River. Flighty zebras sense her presence and stay alert, but a herd of wildebeest plunges headlong into the water, giving the lioness the opportunity she has been waiting for.

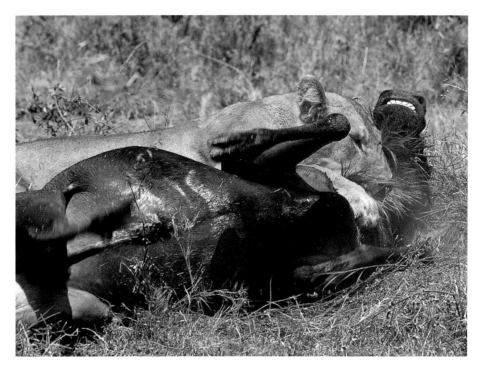

ABOVE The skin of a wildebeest's throat is extremely thick and cannot be penetrated by a lion's teeth. Once prey has been brought down it rarely struggles, and the victim is strangled to death.

BELOW Most animals will tolerate the attentions of Yellow-billed Oxpeckers. Although these commensal birds eat ticks, dandruff, earwax, and other tasty morsels around eyes and noses, they mainly feed on blood, which is obtained by pecking at the host animals' cuts and injuries.

RIGHT Parasol-topped acacias are a hallmark of the central Serengeti. Giraffes are able to feed at the highest levels of these trees as they have an elongated neck, and a long and leathery tongue allows them to strip the leaves of the uppermost branches.

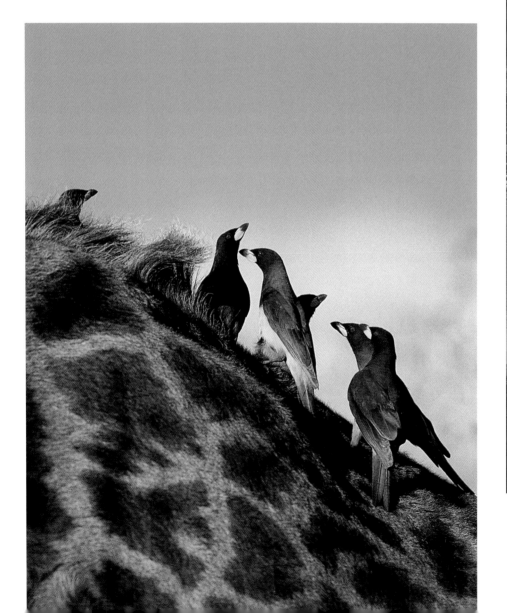

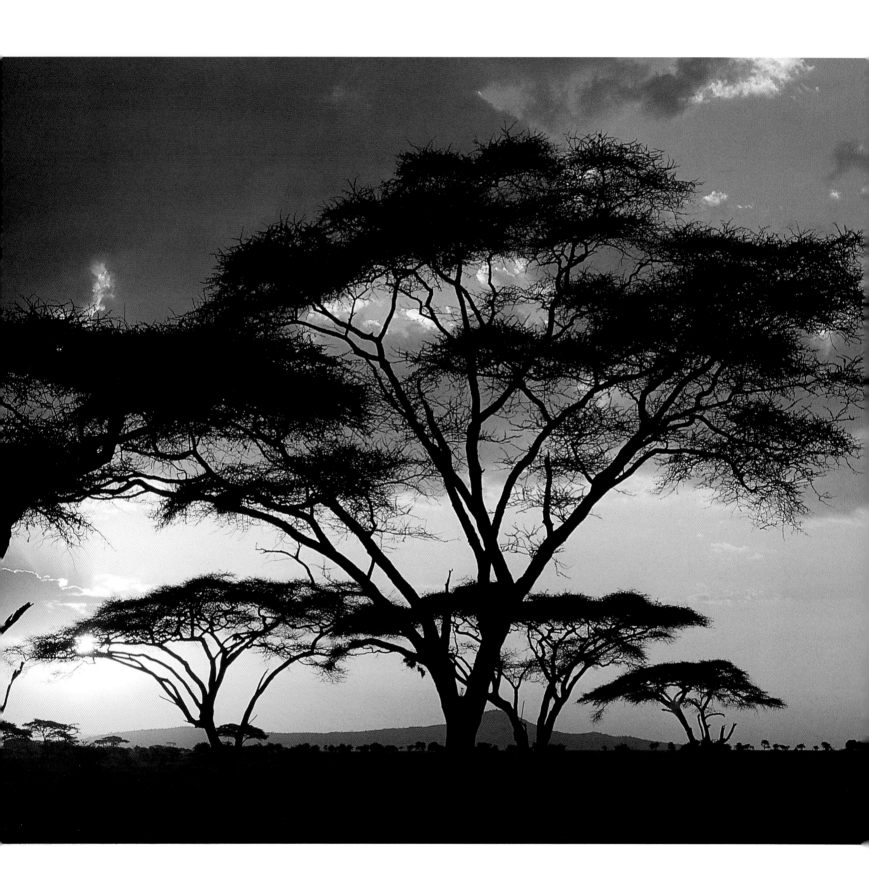

BELOW The approach of night stirs a leopard from its sleep. Nocturnal ramblings can take it on a 30 kilometre inspection tour of its home range in a single night.

OPPOSITE Leopards are the most secretive and elusive of the larger carnivores, and for this reason their numbers in the park can only be guessed at. They are strong, agile climbers and shrewd predators, capable of killing prey larger than themselves. The rivers around Seronera are ideal leopard habitat, where dense, shrubby undergrowth provides cover for stalking as well as refuge from hyaenas and lions.

OVERLEAF Woodland koppies provide the safe environment a leopard needs to raise her cubs, which she keeps hidden in a deep crevice in the rocks away from lions and hyaenas.

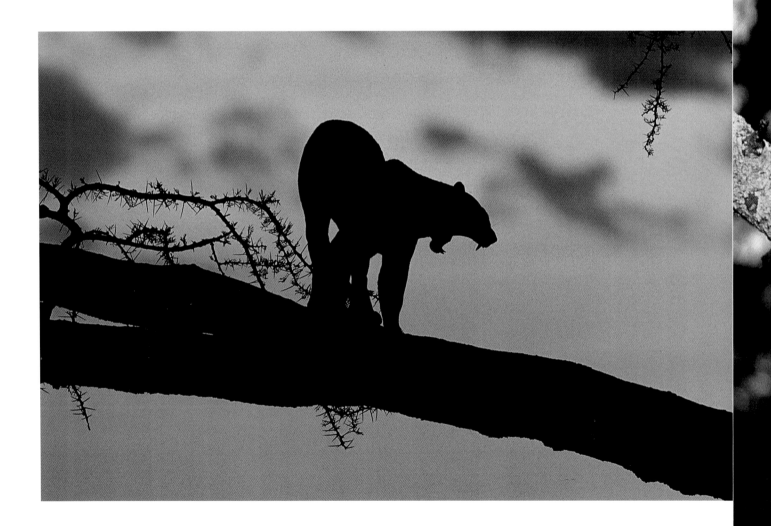

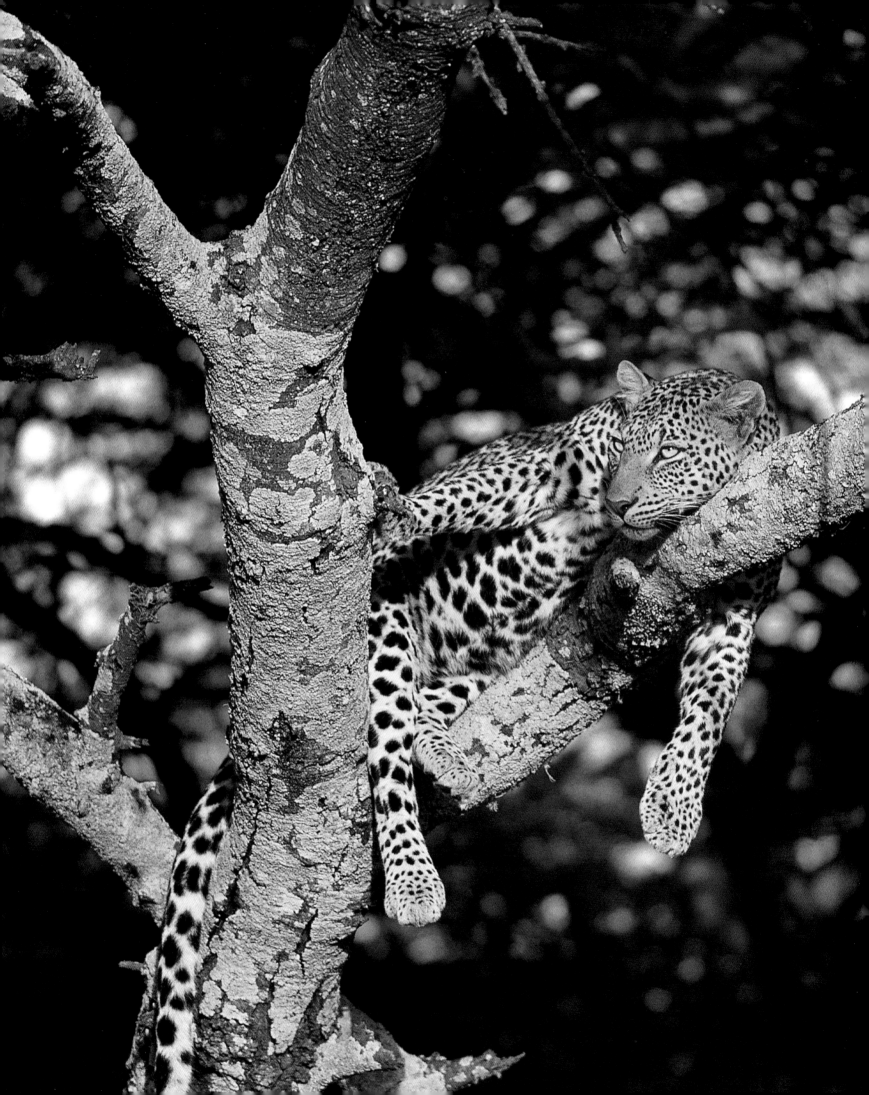

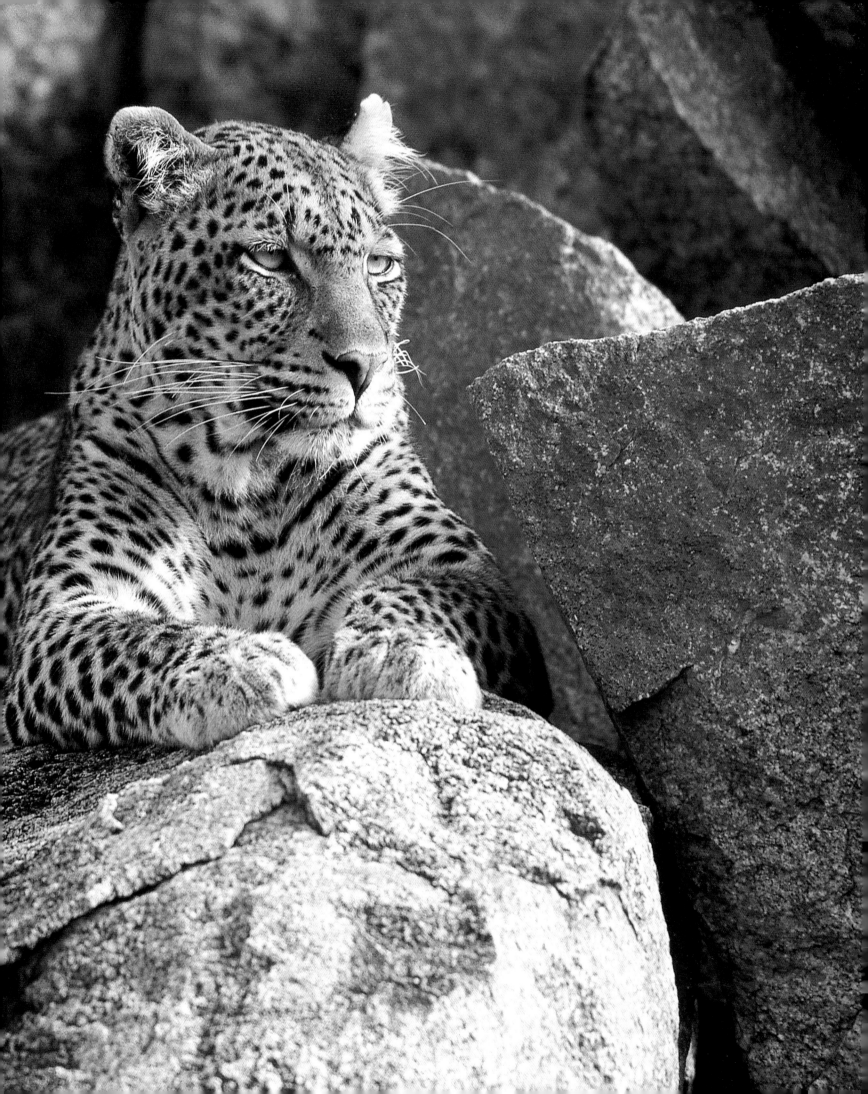

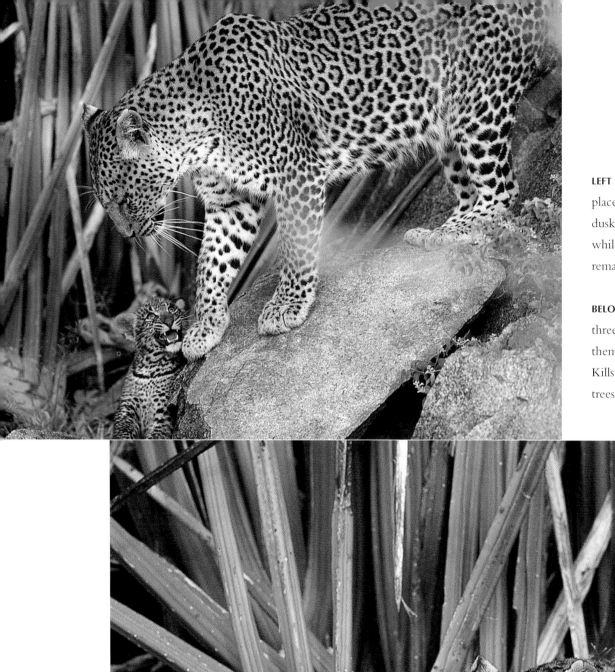

LEFT The cubs emerge from their hiding place for short periods at dawn and dusk, and spend their time playing. But while their mother is away hunting, they remain hidden.

BELOW Leopards suckle their young for three months and gradually introduce them to meat brought back from a kill. Kills are stashed in the upper branches of trees – well out of reach of scavengers.

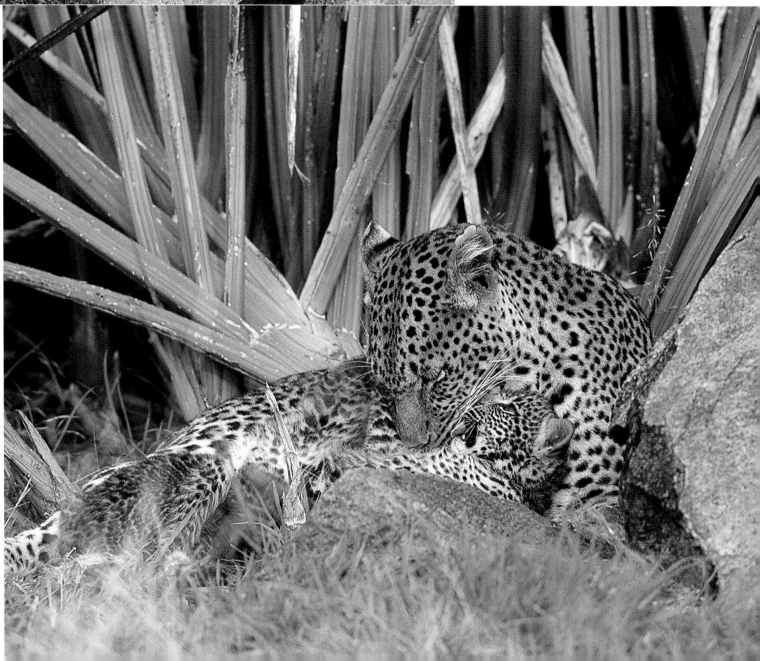

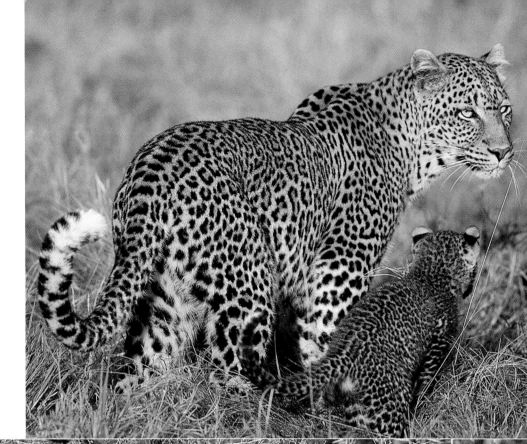

RIGHT AND BELOW The mother watches patiently while her cubs play, gathering skills that will be vital for their survival after independence. Cubs separate from their mother at around two years of age, but the bond between them endures. A mother often reunites with her off-spring after separating, sharing kills with them until they can hunt competently by themselves. Adult leopards lead a solitary life, only associating long enough to mate.

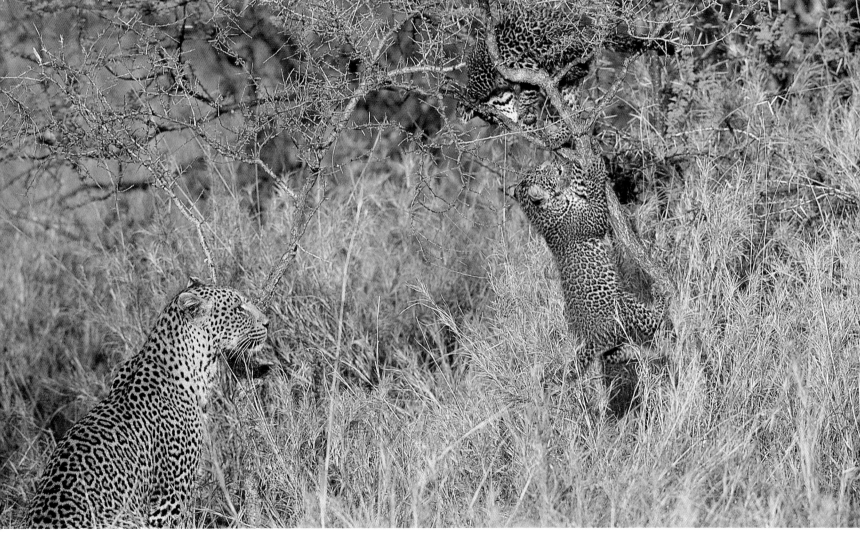

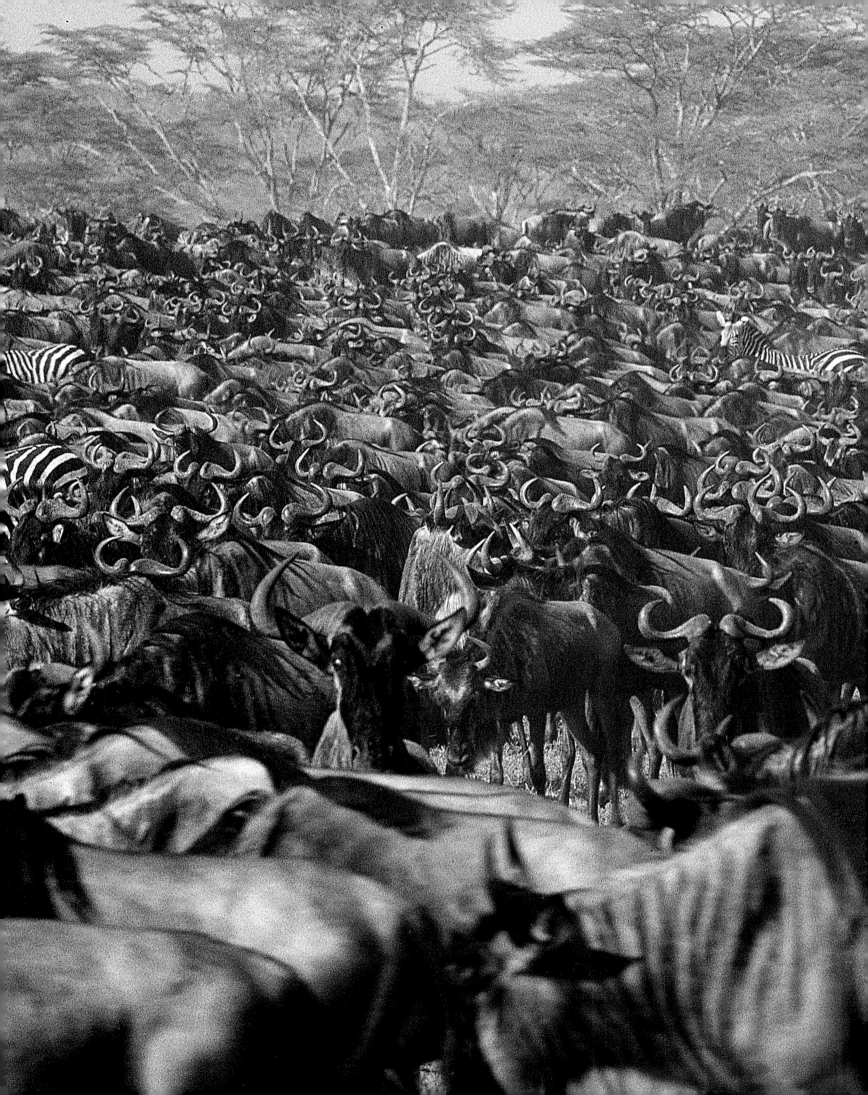

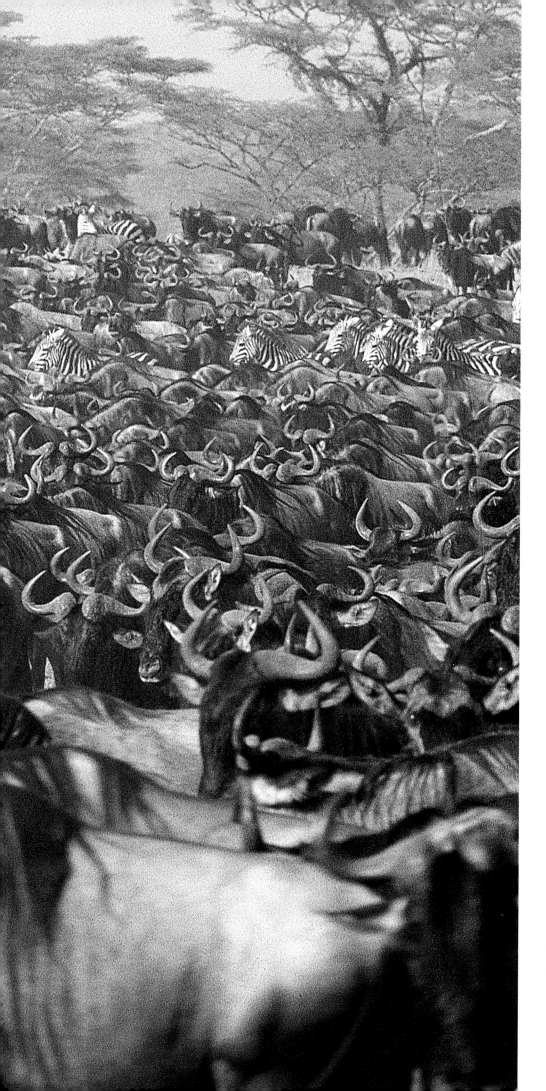

Predation has a relatively small impact on wildebeest numbers. The large number of calves born each year – around 90 per cent of adult females give birth annually – more than replace the thousands of animals that are taken by predators, or die of disease, malnutrition, accidents and injuries.

Climate, which determines the availability of food, is the greatest force that modulates wildebeest numbers. In 1977, the population stood at 1,4 million, but a severe drought in 1991 reduced their numbers to 900 000; by 1999, after several years of good conditions, the population had recovered to 1,2 million.

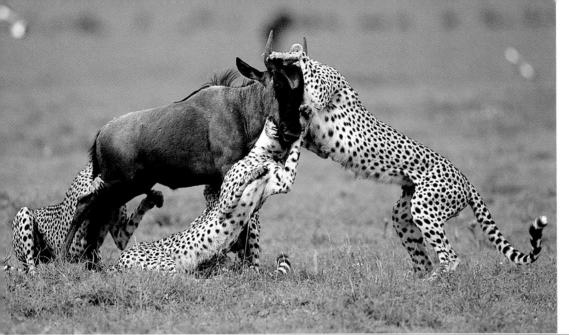

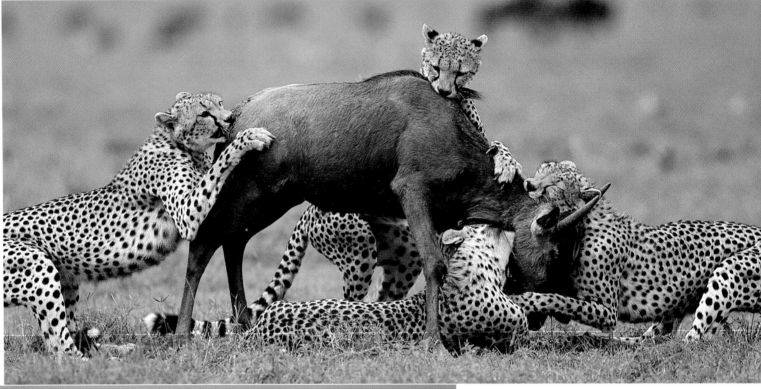

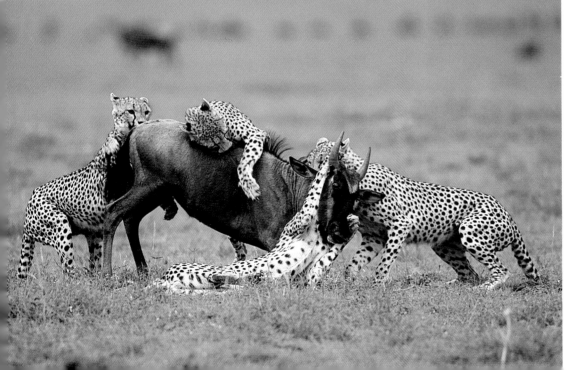

Despite their youth, four cheetah siblings have already become bold hunters. They manage to catch a young wildebeest, but struggle for some time to bring it down. By the time the cheetahs have finished eating, they look as though they have swallowed basketballs, and will not have to hunt again for several days.

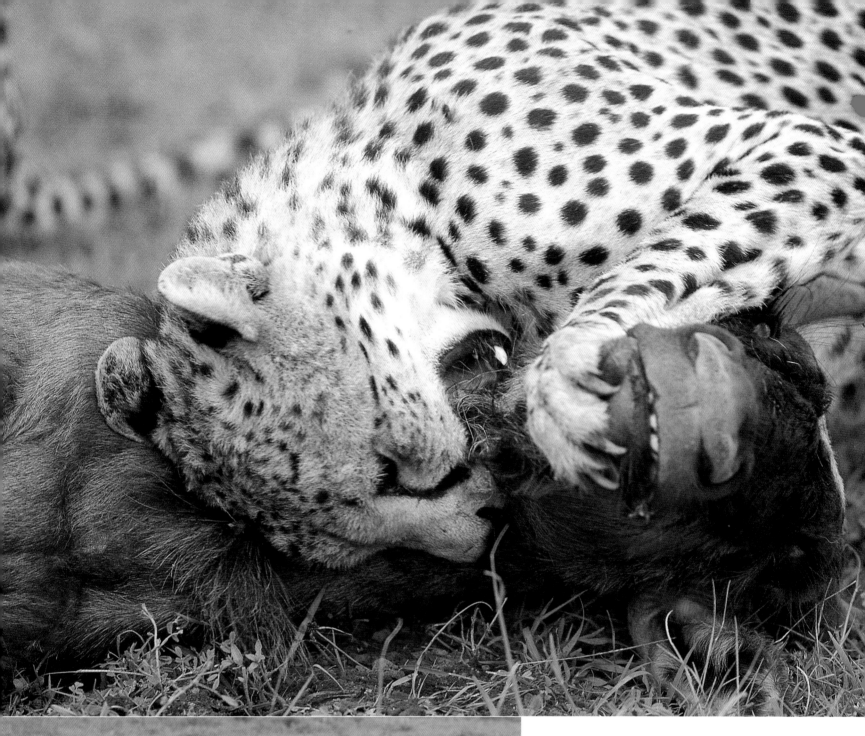

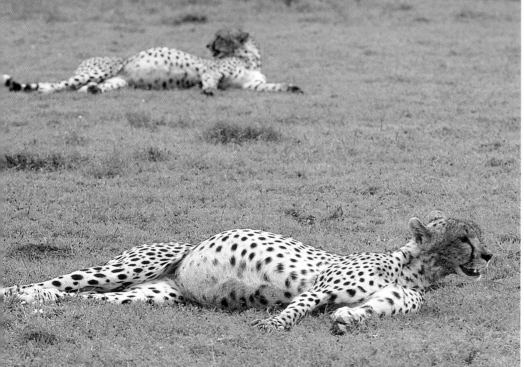

Preferring to hunt in the cool of morning, cheetahs locate their prey from a vantage point such as a rock or termite mound and then patiently close in. After creeping as close as possible, they rush at their prey in a spurt of astonishing speed. When a hunt is successful, the prey is consumed quickly, before descending vultures alert scavengers to the remains.

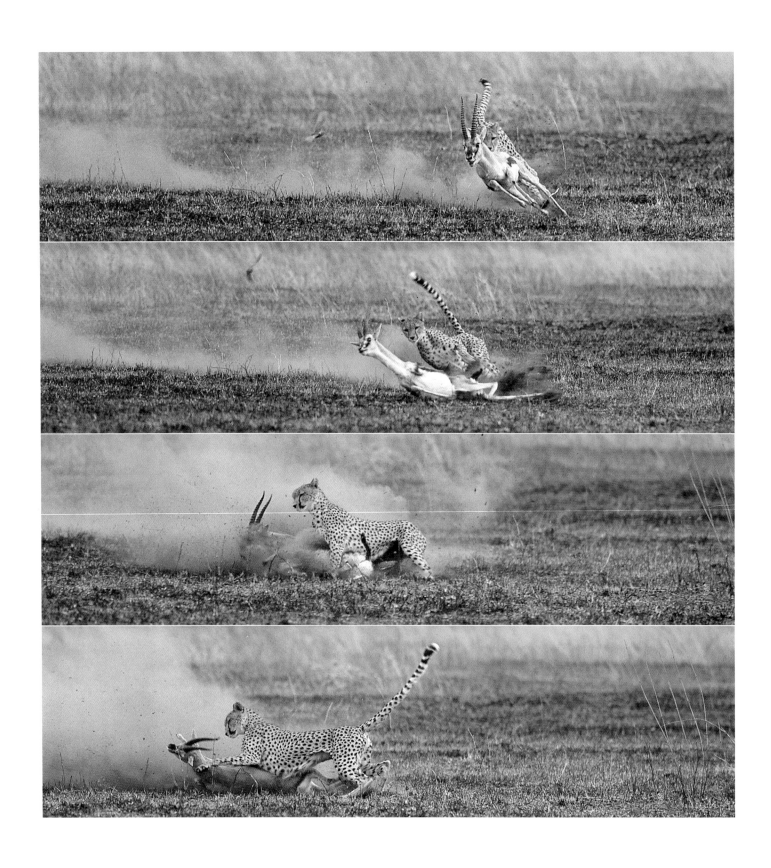

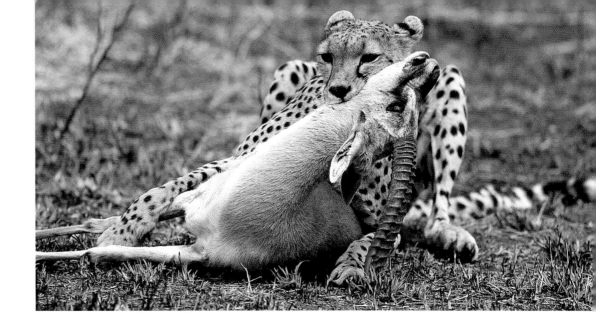

OPPOSITE AND ABOVE In a futile attempt to evade capture, a startled Tommy tries to outdistance a cheetah by swerving and changing direction unexpectedly. The cheetah catches its prey by knocking it off-balance with its front paw. This immobilises the prey, and the cheetah then clamps the animal's throat tightly to suffocate it.

BELOW The cheetah drags the kill to a sheltered spot where it is less likely to be seen by scavengers. While cubs are very young, they instinctively know to stay behind when their mother stalks prey, and wait until she calls them to join her. As they grow and learn new skills, they often try to assist with the hunt, sometimes spoiling the hunting manoeuvre and making their mother's task of keeping them fed increasingly difficult.

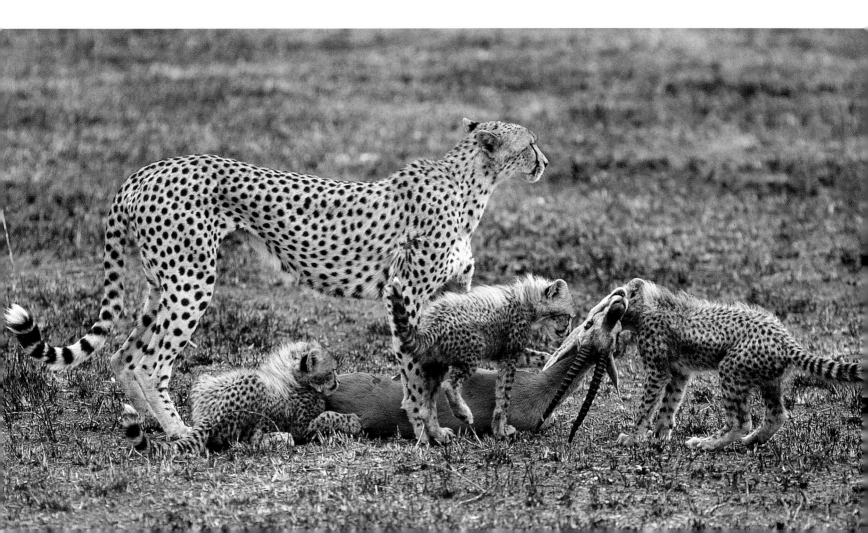

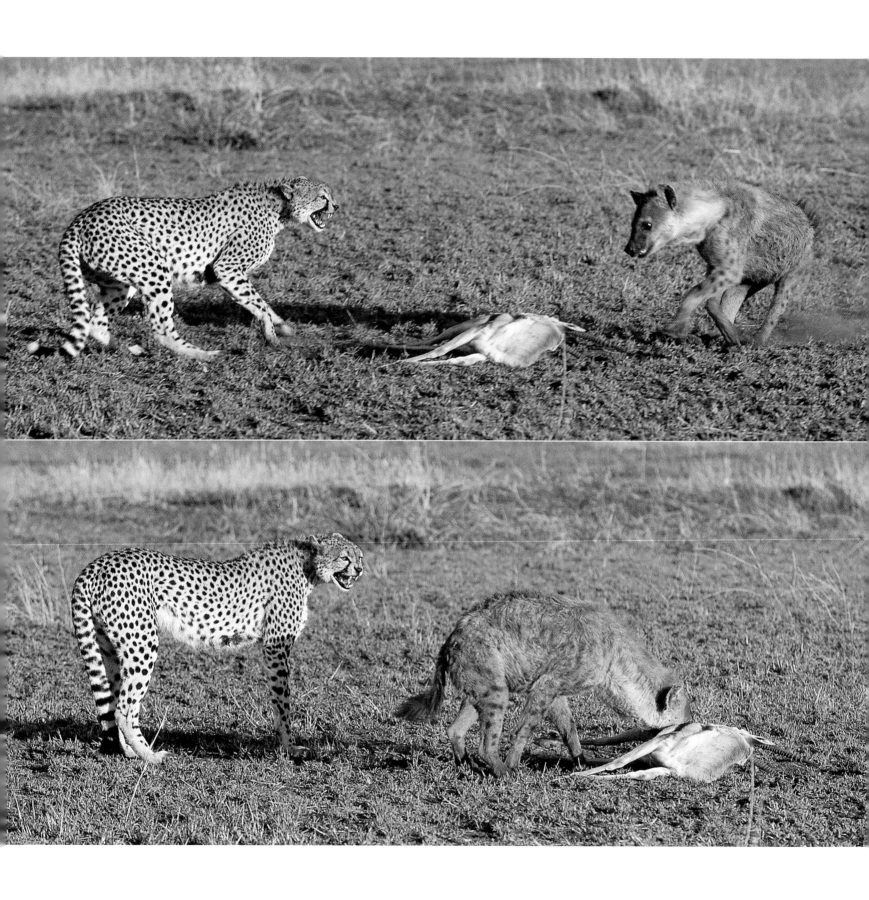

OPPOSITE AND BELOW No sooner has a cheetah made a kill than a spotted hyaena sniffs out the carcass. Ignoring the cheetah's attempt to intimidate it, the hyaena takes possession of the carcass and greedily tears at it. The cheetah waits patiently before tentatively approaching the hyaena again. But the hyaena is not interested in magnanimity, and the cheetah resignedly departs in search of more prey. Most maligned of the large predators, Serengeti's spotted hyaenas are also its most numerous. Not only scavengers, they are clever and tenacious hunters and derive more than half their food from animals that they actively hunt. With their immense stamina and an uncanny nose for detecting the stragglers in a herd, they single out their quarry and simply run it to exhaustion. Hunting mainly at night, they commute from their territories to the nearest herds along the same paths that have been used for generations.

RIGHT When predators have eaten their fill, vultures move in for the final clean-up, squabbling over small morsels. Their eyesight is so acute they can spot a carcass from a height of more than 300 metres. As they glide down to the kill, their descent is noticed by other vultures from kilometres away, and the carcass is soon submerged in a dense scrum of dozens of birds.

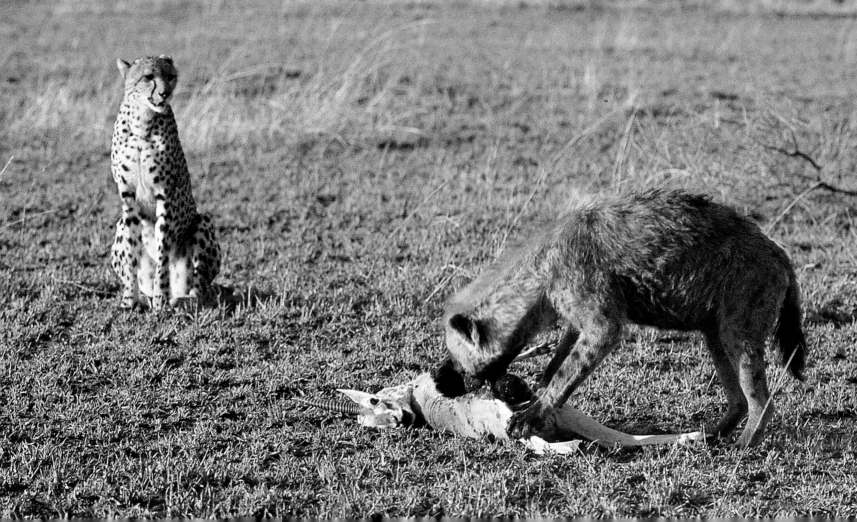

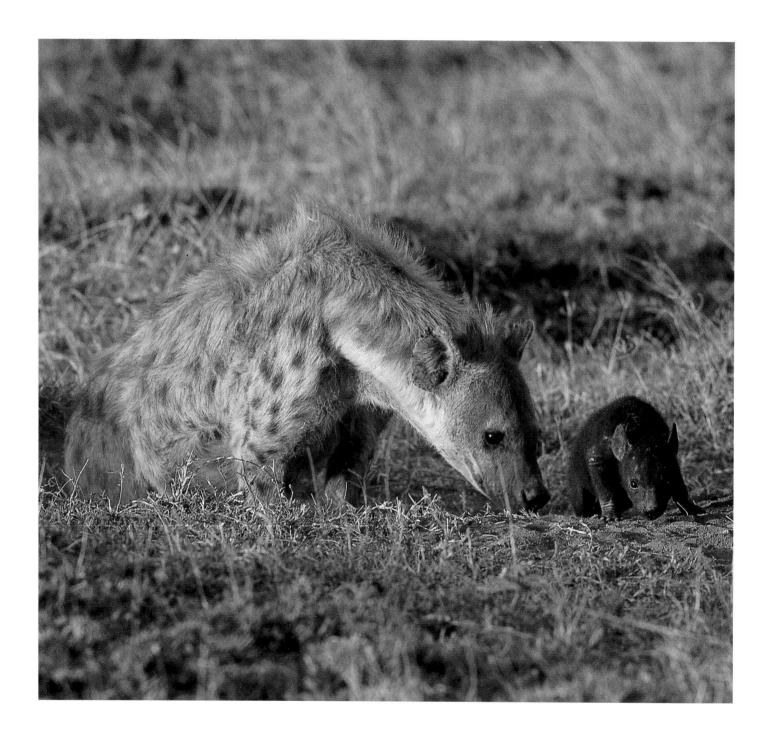

Black as soot at birth, spotted hyaena cubs are born with their eyes open. They develop white eyebrows at two weeks, and the first spots appear at one month. For the next two months, the cubs do not emerge from the den unless called out by their mother, and scamper back at the slightest provocation.

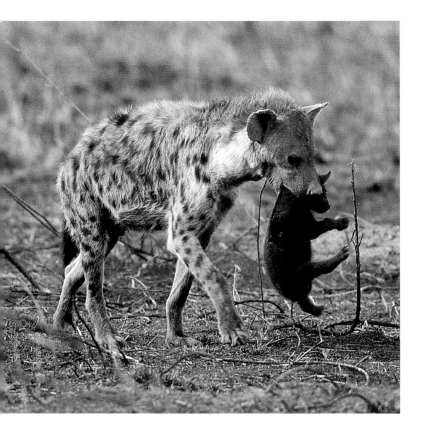

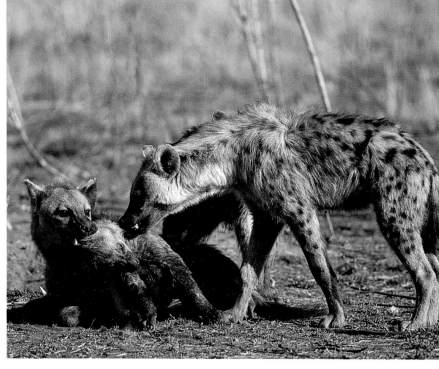

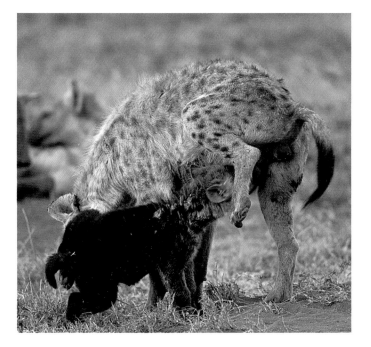

ABOVE LEFT Cubs are born in litters of one or two in a private birth den and gingerly transferred at two weeks to the communal den. Cubs can be killed by lions or by hyaenas from other clans, and when their mother resumes her hunting trips, they remain hidden in their den.

ABOVE Games of chasing and ear chewing are popular with cubs as they become more confident in venturing from the den. By the time they reach 12 months, they start accompanying their mother on hunting trips.

ABOVE When spotted hyaenas meet, a strict greeting ritual must be followed. Spotted hyaenas live in hierarchical clans of up to 60 animals in which rank is inherited, with the males at the bottom of the heap. Lower-ranking animals must submit themselves to higher-ranking ones by cocking their leg to allow their genitals to be sniffed. Females have pseudo-male genitalia due to their high levels of testosterone, which match or, in the dominant female, outstrip most males. It is only after puberty that the female's genital opening and teats enlarge.

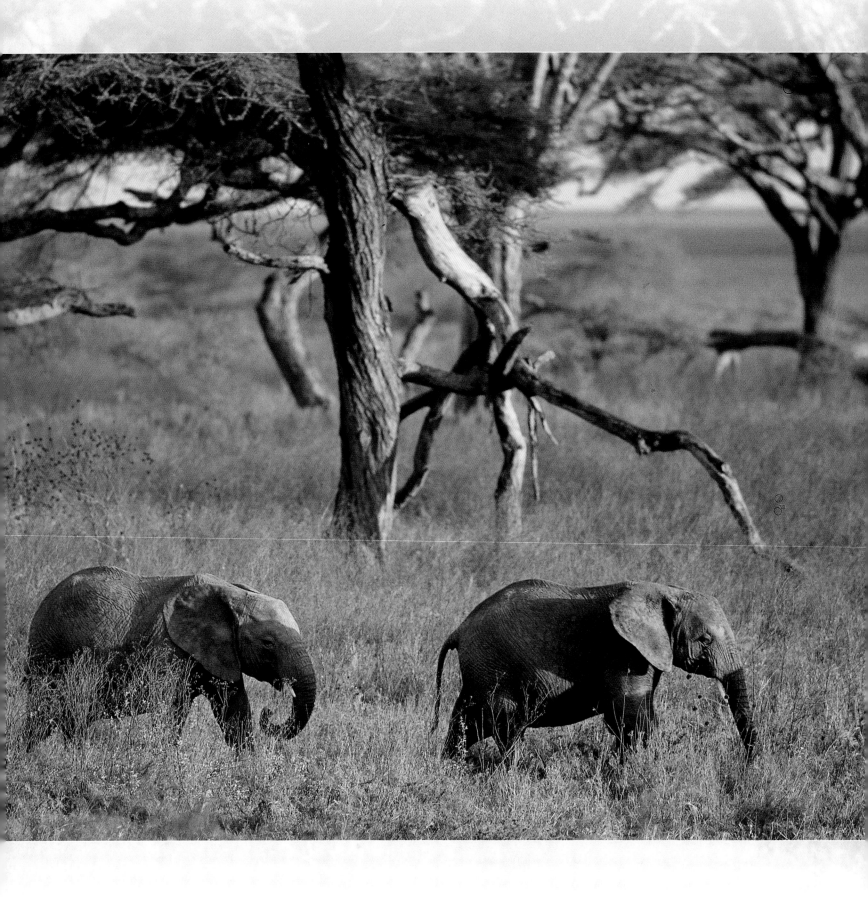

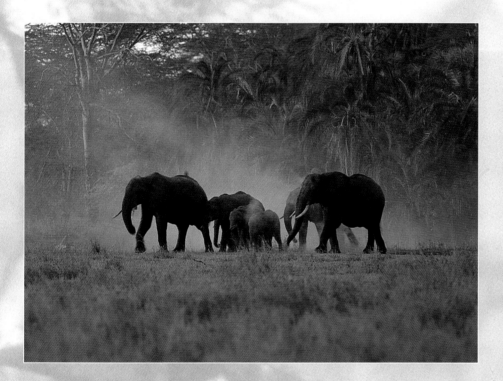

Elephants also live in tightly knit family units – each herd consists of related females and their offspring. The family unit is led by the matriarch, usually the largest cow in the herd. She dictates their movements – when she stops to feed, so do the others; and when she moves on, the others follow. Constantly on the move in search of water and fodder, elephants spend about 16 hours a day feeding. Their digestive systems are hugely inefficient, and about 90 per cent of the 100 to 220 kilograms that an adult consumes is excreted each day.

Elephants were almost exterminated from the park in the 1970s; those that were not killed by poachers fled to the safety of the Maasai Mara. Since anti-poaching efforts have intensified in the park, these highly social and intelligent animals are returning in increasing numbers.

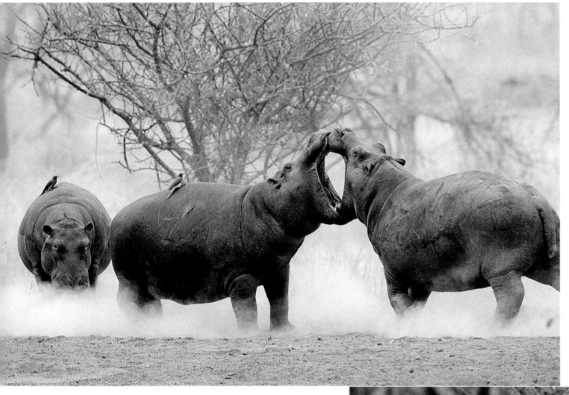

LEFT AND BELOW In a playful contest of push-and-shove, young male hippos practise for the day they will be old enough and strong enough to challenge mature males for dominance. In real contests, body weight and jaw span are decisive.

OPPOSITE TOP Highly gregarious hippos sunbake side by side on the banks of the Seronera River.

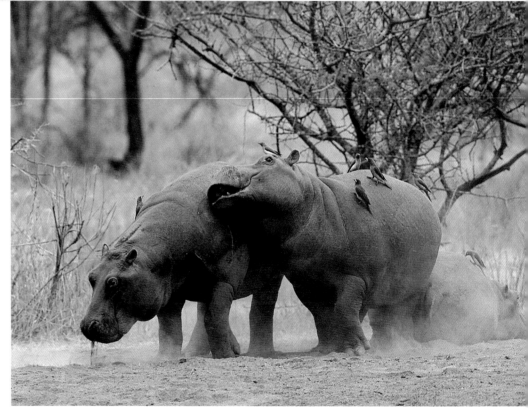

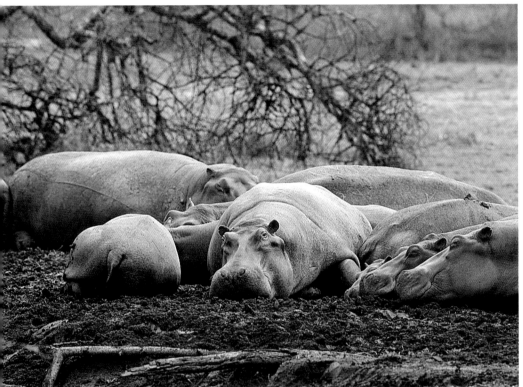

BELOW AND OVERLEAF Although water still fills the waterholes and rivers of the central Serengeti, by June the surrounding pastures are rapidly withering. Rain is needed to stimulate the new grass growth that the nomads need, and there will be none for several months. It is time to resume the journey north.

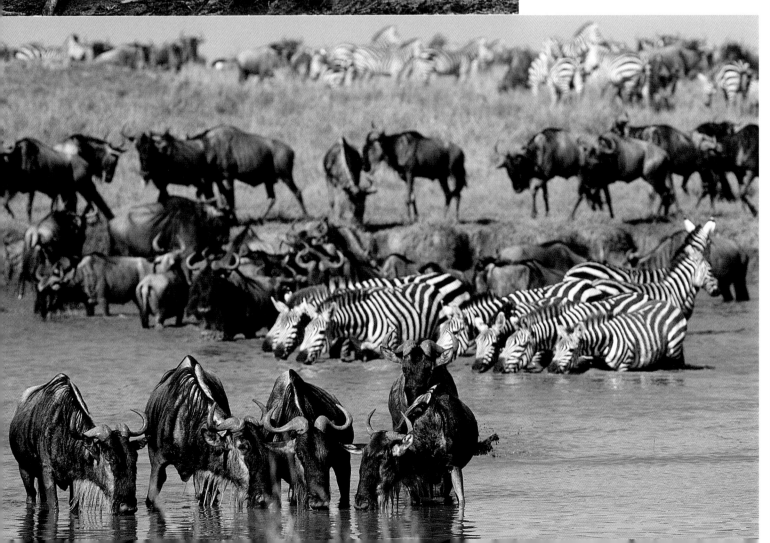

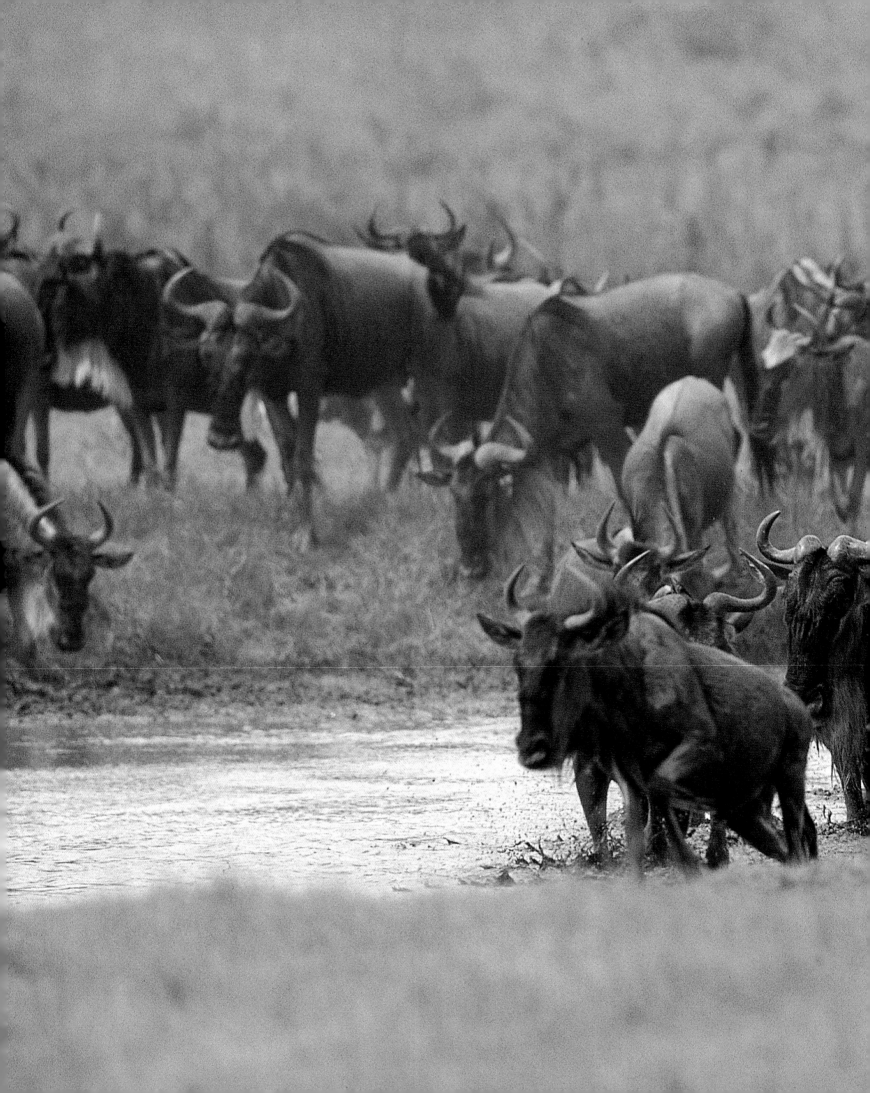

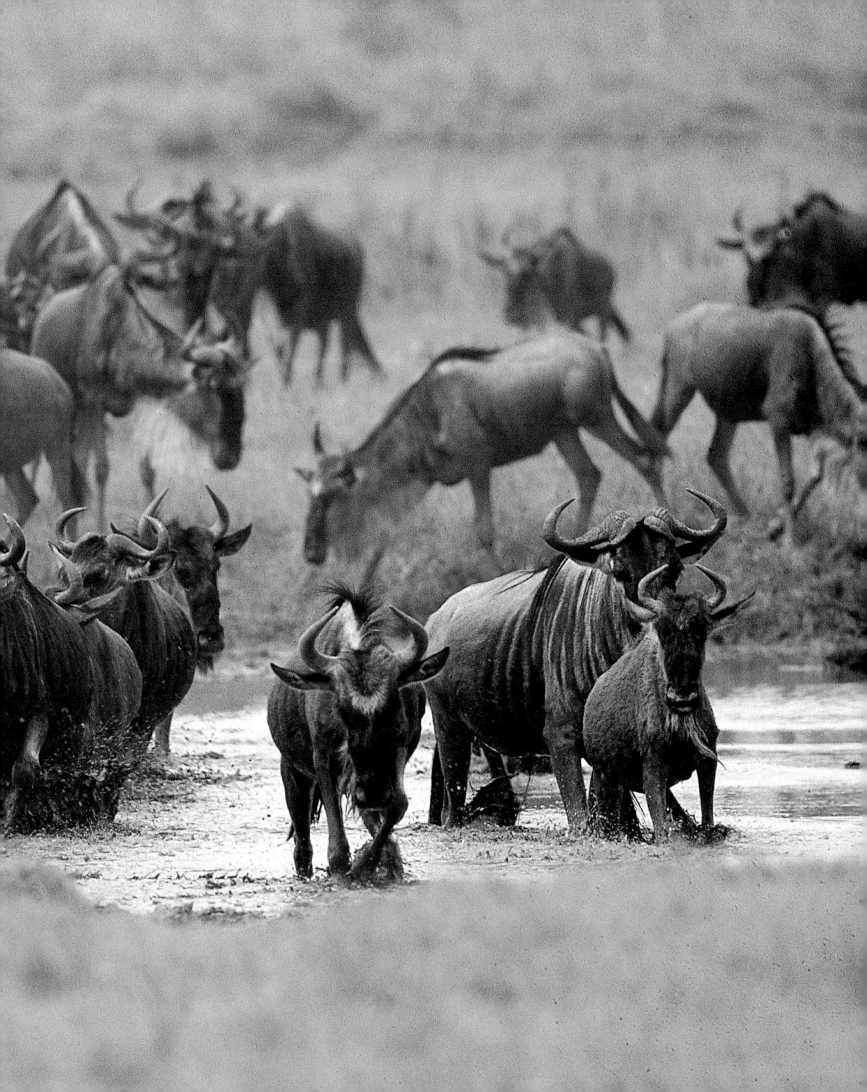

WESTERN
CORRIDOR

As the billowing clouds and leaden skies of the 'long wet' disappear, the wildebeest decamp from the southern plains, moving north-west through hilly woodland to congregate on the plains flanking the Grumeti River in the Western Corridor. It is well into June by the time they reach the Grumeti River, and without cloud cover the days are relentlessly hot.

The whistling thorns that grow in dense stands on the plains of the Western Corridor thrive in the poorly drained black cotton soil. Rocky hills that bound these plains to the south are clothed in woodland dominated by acacia trees, of which there are 38 species. Old beds of Lake Victoria form the alluvial plains furthest to the west and support mostly flood-plain grasses that are grazed by topis, gazelles, zebras, and resident herds of wildebeest.

The Grumeti River is an important resting point in the wildebeest's long trek, and by the time they arrive, the rut is in full swing. They are in peak condition after having fed for several months on the fertile volcanic pastures of the south-ern plains. Bulls use this resting point to establish small terri-tories, which they demarcate with eccentric testosterone-charged behaviour. In frantic displays of cavorting, head-shaking, snorting and scent-marking, they defend their terri-tories and woo a harem of oestrus females. The rut lasts a

short six weeks, ensuring that all the calves are born at more or less the same time eight months later during February.

The river is also a vital watering point during the migration, but the calm of its shadowed waters deceives. The river is infested with the world's largest Nile crocodiles, and by June they are hungry – it has been almost a year since the last feast, and they eagerly await the arrival of the nomads. When heat drives the wildebeest to the water's edge to quench their thirst, the careless become meals for the hungry reptiles.

Migrating herbivores dominate the Serengeti plains, but in the western part of the park, where woodland and savanna intermingle, warthog, impala, giraffe, topi and buffalo are numerous. More than one million people live close to the protected area boundaries in the west, and the demand for wildlife meat is high. The controlled areas bordering much of the Western Corridor act as buffer zones by increasing the distance between the human population and the national park. Yet densities of resident animals have declined in recent years, and natural predators are not the only threat to the nomads.

OVERLEAF Lush riverine forest encloses the Grumeti River as it curls through the Musabi Plains. Soon after the end of the wet season the river stops flowing and segments into a ribbon of sand, jointed by murky brown pools.

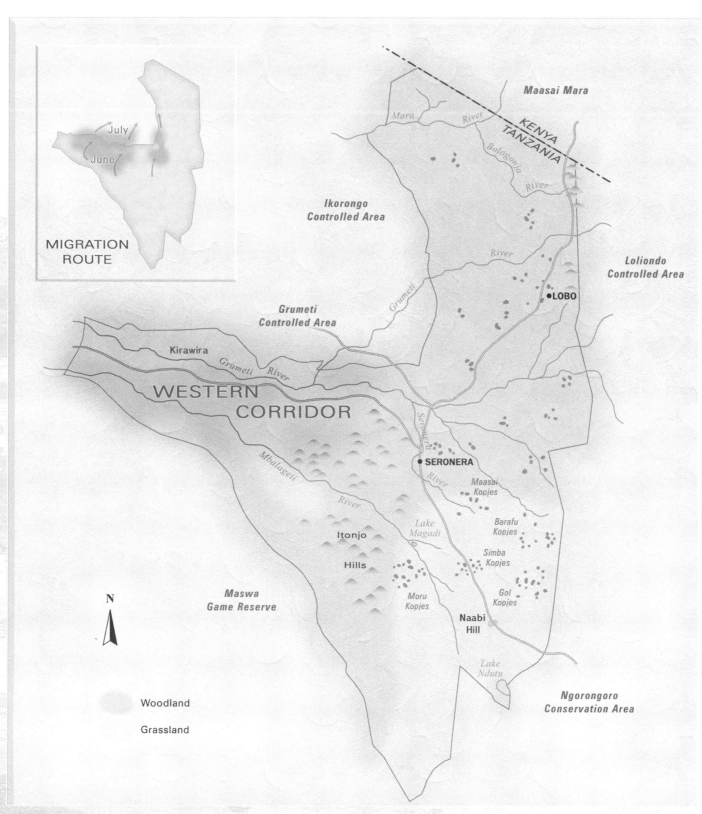

MIGRATION
ROUTE

July

June

Maasai Mara

Mara

River

KENYA
TANZANIA

Bologonja

River

Ikorongo
Controlled Area

Loliondo
Controlled Area

River

Grumeti

●LOBO

Grumeti
Controlled Area

Kirawira

Grumeti River

WESTERN
CORRIDOR

Seronera

●SERONERA

Mbalageti

Maasai
Kopjes

River

*Lake
Magadi*

Barafu
Kopjes

Itonjo

Simba
Kopjes

Hills

Gol
Kopjes

N

Maswa
Game Reserve

Moru
Kopjes

Naabi
Hill

*Lake
Ndutu*

Ngorongoro
Conservation Area

Woodland

Grassland

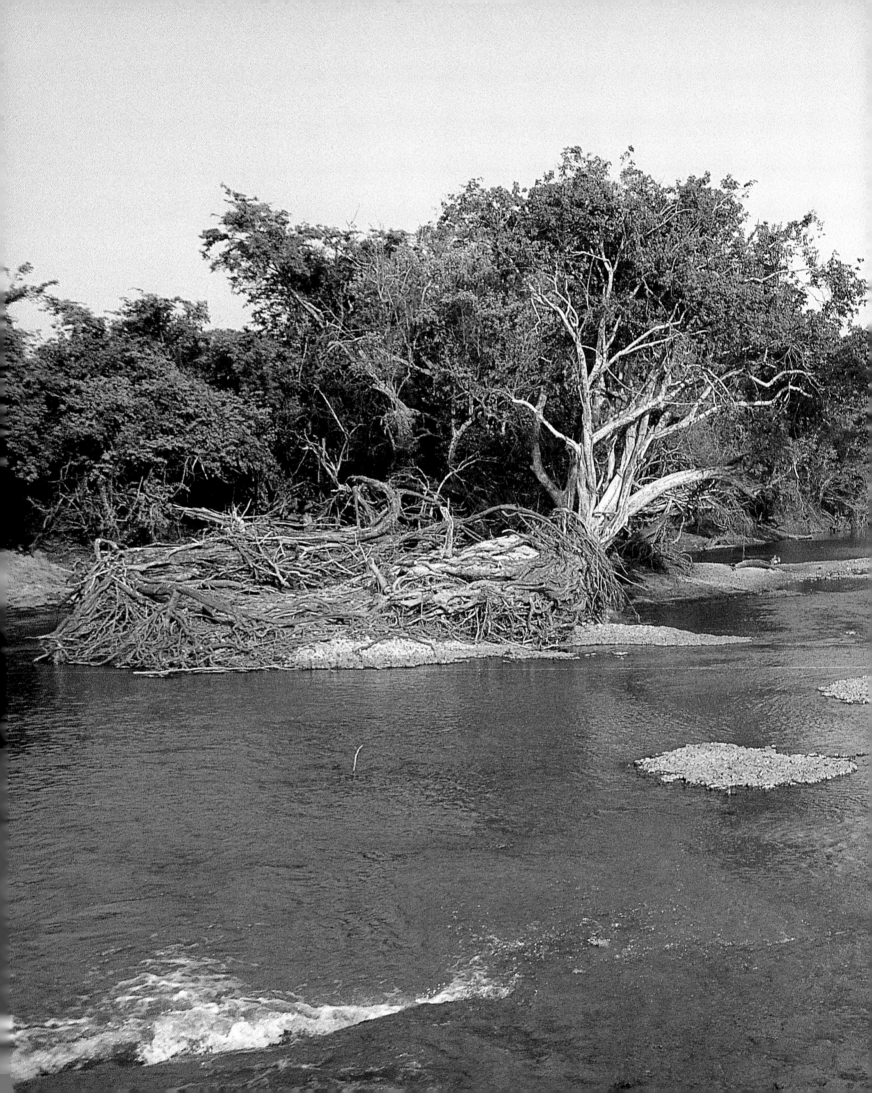

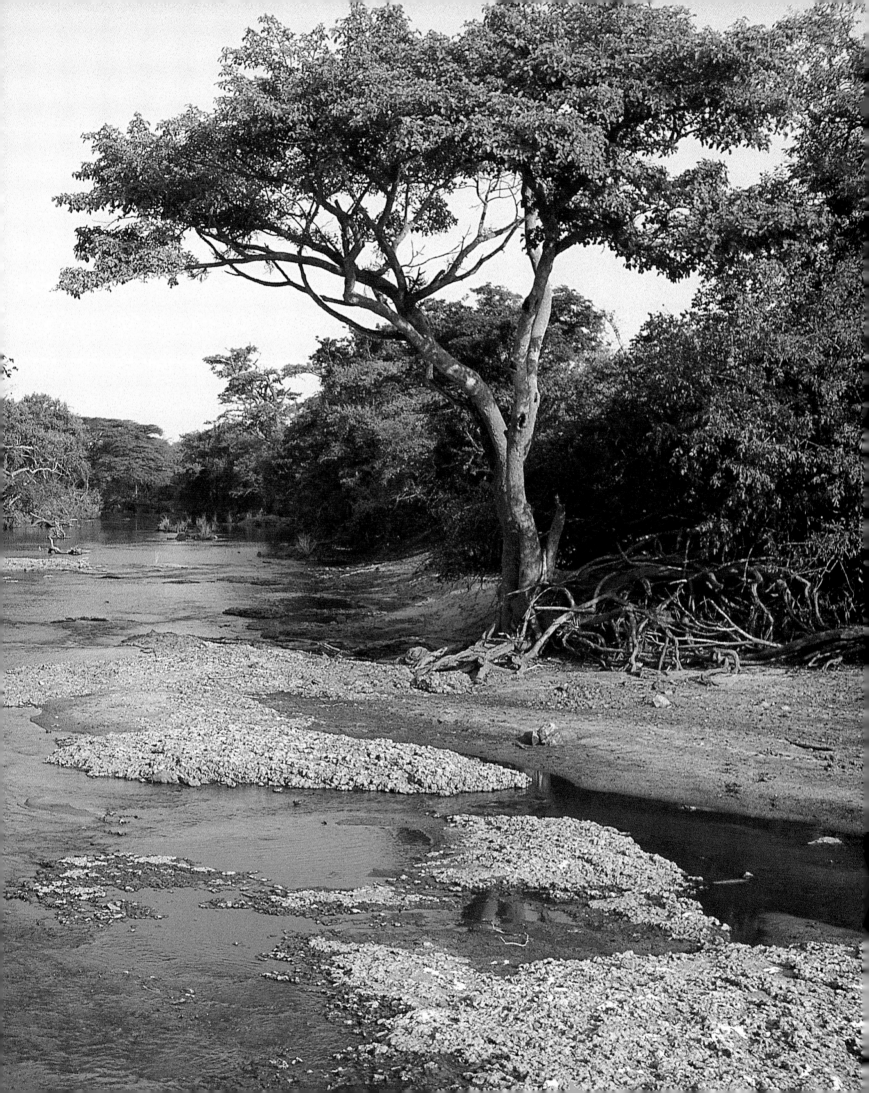

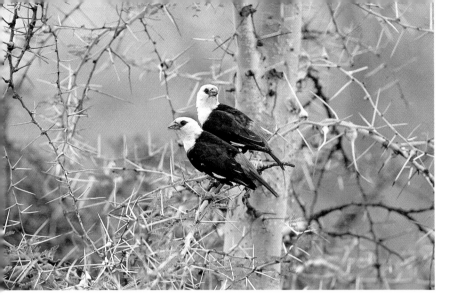

LEFT White-headed Buffalo Weavers search the ground for insects in the acacia woodlands of the Western Corridor. When disturbed, they flit to the nearest thorn tree, flashing their red tail feathers.

MIDDLE LEFT A Hamerkop waits patiently by the rushing stream for a fish meal. The first flush of fresh water at the end of the dry season regenerates life in the Grumeti. Catfish come alive, providing a feast for storks, pelicans, kingfishers, herons, ibis, Hamerkops and Fish Eagles.

BELOW Often seen only as a brown flurry skulking in the shrubbery, the White-browed Coucal is a clumsy bird. Its attempt to fly when disturbed is feeble, and it quickly crash-lands back into the undergrowth.

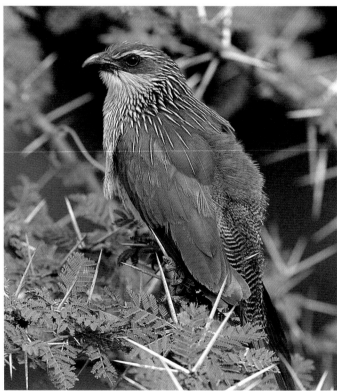

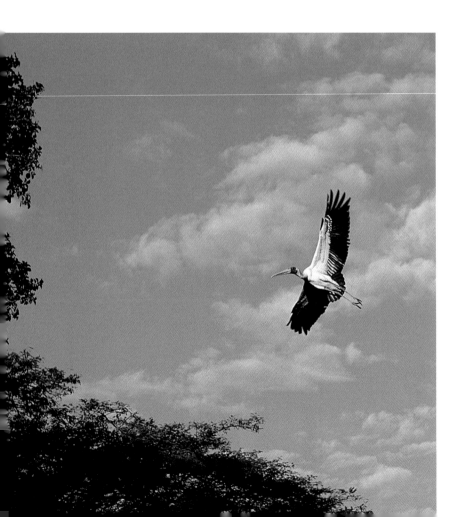

LEFT A Yellow-billed Stork flies to the treetops to survey the river for the best fishing spot.

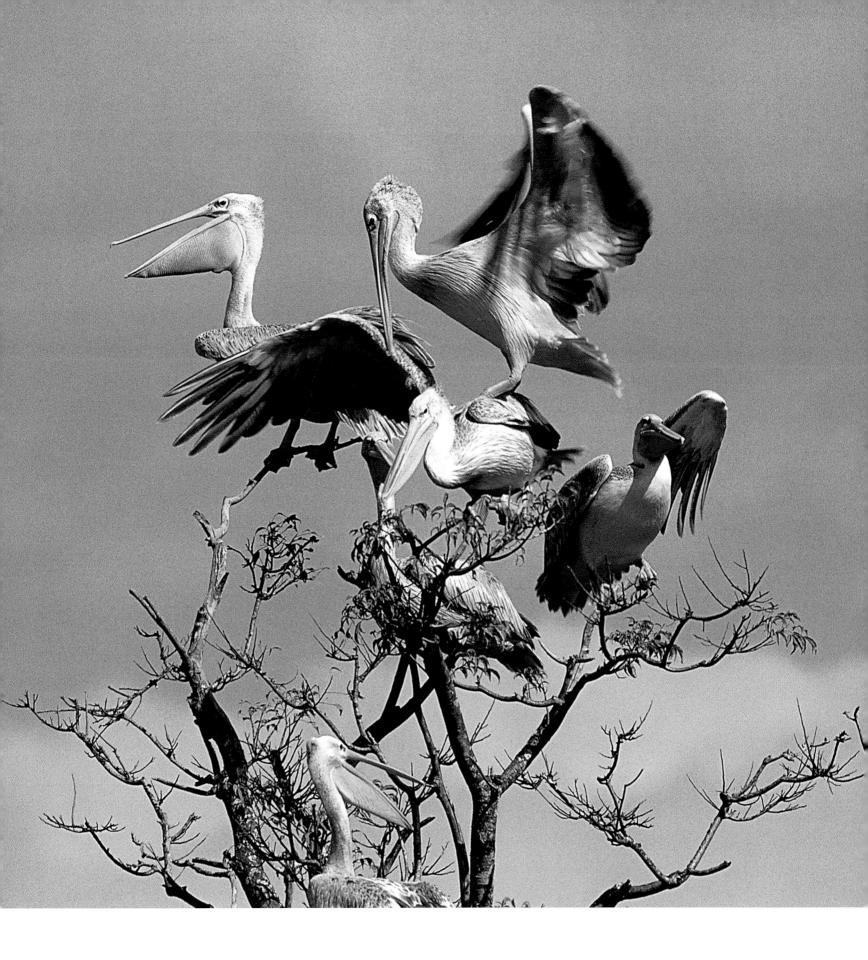

Attracted to the Grumeti by the abundance of young catfish, a White Pelican lands clumsily in an over-crowded treetop. These birds are more common on the edges of shallow rift lakes.

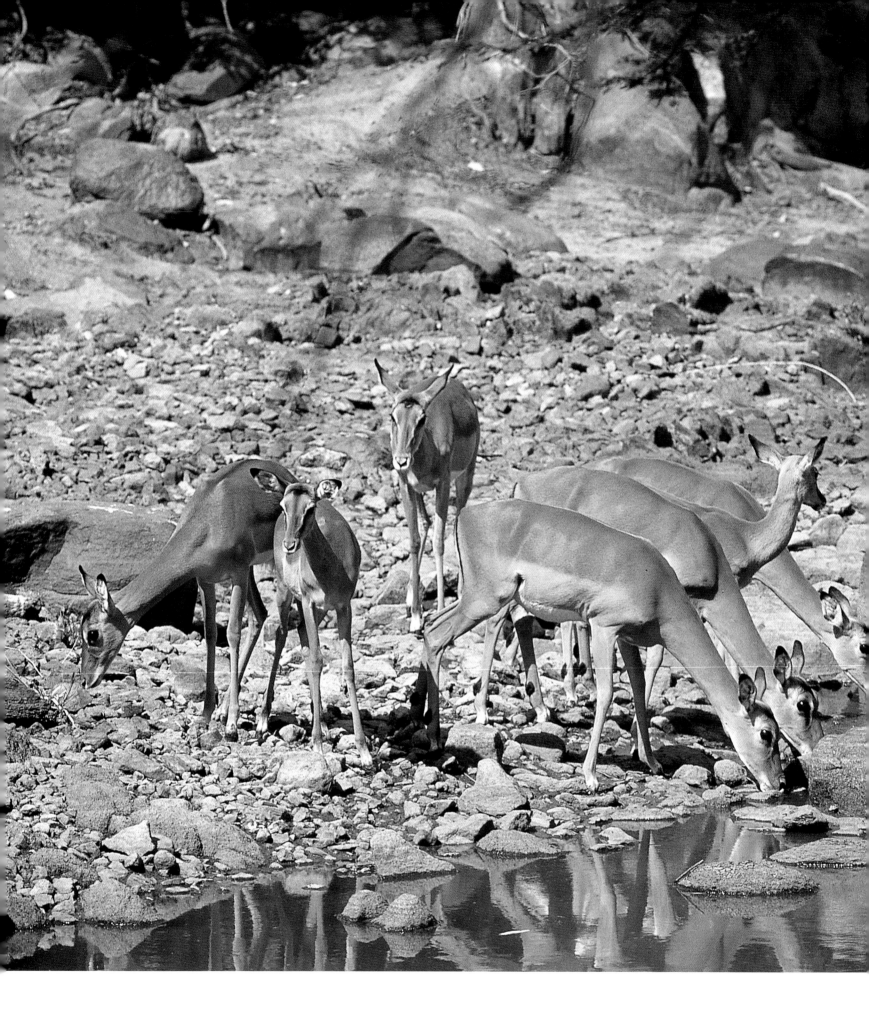

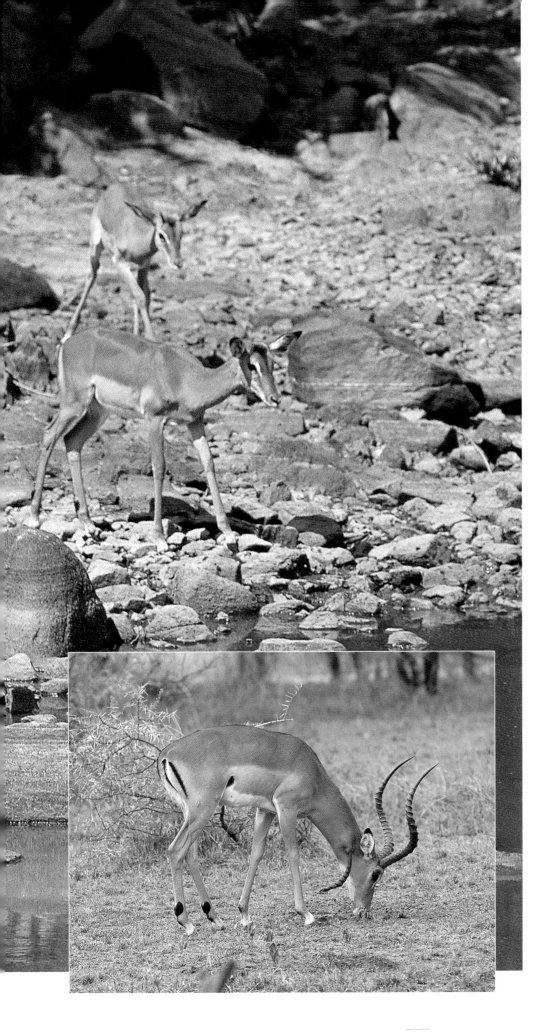

LEFT Ephemeral lifeblood of the west, the Grumeti River gives resident herds a reprieve from the pressures of the dry season. Impala have no need to drink as long as the water content of the plants they eat remains above 30 per cent, but in the dry season, this water content falls and they must stay within reach of water.

BELOW LEFT Slender horns are prone to breaking in vigorous conflicts. Once his horns are damaged, a male impala can never win a contest over females, and so is condemned to lifelong bachelorhood.

OVERLEAF A male impala's battle for supremacy is never-ending. During the mating season, he consumes all his energy herding and copulating with his harem, which can number 100 females or more, and chasing away his competition. It will only be a matter of time before he succumbs to exhaustion and is defeated by a rival who appropriates his harem.

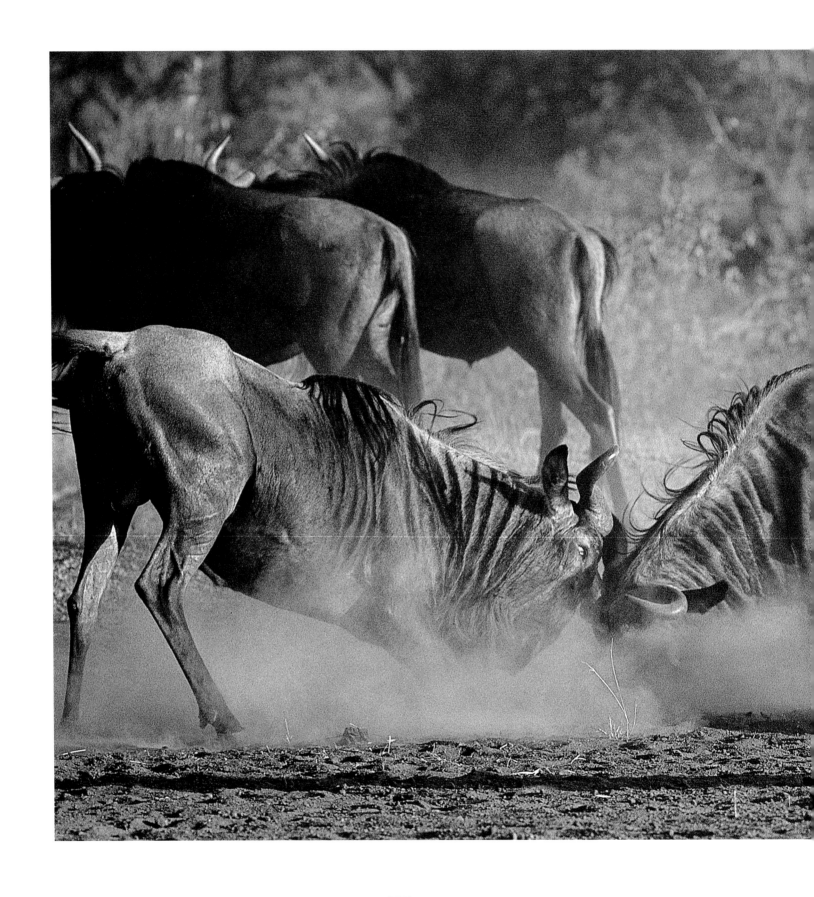

LEFT In a fit of possessive pique, a male wildebeest charges and rams an invader. Though violent, such confrontations during the rut are brief, and the tough elastic horns prevent serious injury.

BELOW Standing in the middle of a territory he has claimed at Kirawira, a wildebeest male surveys his beat. Stimulated by a surge of hormones and goaded by the sight of so many migrating cows, he neither eats nor rests. He expends so much energy defending his territory and herding his harem of a dozen or so females that he sheds 20 per cent of his body weight.

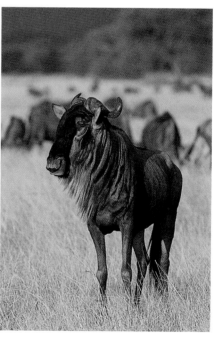

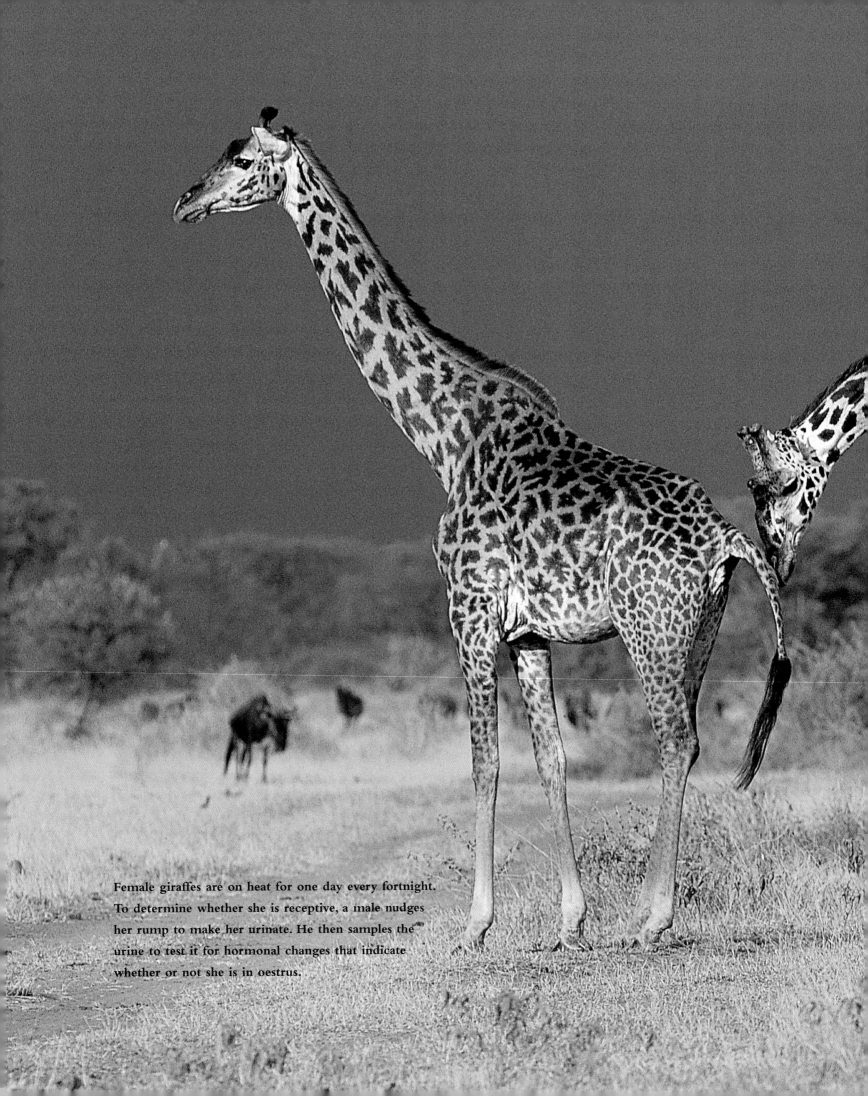

Female giraffes are on heat for one day every fortnight. To determine whether she is receptive, a male nudges her rump to make her urinate. He then samples the urine to test it for hormonal changes that indicate whether or not she is in oestrus.

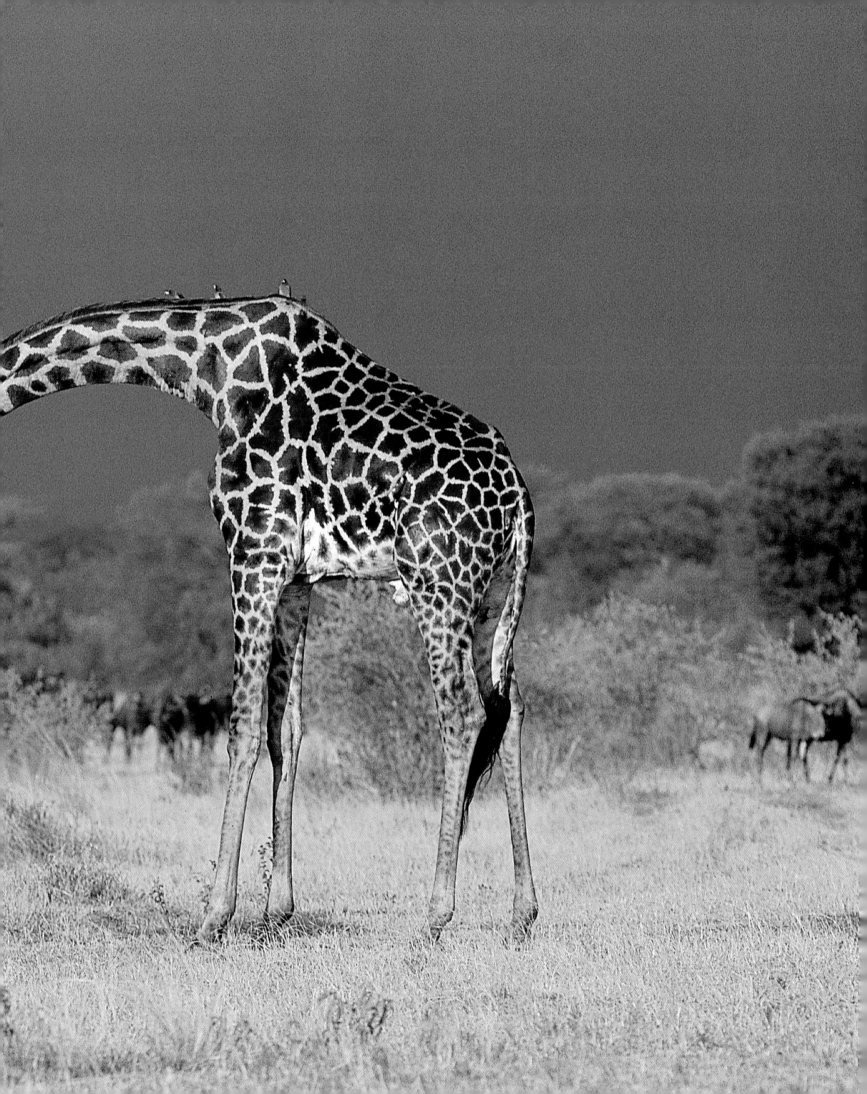

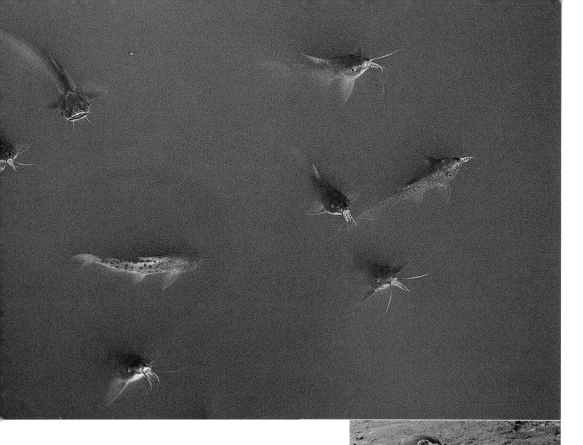

OPPOSITE TOP As the day heats up, the river betrays its darkest secret – the stretch of river at Kirawira is crawling with crocodiles. The fearsome reptiles eagerly await the arrival of the wildebeest, which marks the start of their annual feast.

OPPOSITE BELOW Size carries bullying rights. The largest crocodiles each control their own patch of river, selfishly guarding the best killing spots and chasing away potential usurpers. At more than six metres in length, the biggest are over 70 years old, and bear a lifetime's battle scars.

ABOVE Until the wildebeest arrive, crocodiles snack on baby catfish that swarm to the surface of the river. The sharp dorsal spines of the catfish make it a tricky meal to swallow. The crocodile typically carries it to the riverbank like a hot potato, where it champs the fish to break up its spines before gulping it down. Occasionally a fish flips out of the crocodile's mouth, which is just what this opportunistic Marabou Stork (right) is waiting for.

RIGHT Unlike the ugly duckling, Marabou Storks grow even more grotesque with age. In the Serengeti, they feed mostly on carcasses, but because they cannot tear meat with their large awkward bills, they wait for vultures to do the work, and appropriate scraps from them.

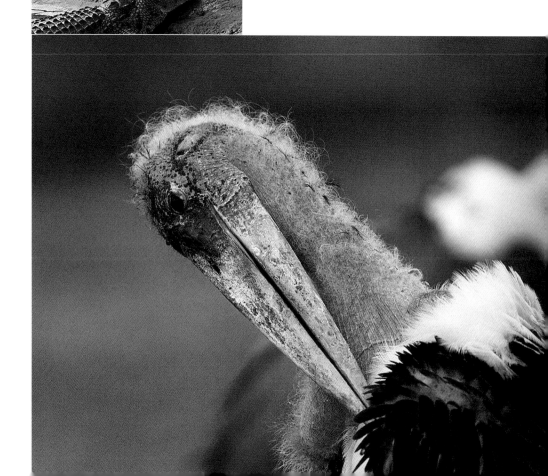

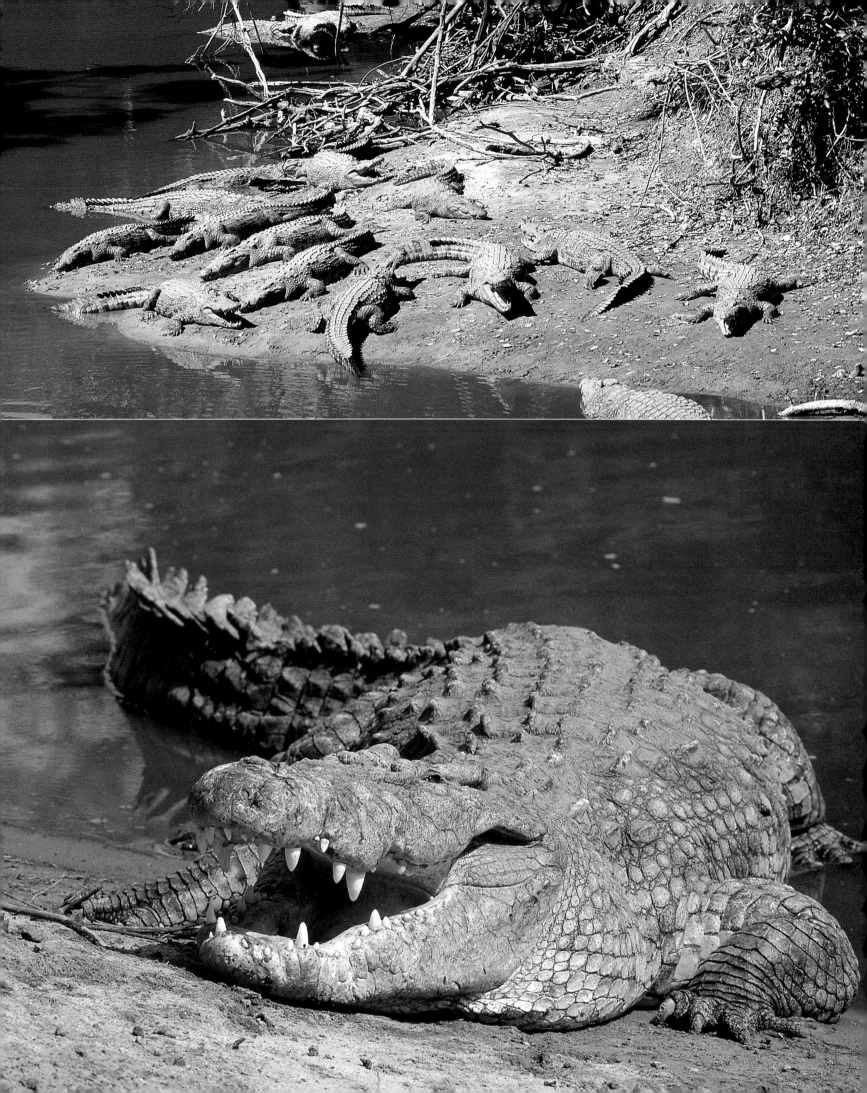

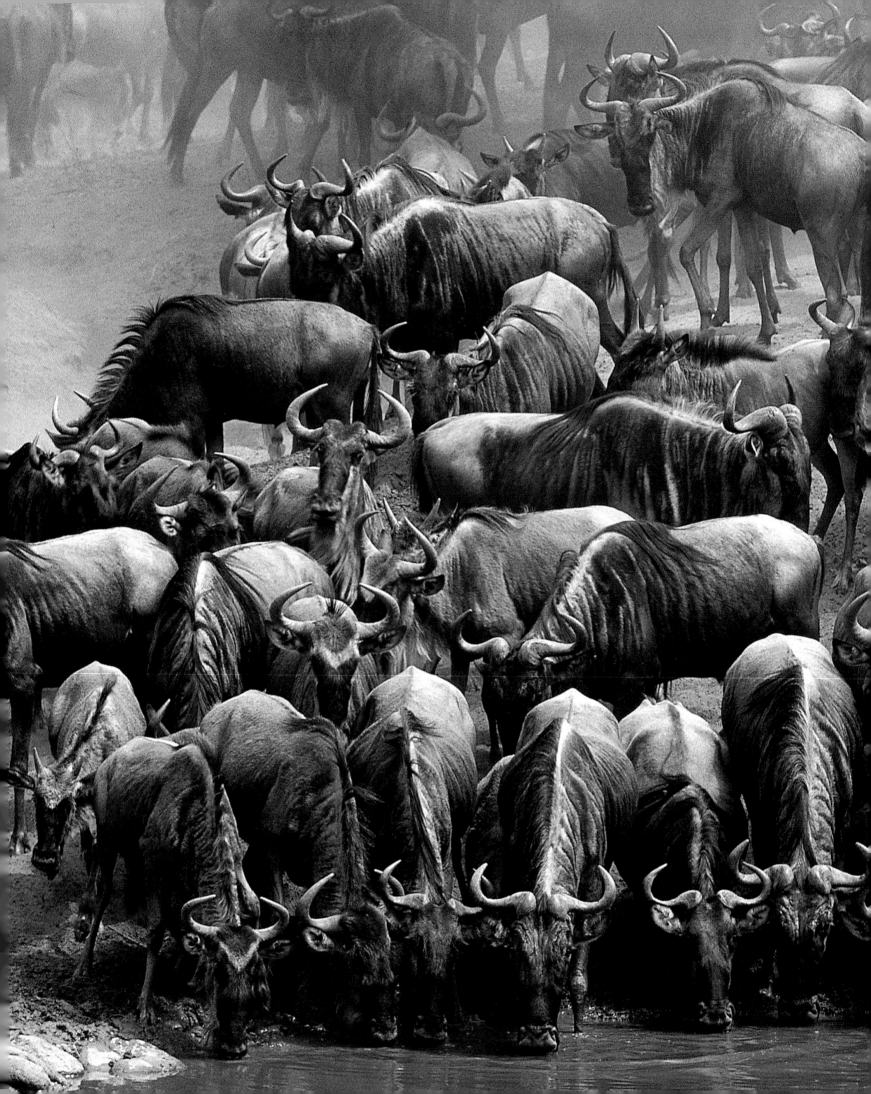

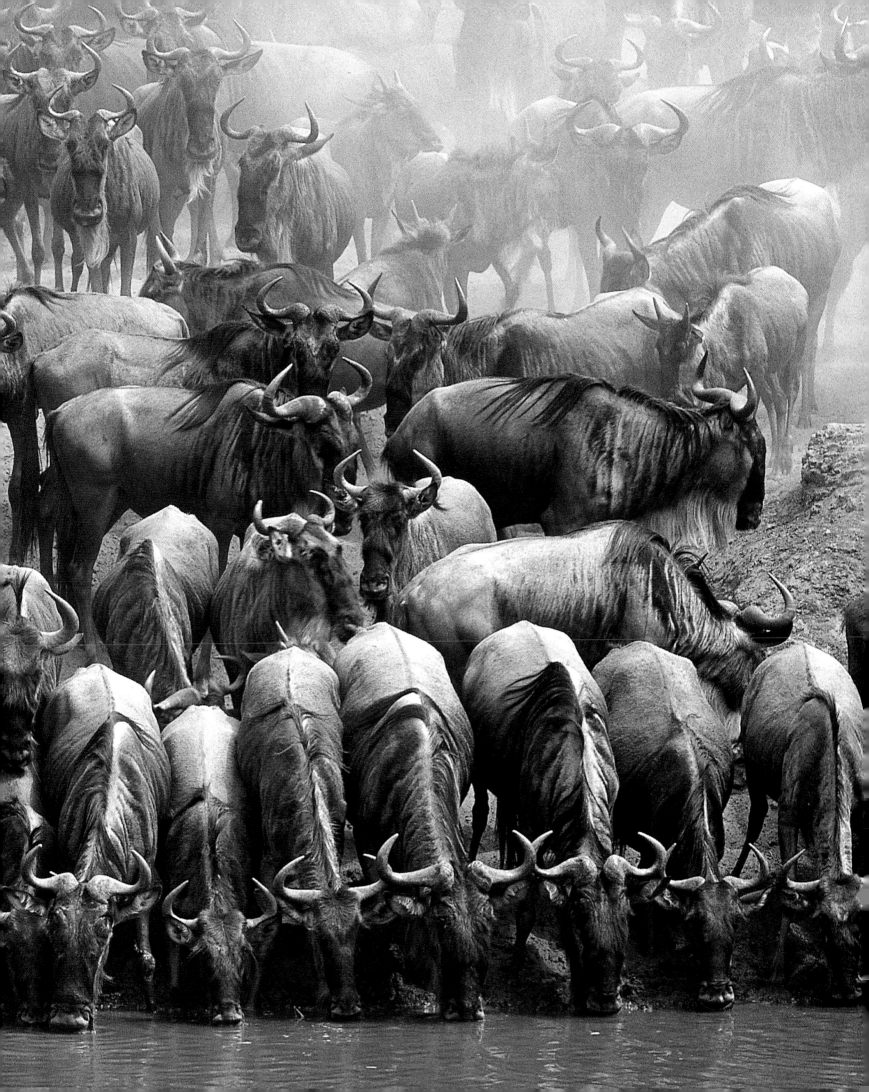

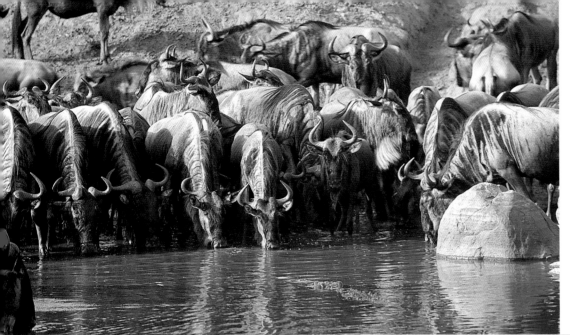

PREVIOUS PAGE Thirst drives the tentative wildebeest to the Grumeti River's edge. Calves have not yet learnt to fear the river and their lack of caution makes them easy targets.

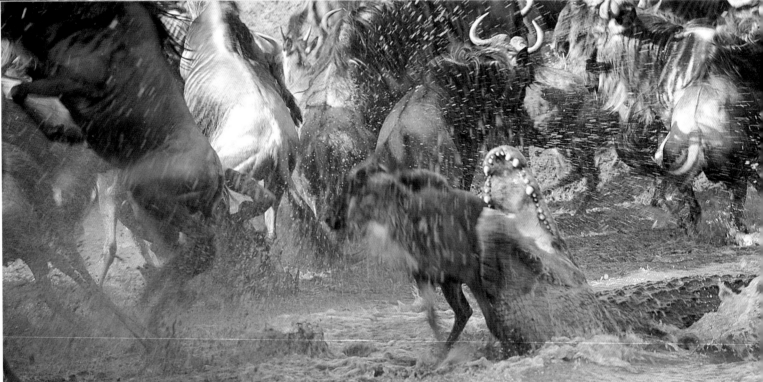

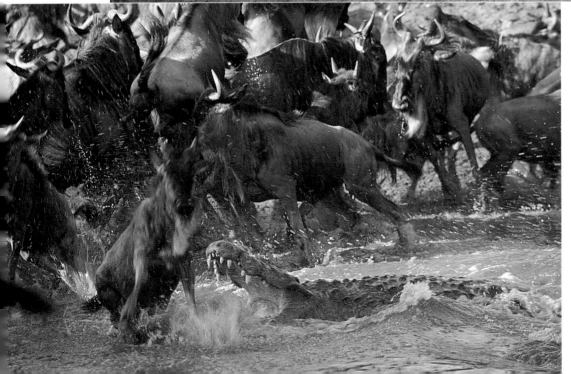

THIS PAGE The sound of approaching grunts is a signal for the crocodiles to slide silently into their ambush positions. A herd shuffles towards the riverbank. Desperation finally pushes them to the water's edge.

With jaws clashing, a crocodile explodes from the water, only narrowly missing its target.

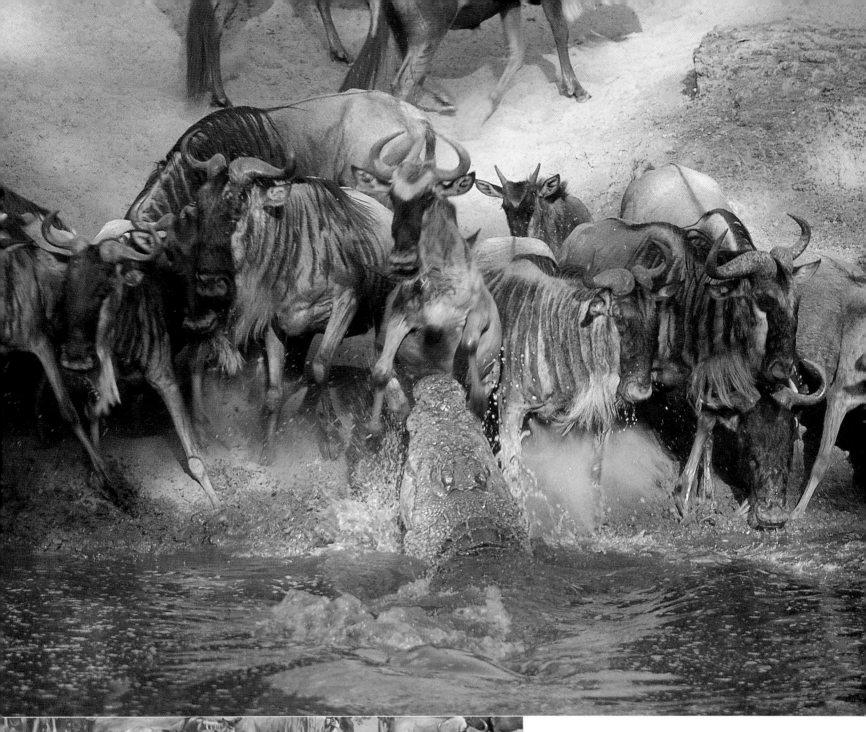

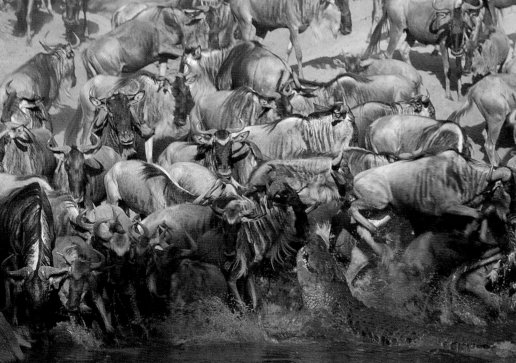

Not all attacks are successful. When submerged, a crocodile can only vaguely distinguish the shape of its prey, and its imprecise aim, coupled with the wildebeest's fast reflexes, is often enough to buy time for the wildebeest.

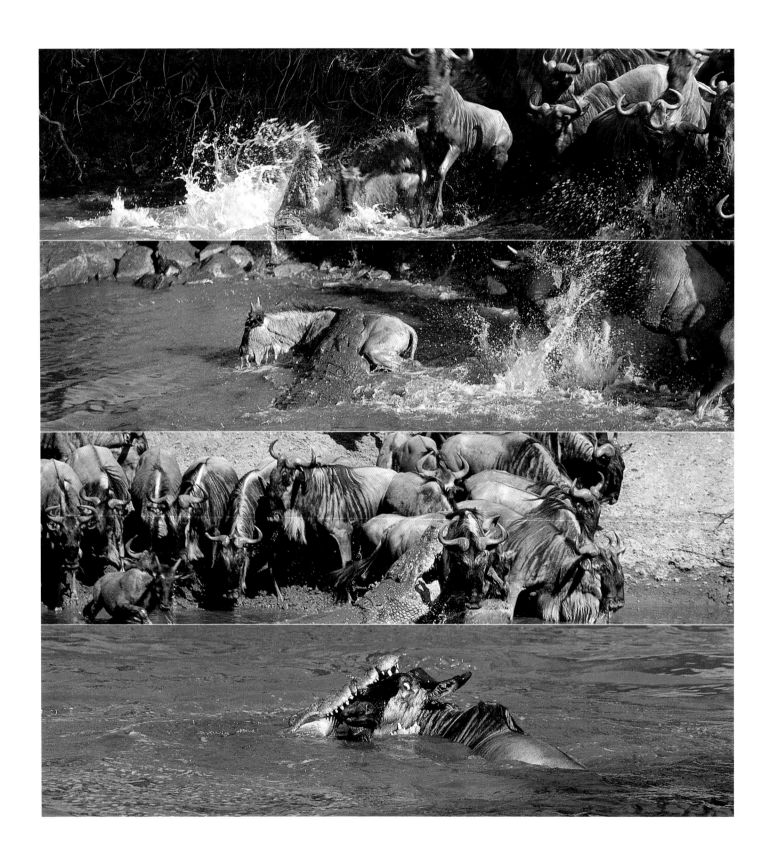

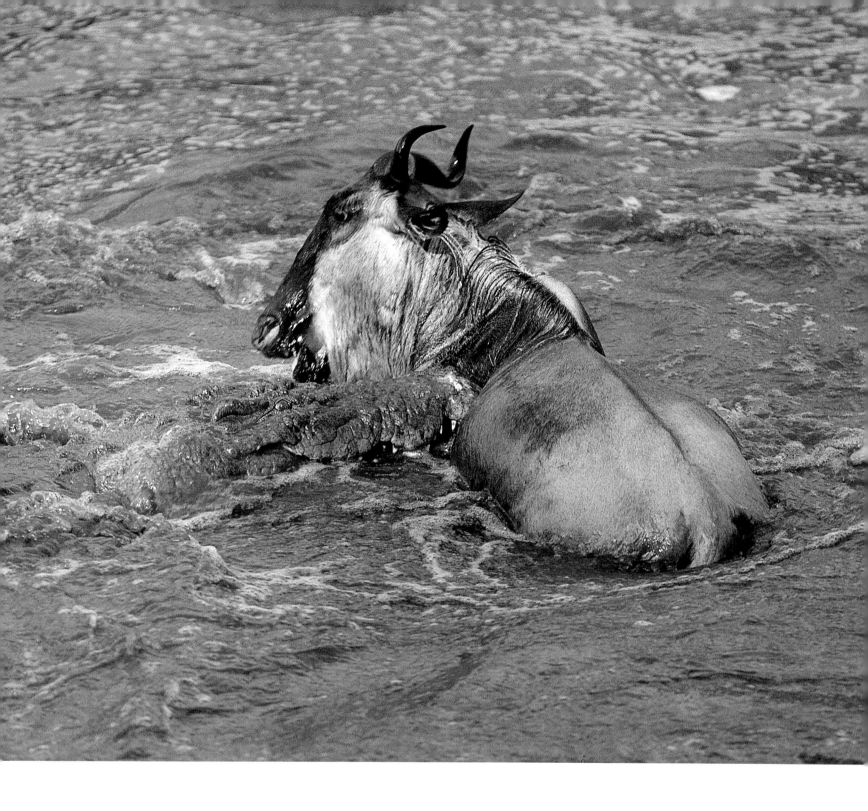

OPPOSITE AND ABOVE Its face contorted with fear, a wildebeest fights desperately for its life. Though its struggle proves hopeless, a fully grown animal can take some effort to overcome, and other crocodiles ensure themselves a share of the kill by helping to drag the animal under. A calf stands no chance against a one tonne reptile. An attack can be so swift and silent that the crocodile has its jaws clamped around its victim before the animal has had time to react.

OVERLEAF Crocodiles do not have any internal mechanisms for controlling their body temperature, and must sunbake to warm up and enter the water to cool down. They also dissipate excess heat by lying on a sandbank with their mouths open. The powerful jaws can exert a pressure of several tonnes, but the muscles used to open the jaws are surprisingly weak.

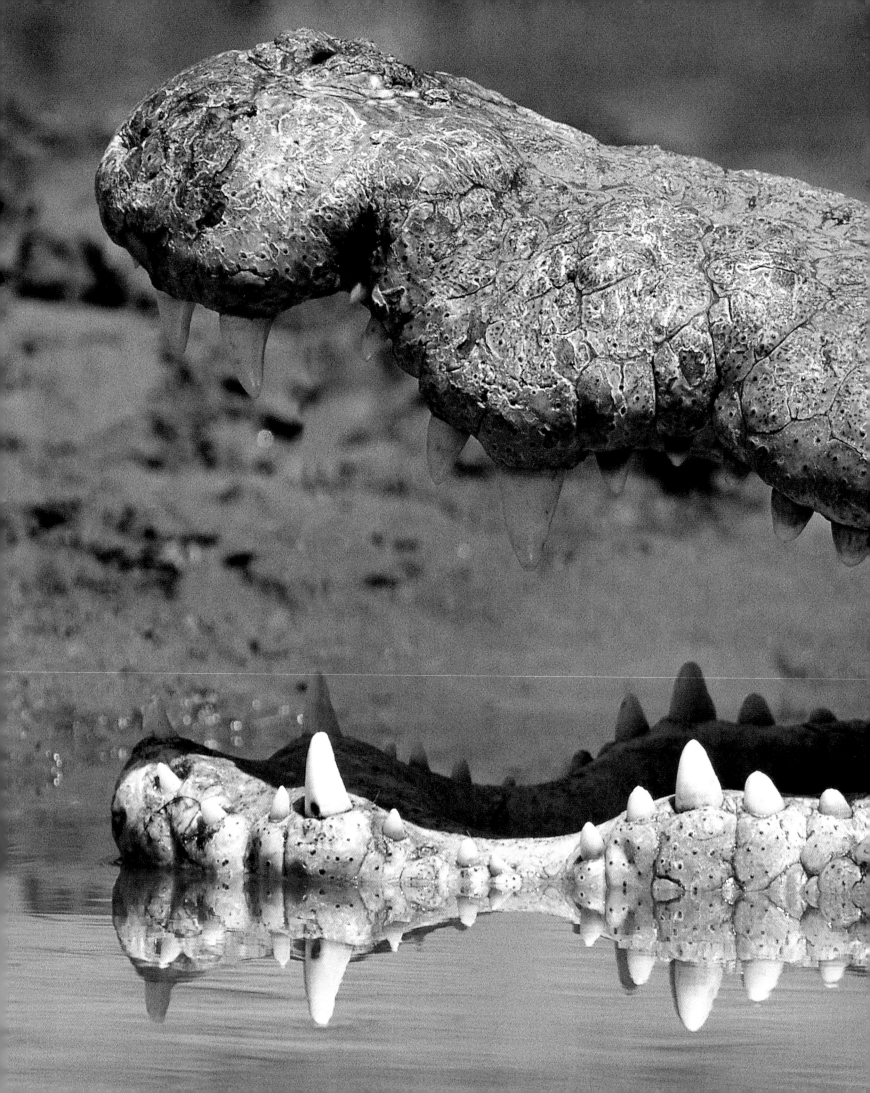

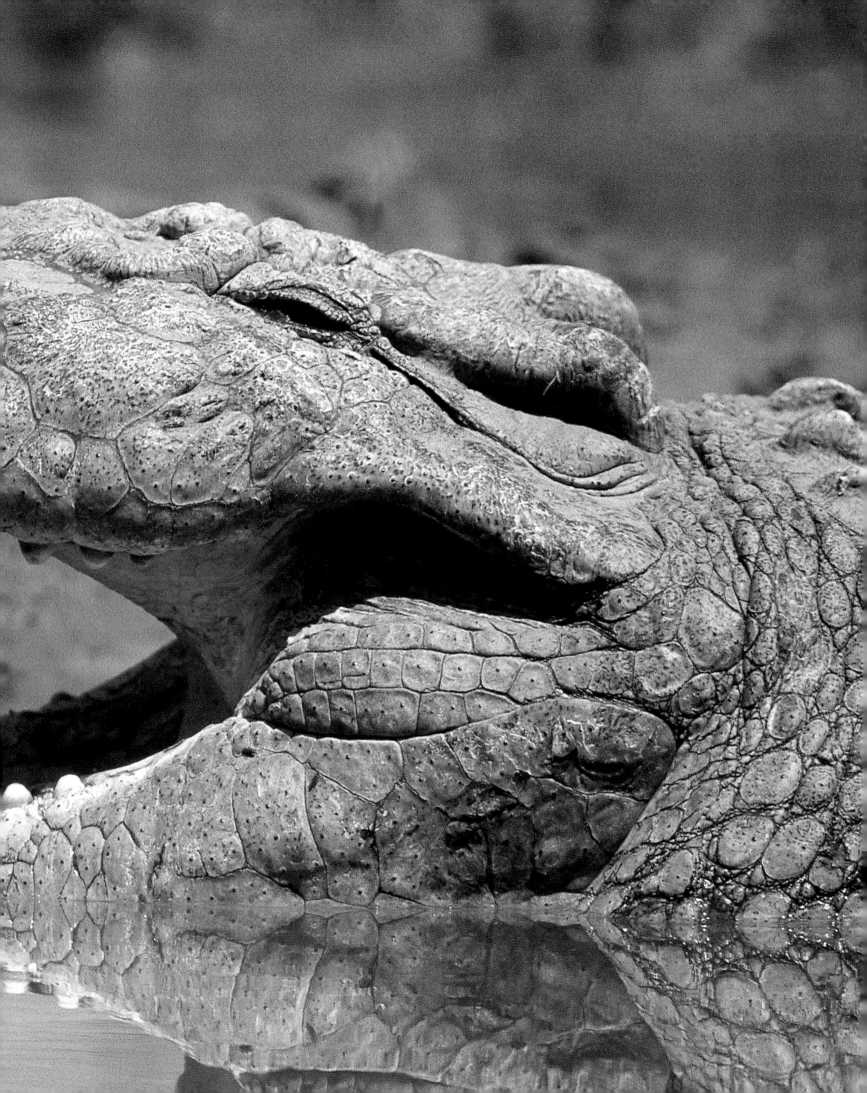

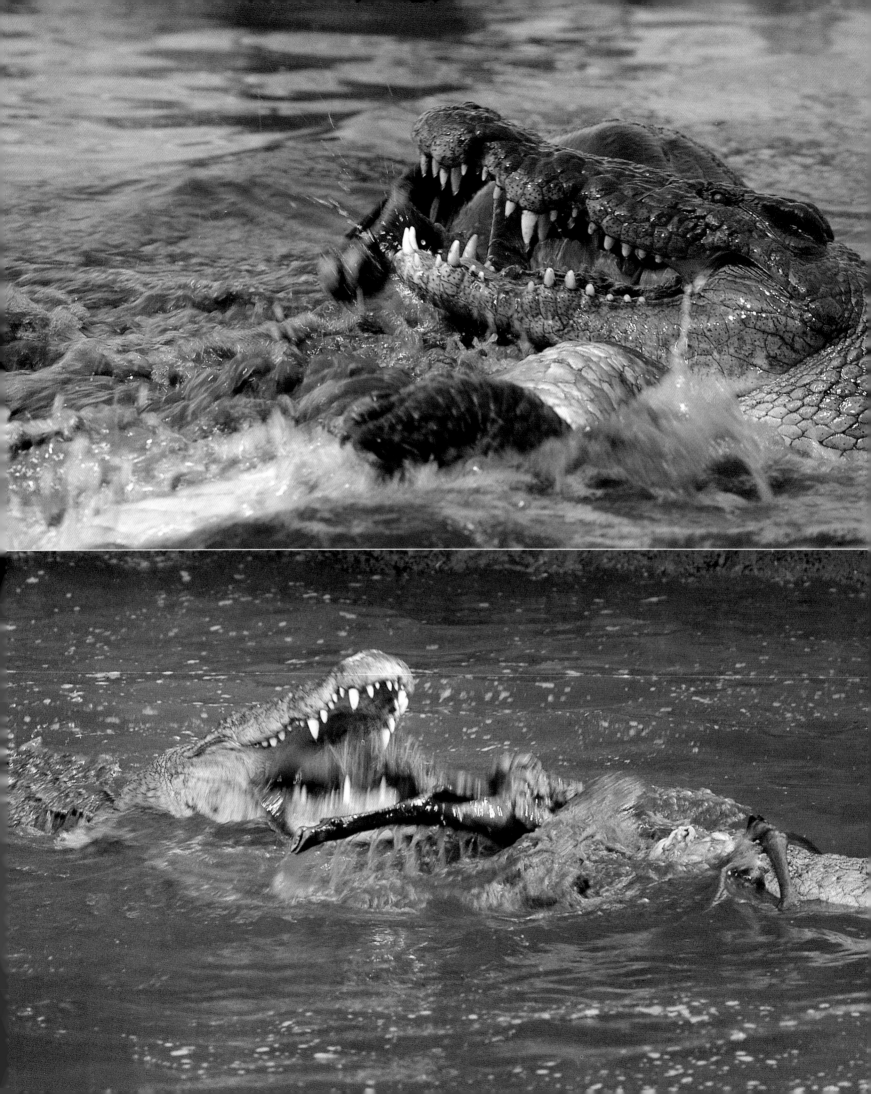

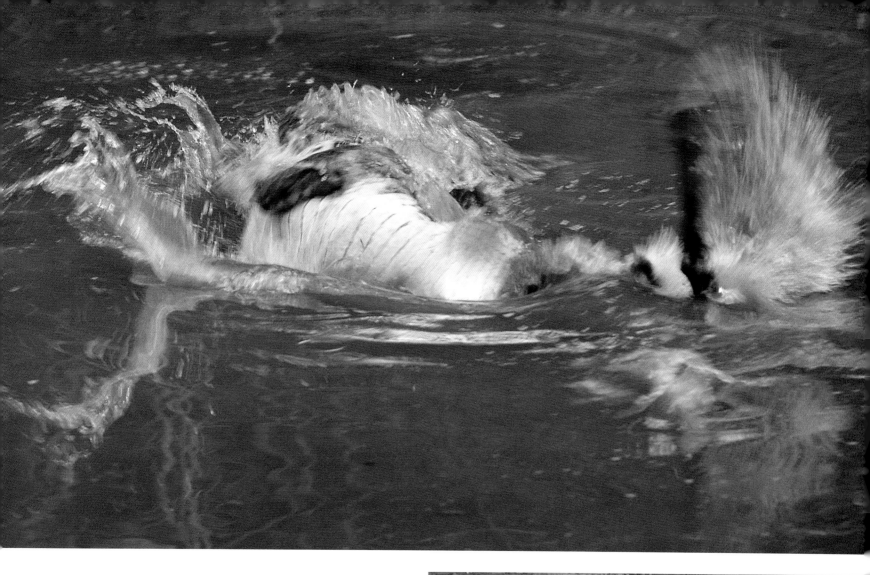

The water churns as crocodiles rush to share the kill. Dismembering the fresh carcass is not easy – a crocodile clamps a limb in its jaws and rolls over several times to twist it off. A crocodile's jaws are not designed for chewing, and large bones must be broken up before being swallowed. This is sometimes achieved by slapping the piece of a carcass against the riverbank. A flap of skin at the back of the throat that closes their respiratory tract allows crocodiles to eat underwater. Small stones are ingested to help grind food in the stomach. Sometimes carcasses are stashed in submerged hollows for some time, which allows the carcass to rot and disintegrate to a point where it is easy to ingest.

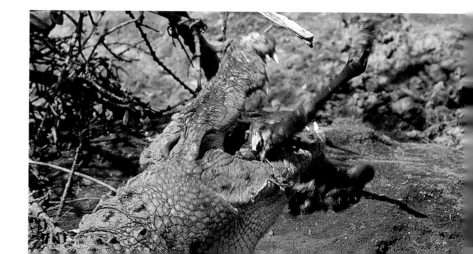

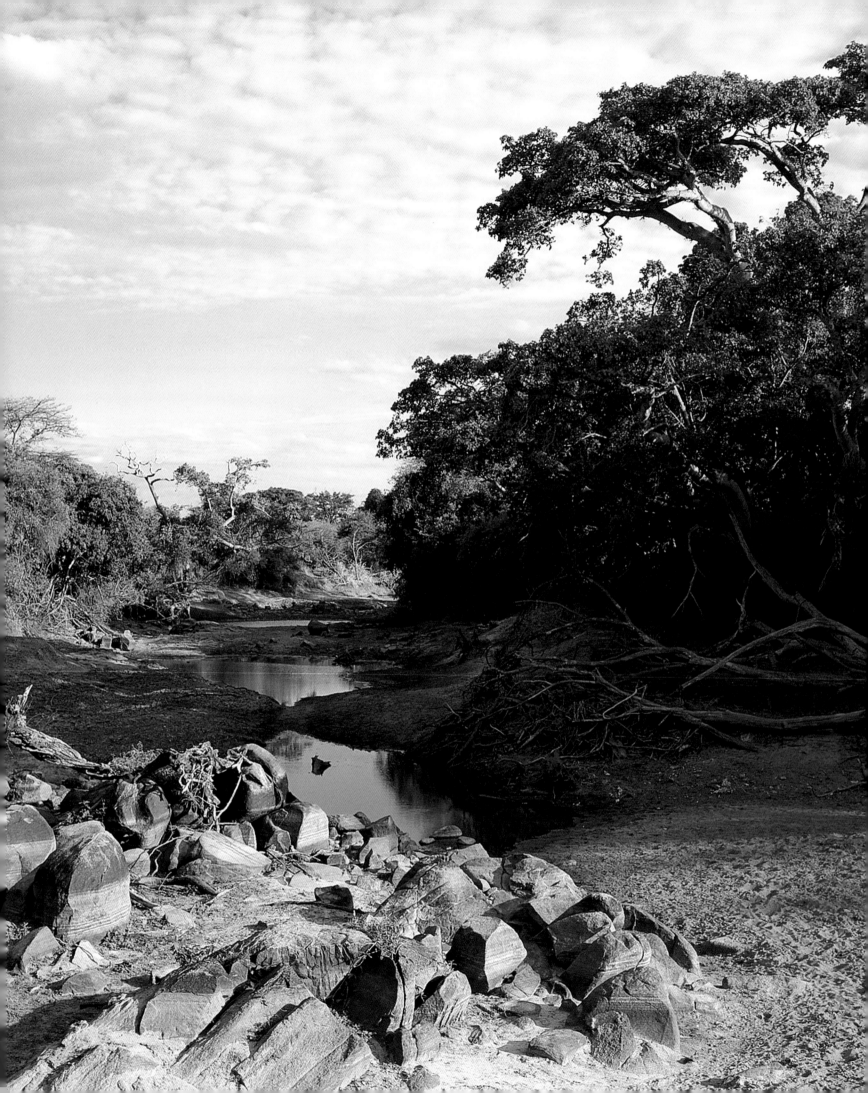

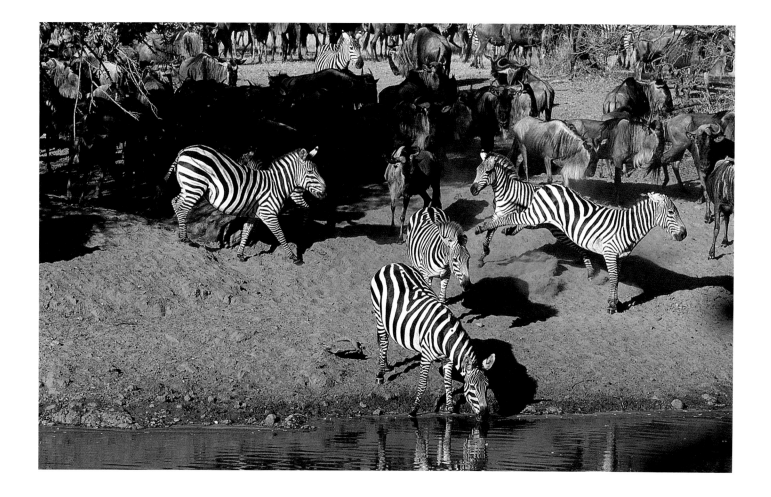

OPPOSITE The dense green forest fringing the Grumeti River contrasts sharply with the surrounding plains. In seasons with little rain, the Grumeti River shrinks to a few shallow pools by the time the wildebeest arrive. This works in the nomads' favour: crocodiles rely on their immensely powerful tails to propel themselves from the water, and in these shallow pools they cannot get enough momentum to launch a successful attack.

ABOVE Tension frays tempers when the ultimate price of a drink may be a life. With ears flattened in the posture of threat, a zebra turns and kicks at another. Kicks can cause serious injury, and are a zebra's most overt way of showing aggression.

BELOW A hippo's voracious appetite sometimes keeps it grazing well into the daylight hours. It can consume as much as 60 kilograms in one night. Hippos live in close proximity to each other yet frequently brawl in crowded conditions, and most animals bear the scars of recent conflicts. Territorial bulls dominate a strip of river in which they defend exclusive mating rights, but will tolerate other bachelors as long as they remain submissive. Sometimes, however, they savagely attack potential rivals to drive them out of their territory.

OPPOSITE By the middle of the dry season, the Grumeti River has long since stopped flowing. Hundreds of hippos cram together in the rapidly shrinking pools. With daily temperatures reaching 35°C, wallowing space is at a premium.

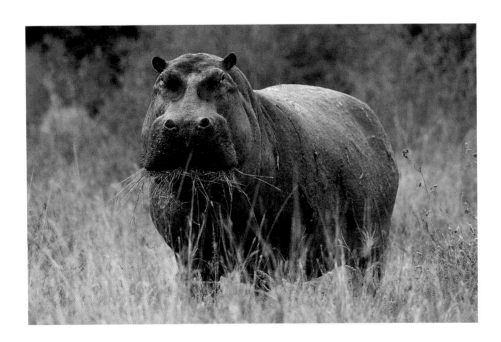

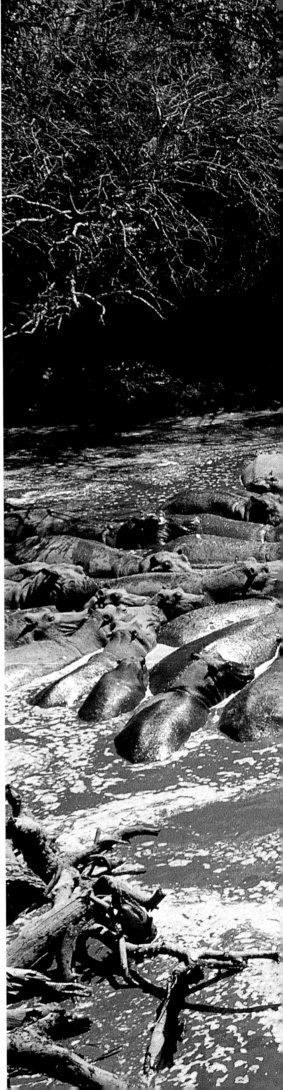

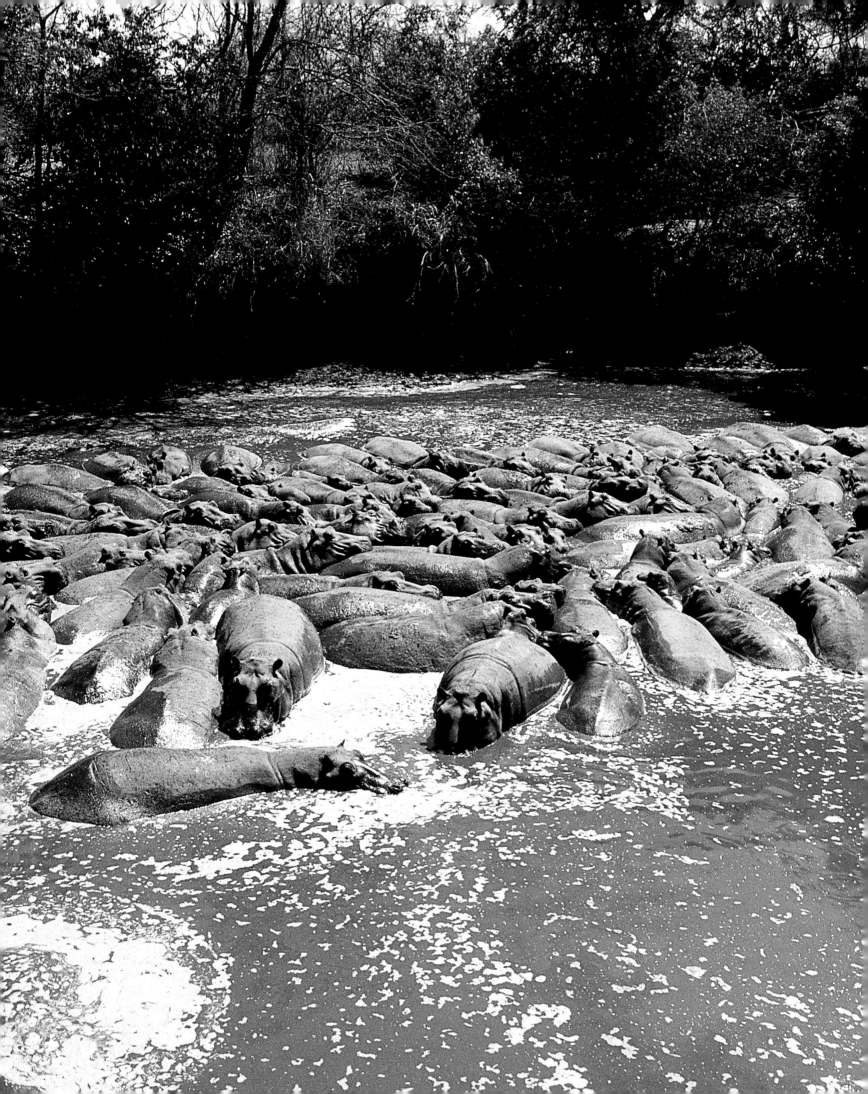

ABOVE One of the few remaining pools in the Grumeti River is well frequented during the heat of day, but at day's end, the river is enveloped in tranquillity.

OPPOSITE A man-made dam at Nyasarore, north of the Grumeti River, entices the nomads to linger, and the surrounding grassland is quickly denuded. Forced to find grazing further afield, they must travel long distances daily to and from the dam.

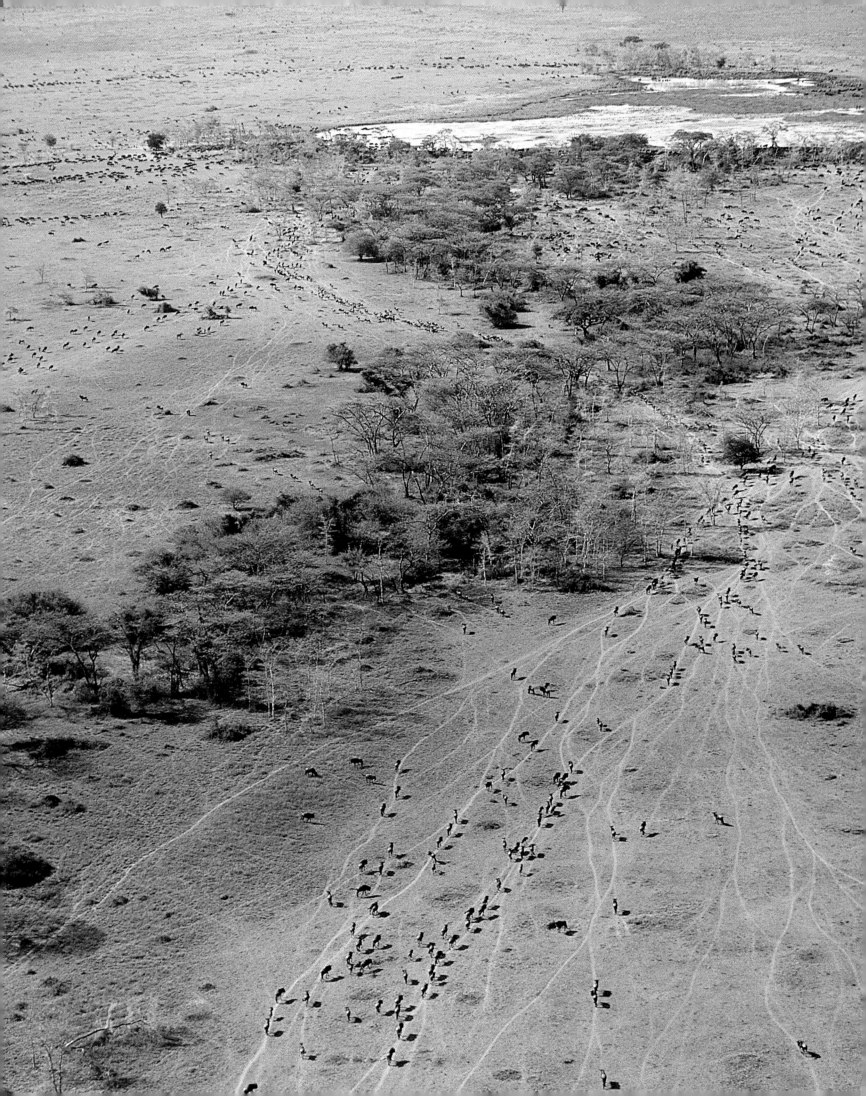

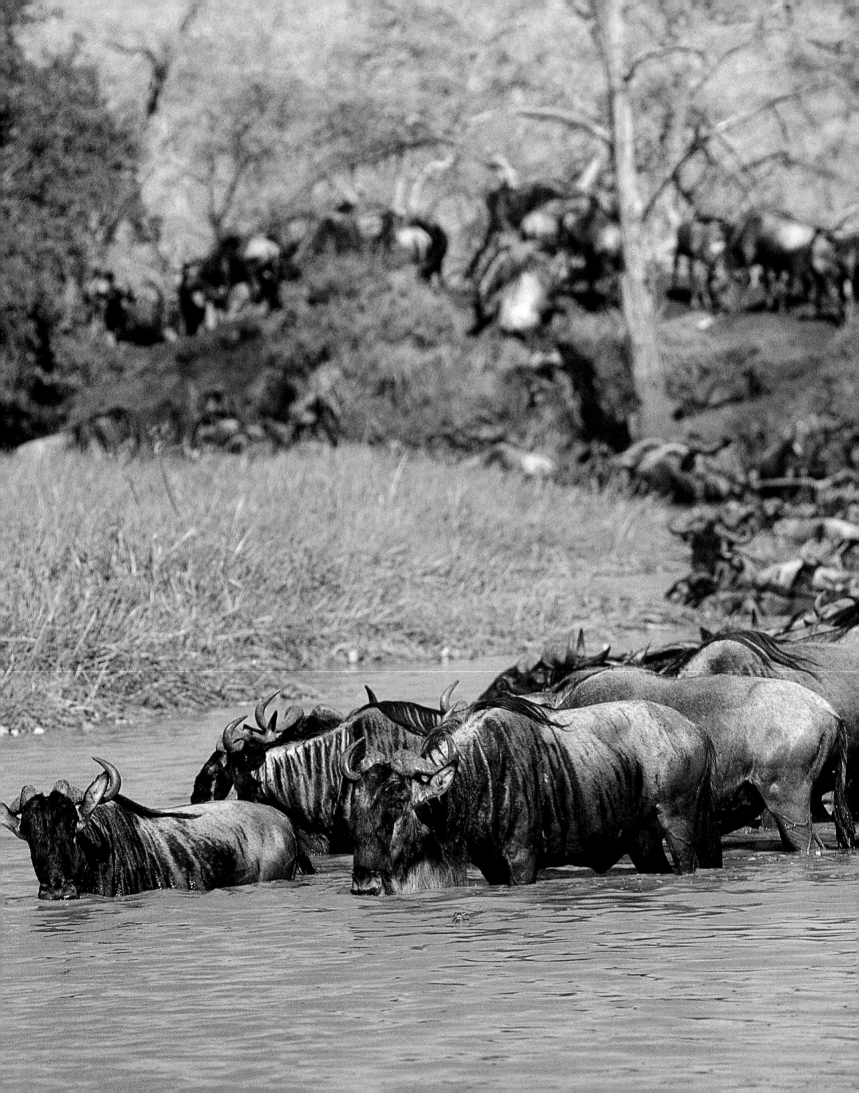

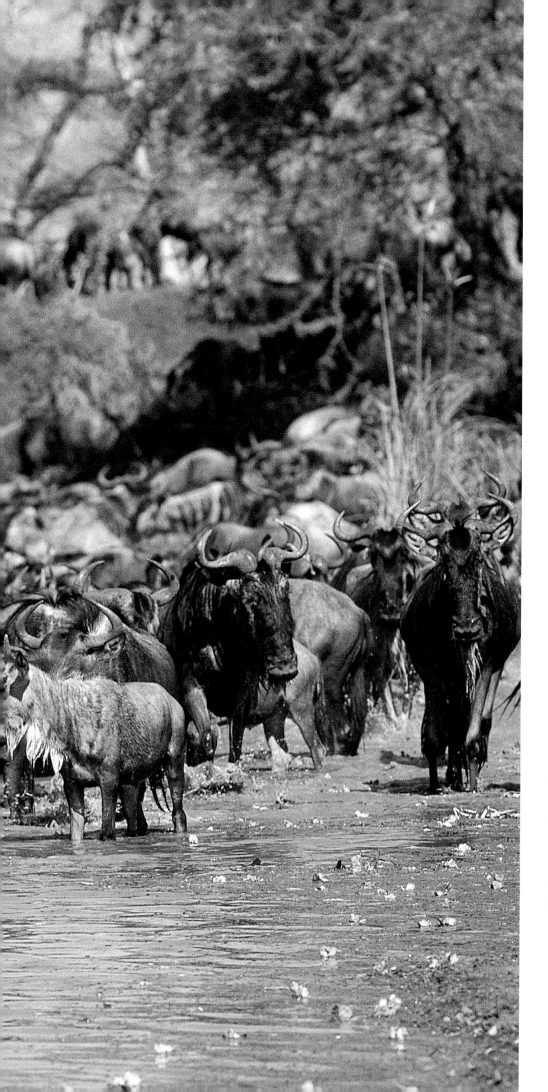

Wildebeest need to drink every day, and must remain within commuting distance of water. Secure in the knowledge that here, at least, no predators lurk in the muddy water, the wildebeest plunge boldly into the dam.

When the pastures around Nyasarore are exhausted they must leave this secure water source and move on. One hundred kilometres still separates them from the pastures of the north, and from here on, water will be increasingly difficult to find. They must reach their destination before ground water dries up completely and small rivers cease flowing. Occasional storms, filled with the promise of rain, thunder over the Isuria Escarpment, which lies at 1 800 metres above sea-level in the distant north, and motivate the wildebeest to continue their journey.

Forever vulnerable to drought, predation, injury and disease, a nomad's existence is a precarious one. When the wildebeest abandon the Western Corridor, the now denuded plains are strewn with carcasses. Injuries sustained on the journey condemn an animal to an early death, and the shortage of high-quality feed in the dry season results in malnutrition and susceptibility to disease. Pasture neighbouring the Grumeti River is soon grazed down to a stubble, and the restless wildebeest resume their trek north.

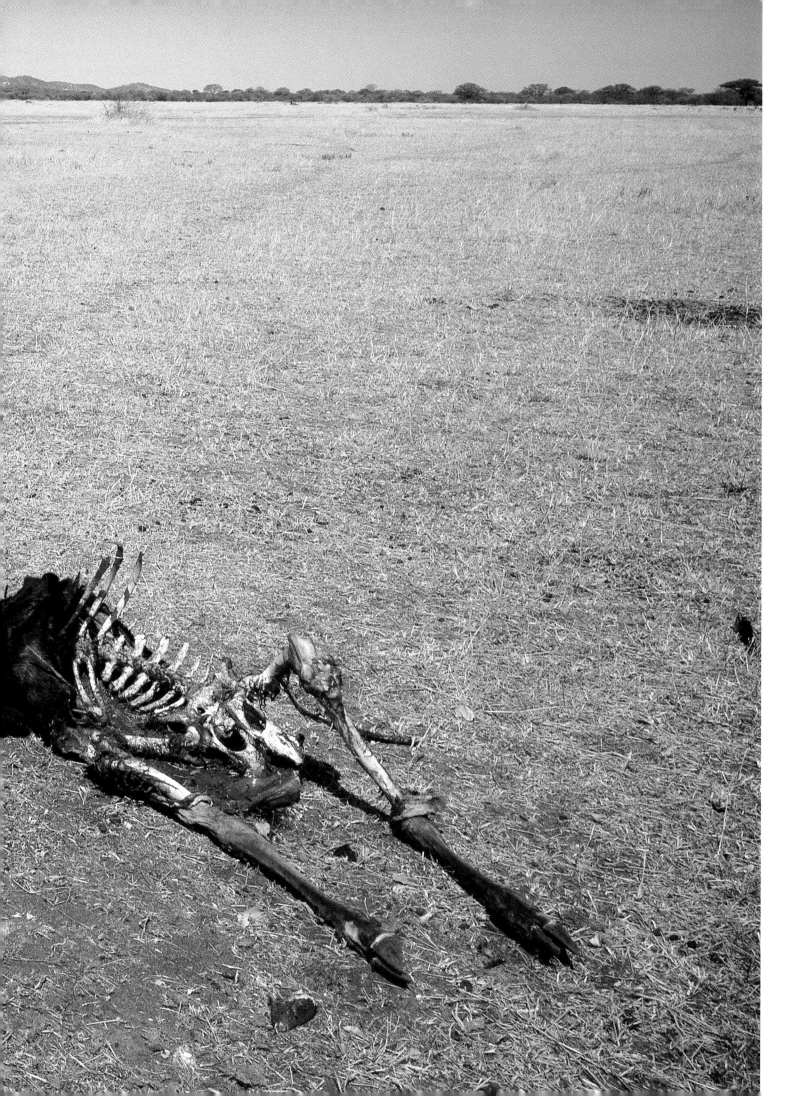

NORTHERN
SERENGETI

When the pastures surrounding the Grumeti River are reduced to stubble, the long march resumes. Trailing plumes of dust, the wildebeest trudge northward from the Grumeti, through woodland until they reach the Mara River, which slices through the northernmost tip of the park. Herds of wildebeest and zebra plunge into the treacherous torrent and thunder up the opposite bank onto the northern pastures. There, beyond the rain-shadow of the Crater Highlands, enough rain falls to ensure a continuous supply of forage through the four- to five-month dry season.

Much of the undulating landscape of the north is wilderness, mottled by thickets of woodland and modified by fire, grazing and elephants. The Serengeti-Mara is a dynamic ecosystem that has experienced major vegetation changes in its recent history. The first resulted from the rinderpest outbreak, when grassland reverted to woodland in the absence of human settlement. A shift back to grassland began in the 1950s when unusually high rainfall, and a near absence of grazers (still recovering from rinderpest) resulted in exceptional grass growth. Devastating fires, started by herdsmen and hunters, were fuelled by the dry grass, and cleared the northern Serengeti of bush, creating lush lawns for the ungulates.

As the ungulate population in the park exploded after rinderpest was eliminated, so too did the human population outside the park, particularly to the north and west, forcing elephants out of these areas and into the confines of the park. Elephants not only damage large trees, but spend significant time browsing on small seedlings, which occur in their highest densities in open grassland. By removing seedlings, elephants prevent the regeneration of woodland, maintaining the grassland that attracts the nomads.

The Mara River is the last obstacle in the wildebeests' trek to their seasonal destination, an area that is bounded in the north-west by the 500-metre-high Isuria Escarpment and enclosed on three sides by densely settled agricultural land. Oblivious to national boundaries, some of the wildebeest continue their trek to the adjacent Kenyan Maasai Mara, while the rest remain on the Tanzanian side of the border. Often crossing and recrossing the Mara, they ceaselessly pursue the rain that induces grass growth.

The wildebeest's journey from south to north is an impressive one, fraught with hazards, which many animals do not survive. But it is only half the journey. As rain clouds gather to the south in late October and the scent of damp earth fills the air with fresh promise, the wildebeest turn south once more, and continue their journey back to the southern plains. The round trip is more than 600 kilometres. If daily movements are taken into account, the distance covered can be twice that.

OVERLEAF The perennial Mara River is still flowing by the time the wildebeest arrive. Beyond the park the Mara empties its water into broad papyrus swamps to the west before reaching Lake Victoria.

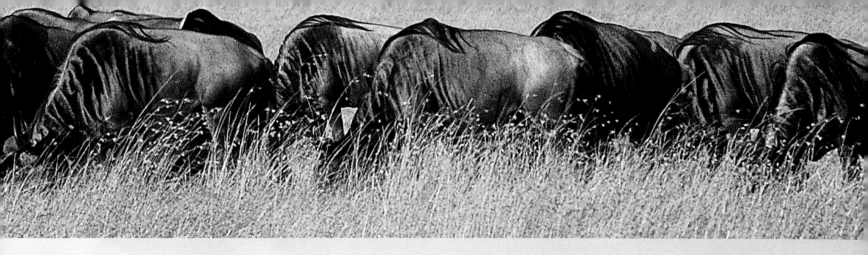

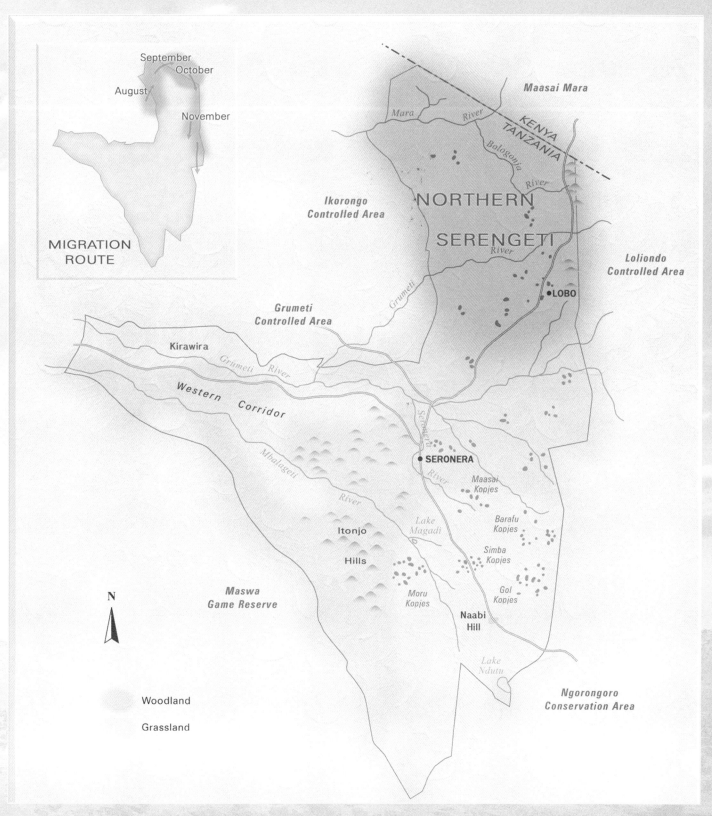

MIGRATION
ROUTE

September
October
August
November

Maasai Mara

KENYA
TANZANIA

Mara

River

Bologonja

River

Ikorongo
Controlled Area

NORTHERN

SERENGETI

River

Loliondo
Controlled Area

Grumeti

●LOBO

Grumeti
Controlled Area

Kirawira

Grumeti River

Western Corridor

Mbalageti

Seronera

River

●SERONERA

Maasai
Kopjes

River

Barafu
Kopjes

Itonjo

Lake
Magadi

Hills

Simba
Kopjes

N

Moru
Kopjes

Gol
Kopjes

Maswa
Game Reserve

Naabi
Hill

Lake
Ndutu

Ngorongoro
Conservation Area

Woodland

Grassland

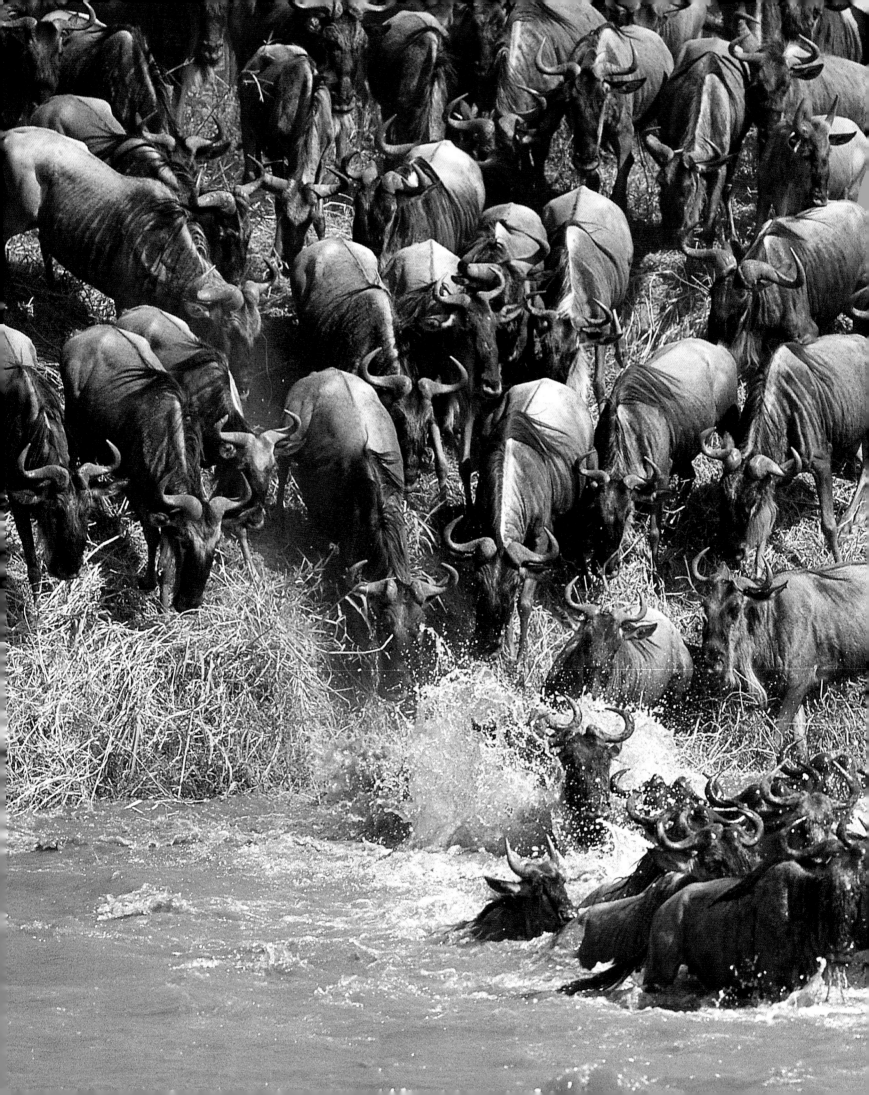

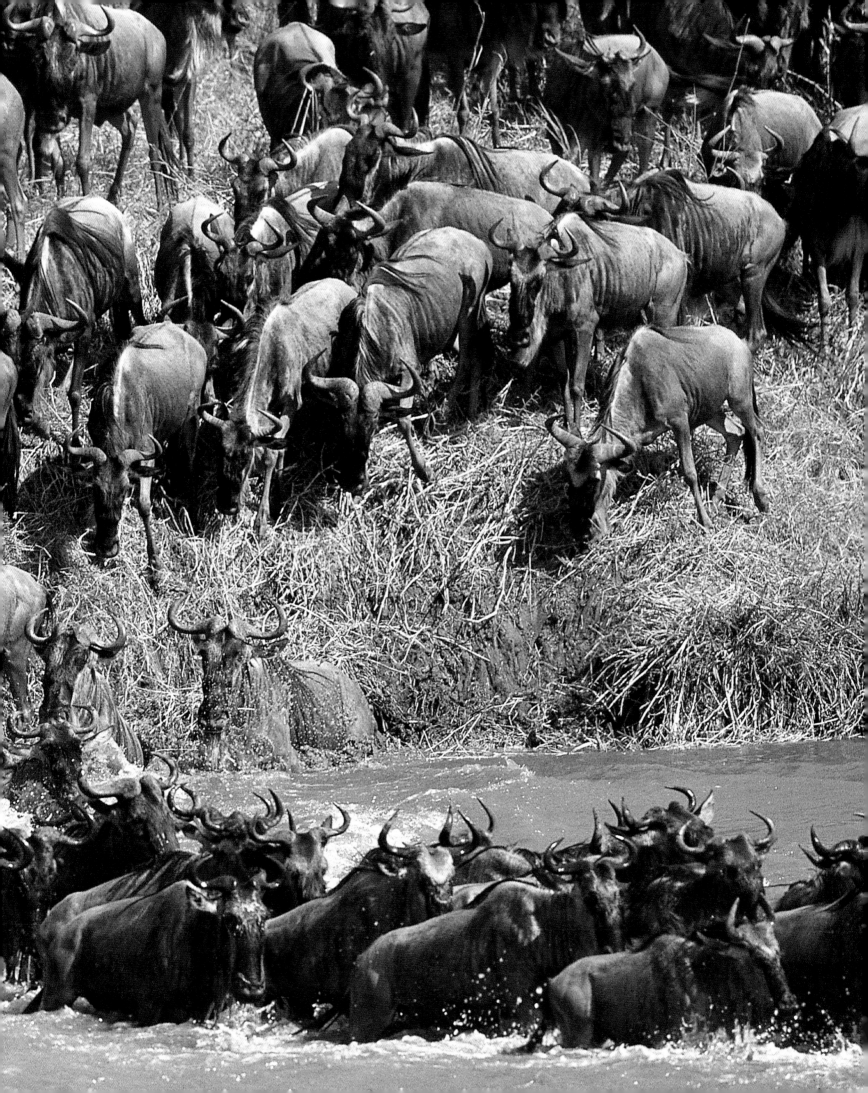

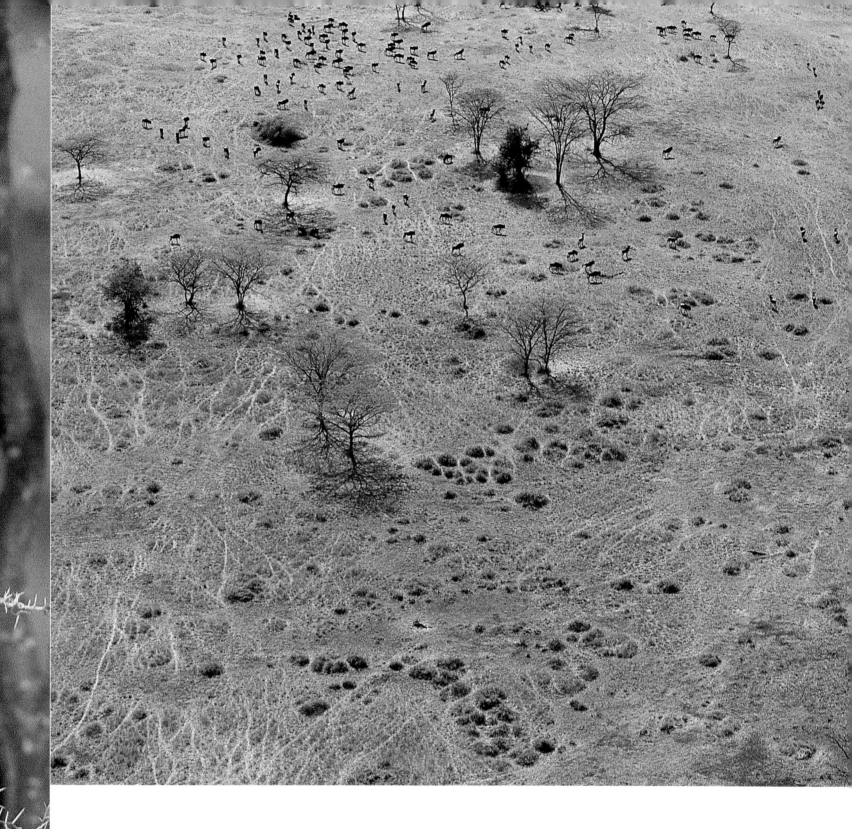

LEFT The whistling thorn acacia has long thorns that are joined to the stem by round hollow galls. Tiny holes in the galls turn the thorns and galls into miniature flutes when the wind blows, giving the tree its common name. Four species of stinging ant colonise the galls and protect the tree by swarming over and biting anything that dares to attack it. The species are fiercely intolerant of each other, and only one will inhabit any particular tree. The most aggressive of the ants, a *Crematogaster* species, feeds on a sugary solution produced by the tree's leaves, and prunes the growing tips of the tree to stimulate production of the nectar.

ABOVE Stragglers dally amid the latticework of tracks left by thousands of plodding hoofs. By quickly exhausting the pasture of an area, nomads depress the populations of resident animals that share the same food and habitat preferences.

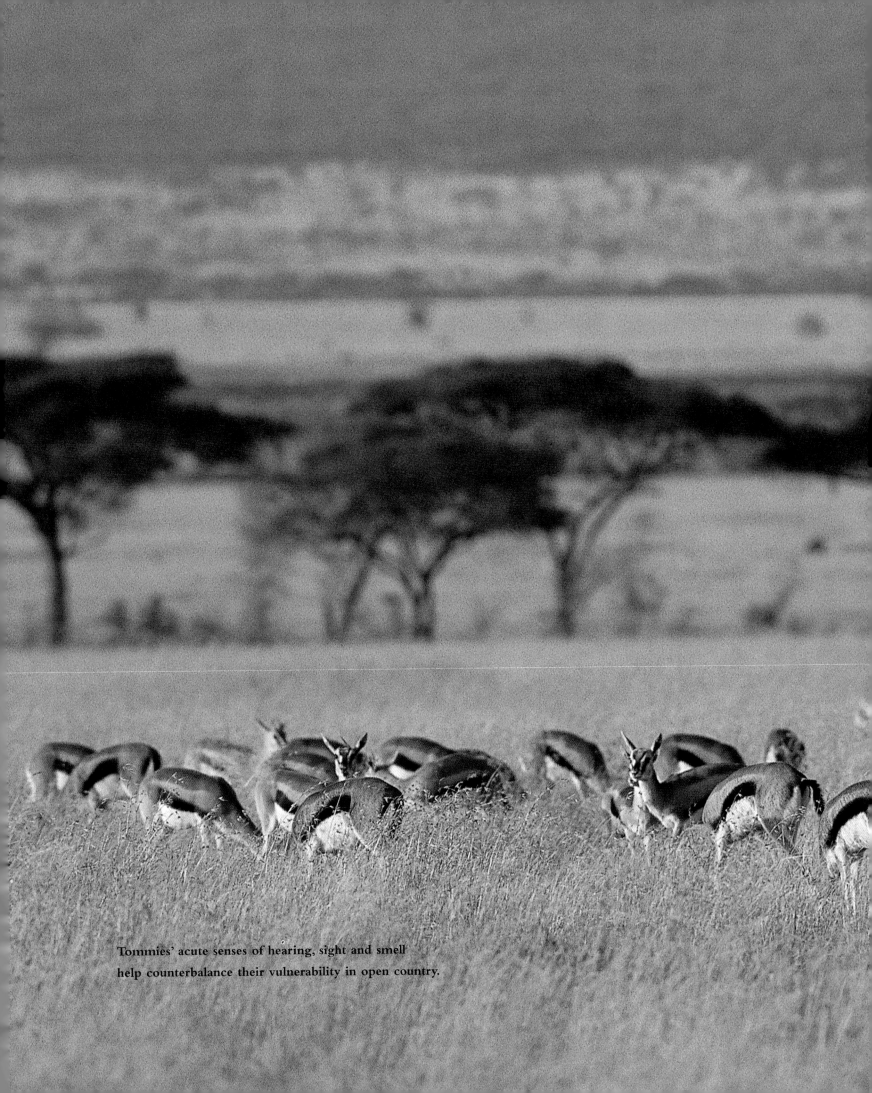

Tommies' acute senses of hearing, sight and smell
help counterbalance their vulnerability in open country.

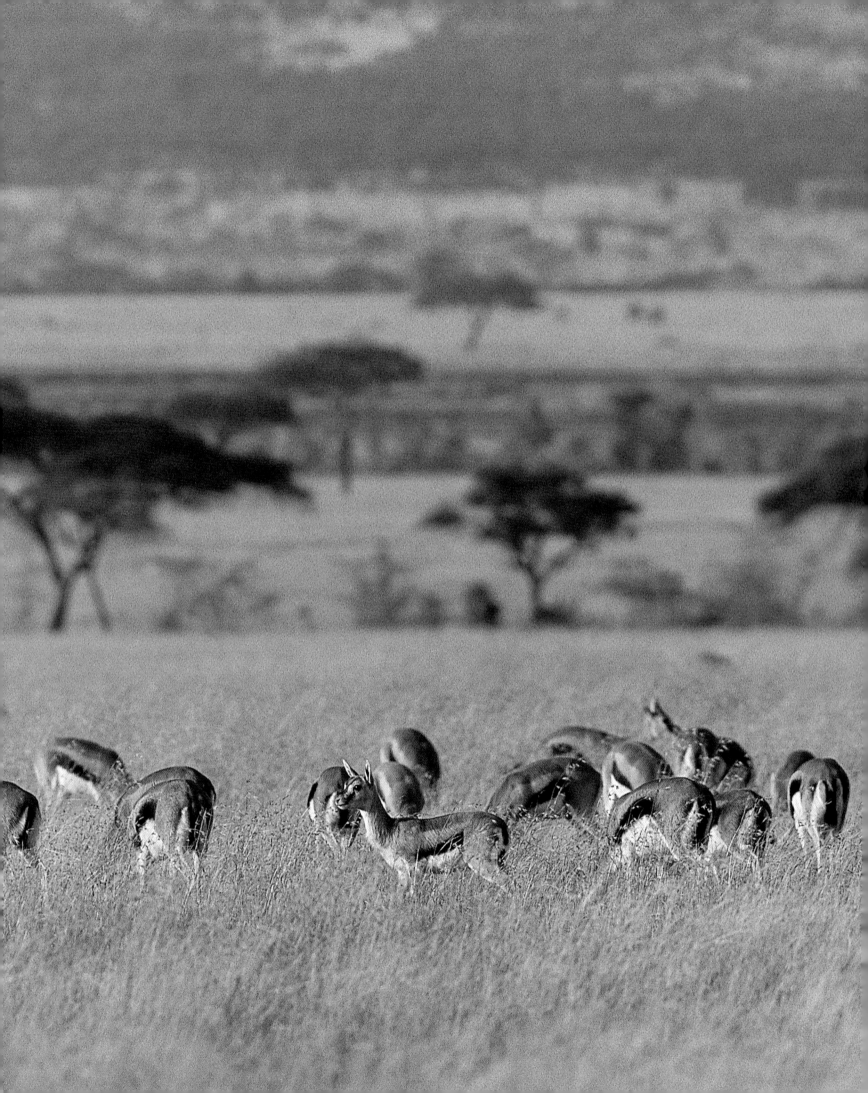

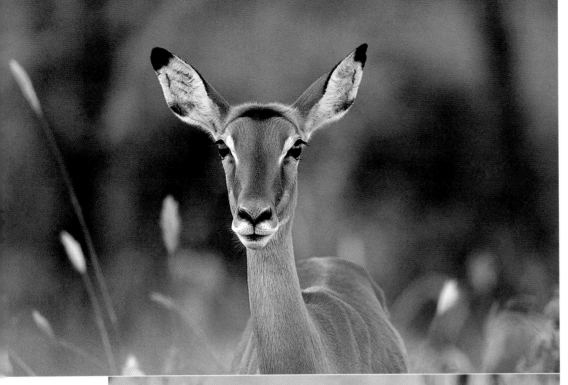

Impala are most at home in the margins between grassland and woodland, where they adapt their feeding strategies to the seasons. They graze when grass is fresh and green, and switch to browsing when the grasses dry out.

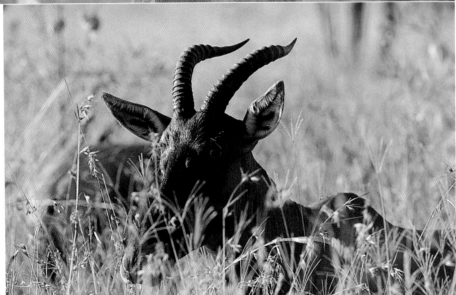

CENTRE A topi's height and high wide-set eyes enhance its vigilance.

BELOW Male topis advertise their territory by standing on a prominently elevated area such as a termite mound for long periods, where they can easily be seen by other topis. Intruders are challenged by locking horns in a pushing contest, and the winner often chases the loser for a long distance.

Horns are the weapons with which antelopes fight for the dominance that guarantees them reproductive success. The degree to which horns are developed typically reflects the degree of competition between males. Monogamous dwarf antelopes such as dik-diks and klipspringers have small simple horns, while species that must constantly defend their claim to a large number of females, such as impala, have large, elaborate horns.

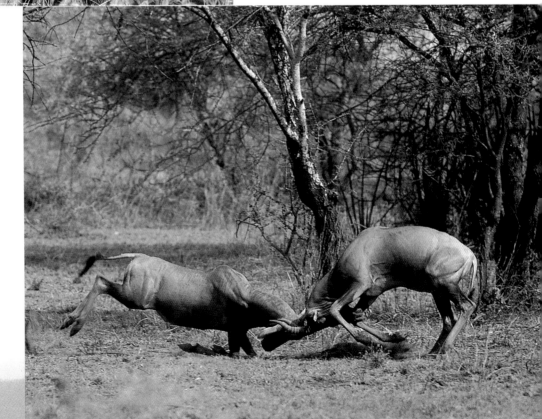

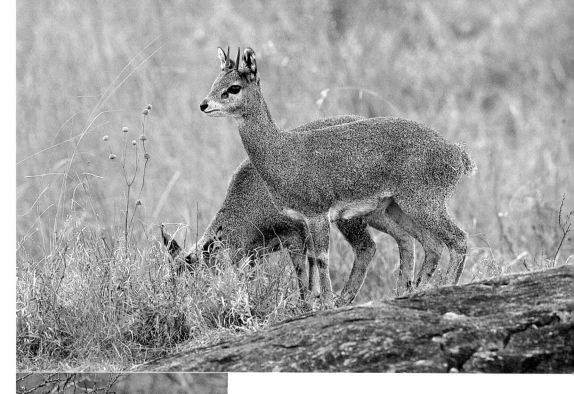

RIGHT Highly developed rock-hopping skills allow klipspringers to exploit the diverse and rich vegetation that sprouts in the rocky outcrops scattered through the north of the park.

CENTRE Oribis thrive in grassland maintained by fire or heavy grazing. The migrating herds provide an efficient mowing service, exposing the shorter grasses on which oribis feed, so helping to improve the oribi's range. The nomads may also help them by distracting predators, which provides a welcome reprieve. Northern Serengeti supports the highest density of oribi in Africa.

BOTTOM LEFT Standing motionless is a bushbuck's first reaction to the approach of a predator, and a thicket renders it virtually invisible. Their days are spent browsing and resting in thickets close to water. Before nightfall they move to more open habitat, where their white markings help to conceal them by disrupting their shape and outline. A predator may pass within metres of a bushbuck without detecting it. Even though they sometimes feed in close proximity to each other and associate with others that live in the same area, they are nevertheless solitary. Their secretive habits mask their ubiquity.

BELOW Ever alert to potential danger, a male Kirk's dik-dik broadcasts alarm to females and young with breathy whistles. As potential prey for a host of predators, dik-diks need to develop an intimate knowledge of their home range, and secure hiding places are essential for their survival.

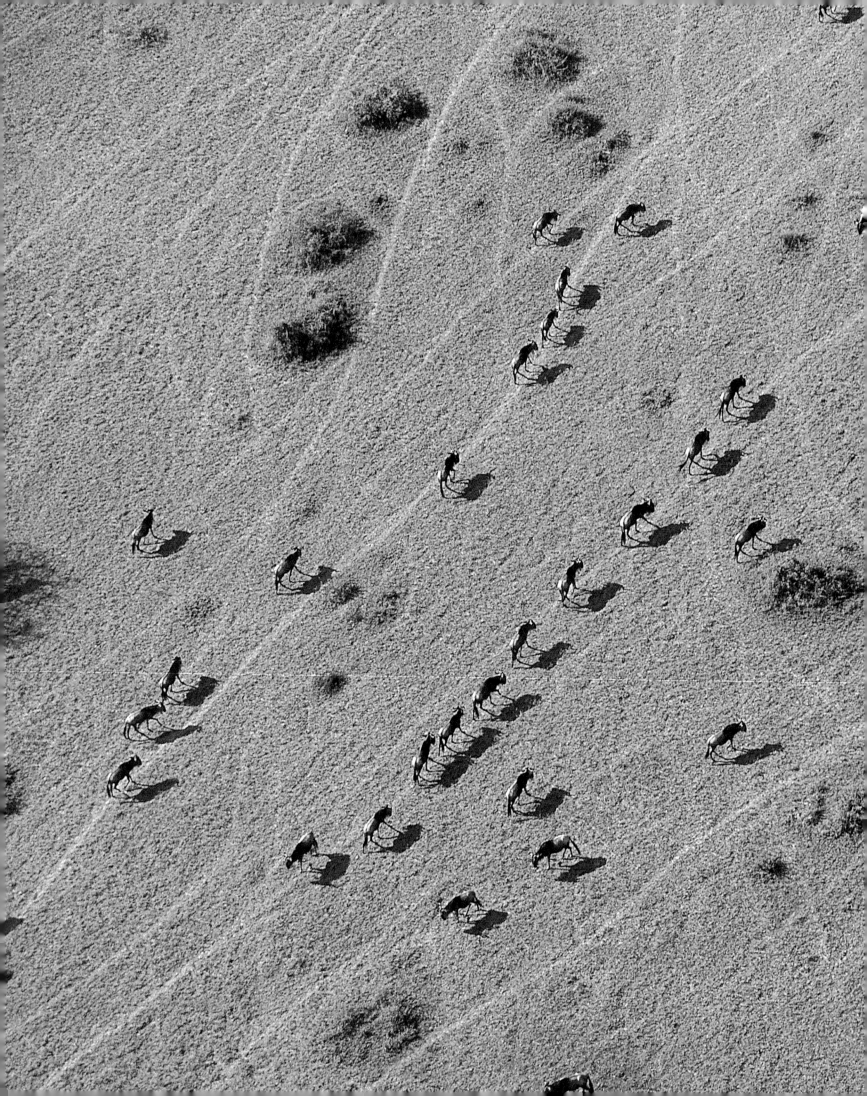

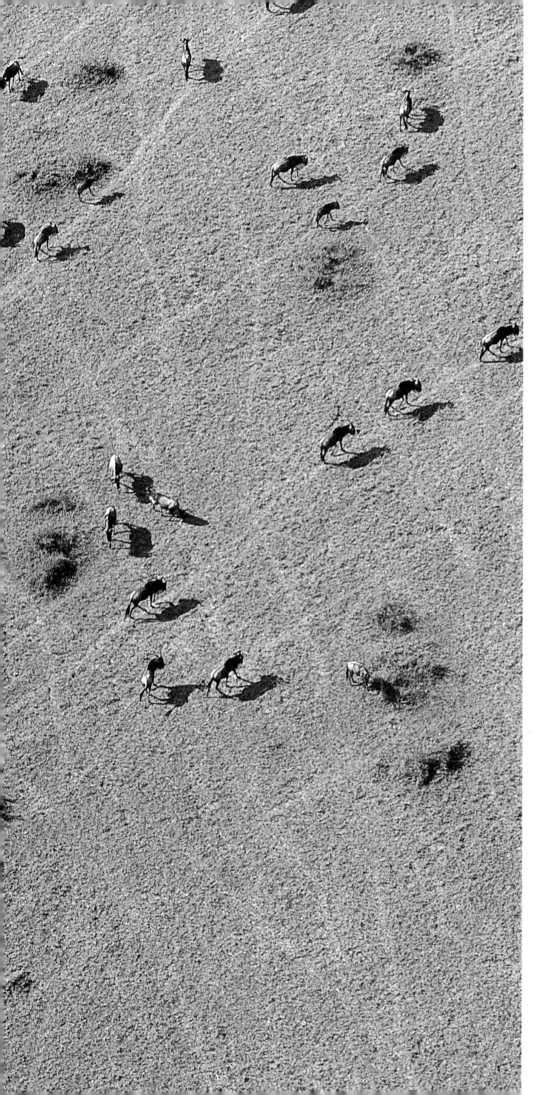

Migrating wildebeest can travel up to 60 kilometres in a day. Their migratory pattern, as well as that of the migratory zebra, depends on local climatic conditions, which may vary from year to year. A singular ability to sense rain from as far as 50 kilometres away spurs wildebeest to seek out the resulting flush of grass. The migration allows these species to optimise their use of the widespread resources of the ecosystem, which in turn enables them to maintain their astonishingly high numbers. The migrating wildebeest do not adhere to any social hierarchy, and are not held together by familial ties. This provides individuals with access to a large potential pool of unrelated mates.

Buffalo were once prevalent in the north, but between 1976 and 1982 about
85 per cent of the population disappeared, hunted by poachers for their meat.
By 1990 only a single herd of up to 200 animals remained. Increased anti-poaching
activities have halted their decline, but the herds of thousands or more are no longer
to be seen, and those that remain are extremely shy.

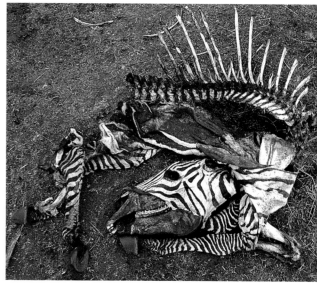

ABOVE Zebras have good reason to be nervous in woodland, where predators use the cover to conceal themselves. Despite being less abundant and harder to catch than wildebeest, their wider and less aggregated distribution throughout the park makes this population more vulnerable to lion predation.

ABOVE RIGHT An intact zebra skeleton in the north attests to the scarcity of hyaenas, which would otherwise quickly obliterate all traces of a carcass. Incidental snaring of hyaenas by game meat poachers as well as deliberate poisoning around hunting camps keeps hyaena numbers in the north lower than in the south.

OVERLEAF Taking a midday break from grazing, zebras rest their heads on each other's backs. Not only is this their way of social bonding, it also provides them with an effective 360° view of their surroundings. Individuals that are on friendly terms also groom each other by scraping with their teeth and nibbling with their mobile, sensitive lips.

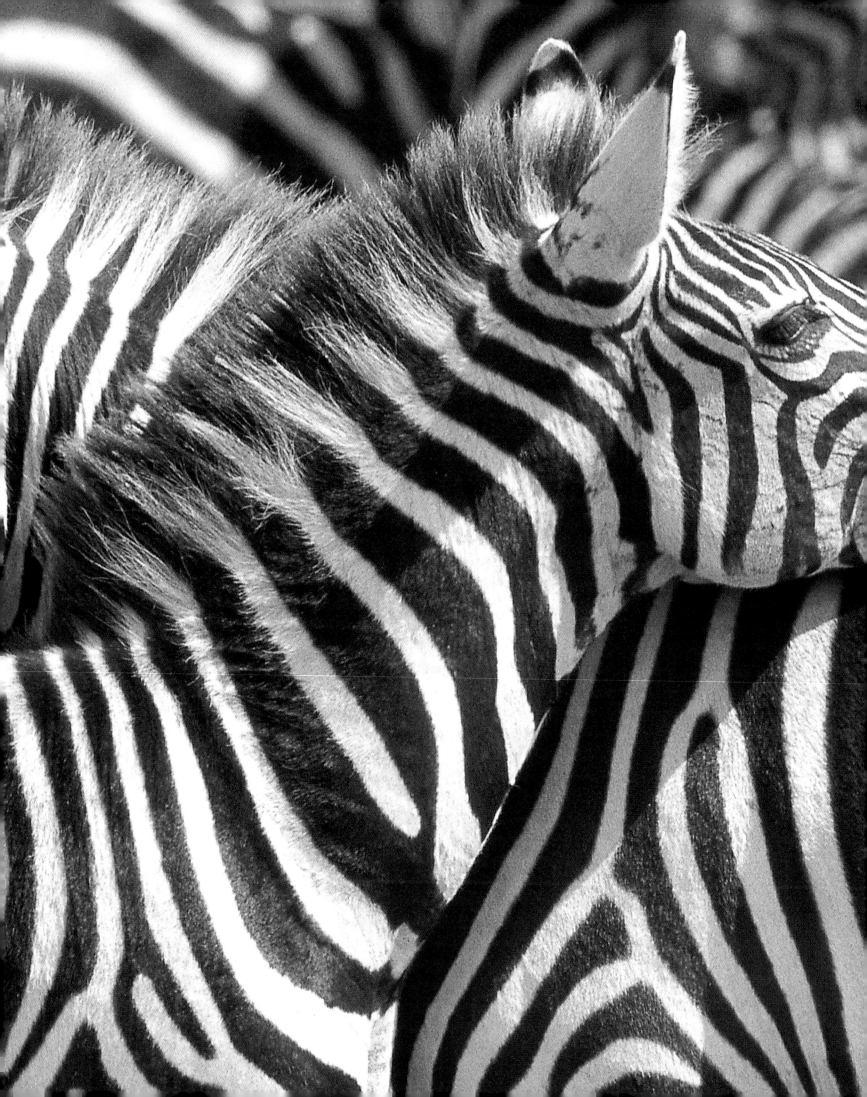

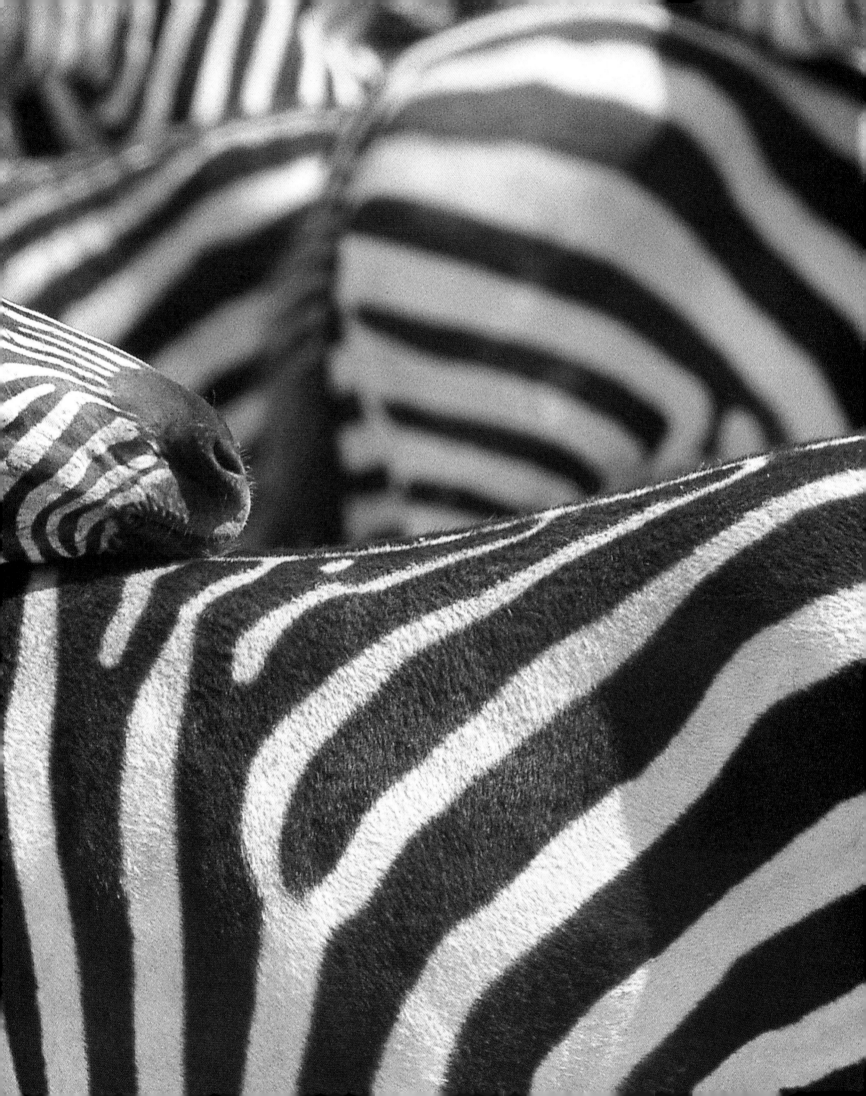

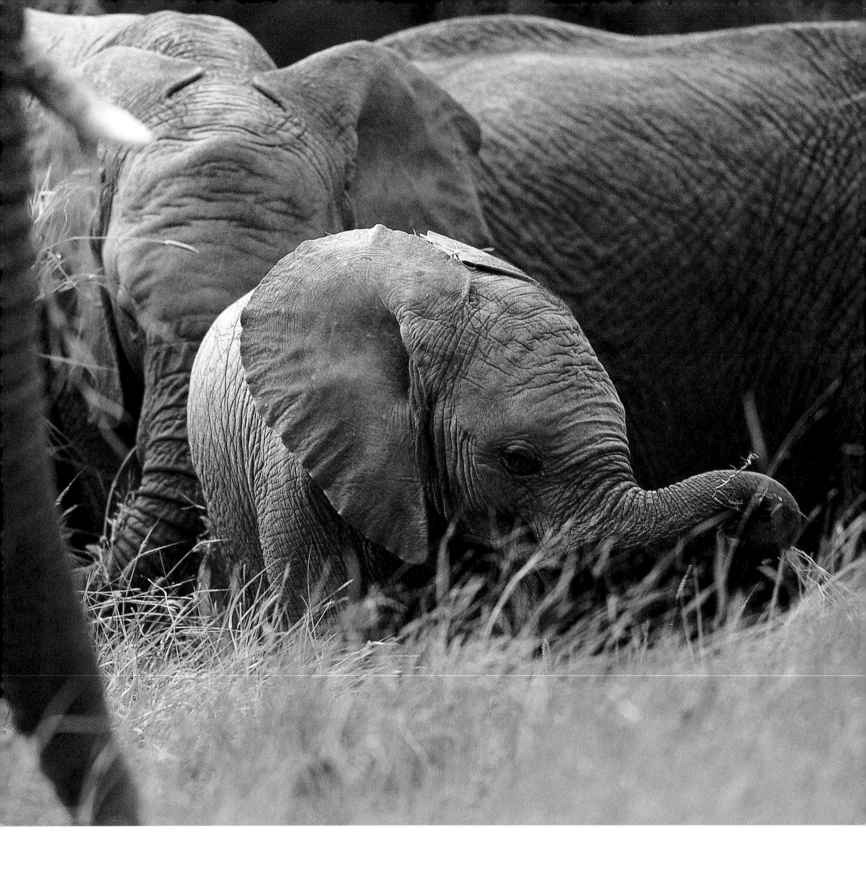

Still uncertain how to operate its trunk, a juvenile elephant attempts to imitate its elders grazing, with limited success. Tender and attentive to her calf's every need, a mother's bond with her offspring can endure until her death. Calves are unsteady on their feet for the first few weeks of life and are fiercely protected by their mother. Never allowing her baby to stray more than a few metres, she keeps it from danger.

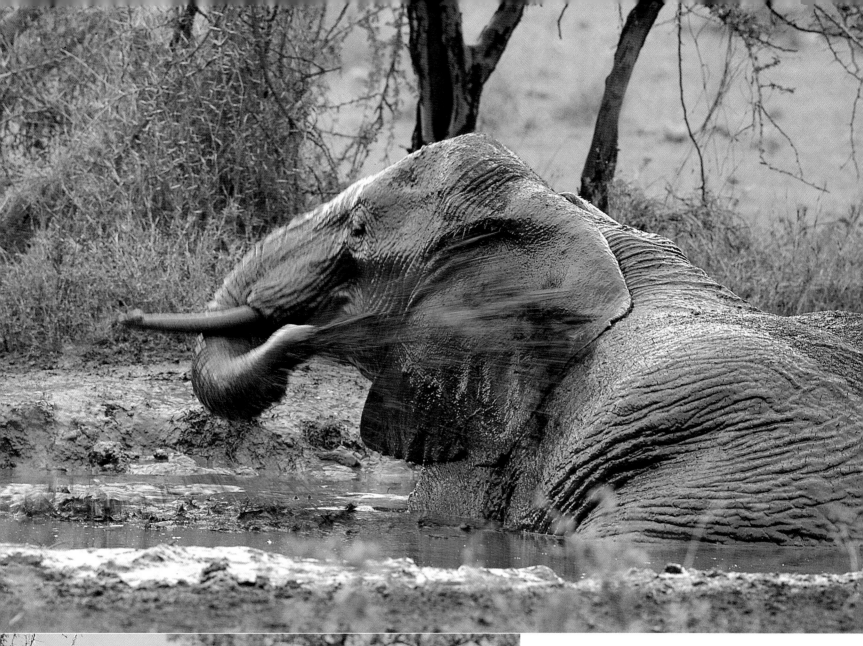

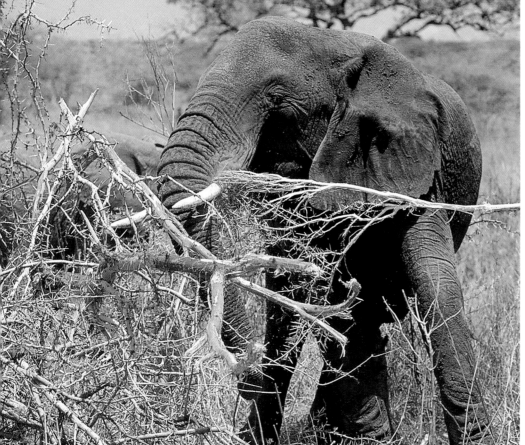

ABOVE Mud-wallowing cools an elephant, while the layer of dried mud protects the elephant's skin from the sun and from stinging insects.

LEFT Agents of change, elephants have a high but localised impact on woodlands. Dragging an acacia branch between its trunk and tusks, an elephant strips off the thorns before eating it. Elephants are particularly fond of yellow-barked acacias and can reduce a stand of mature trees to debris in a single session.

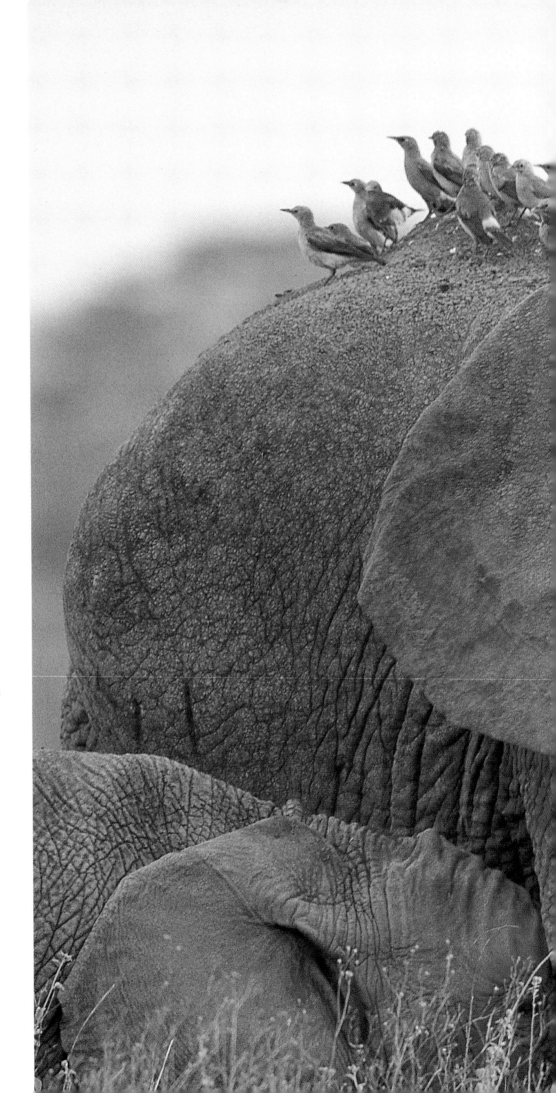

Starlings perch on the most convenient vantage point to watch for insects disturbed by the moving elephants. As their numbers increase, elephant families split into two groups, but they remain closely associated in bond groups of related individuals. Bond groups sharing the same range make up clans of related elephants.

Communication between elephants is highly expressive. Using their trunks, ears, voices and postures, they communicate emotions ranging from contentment and excitement to fear, grief, pain and anger. They are also able to communicate with each other over distances of several kilometres using a series of rumbles, most of them at low frequencies inaudible to the human ear.

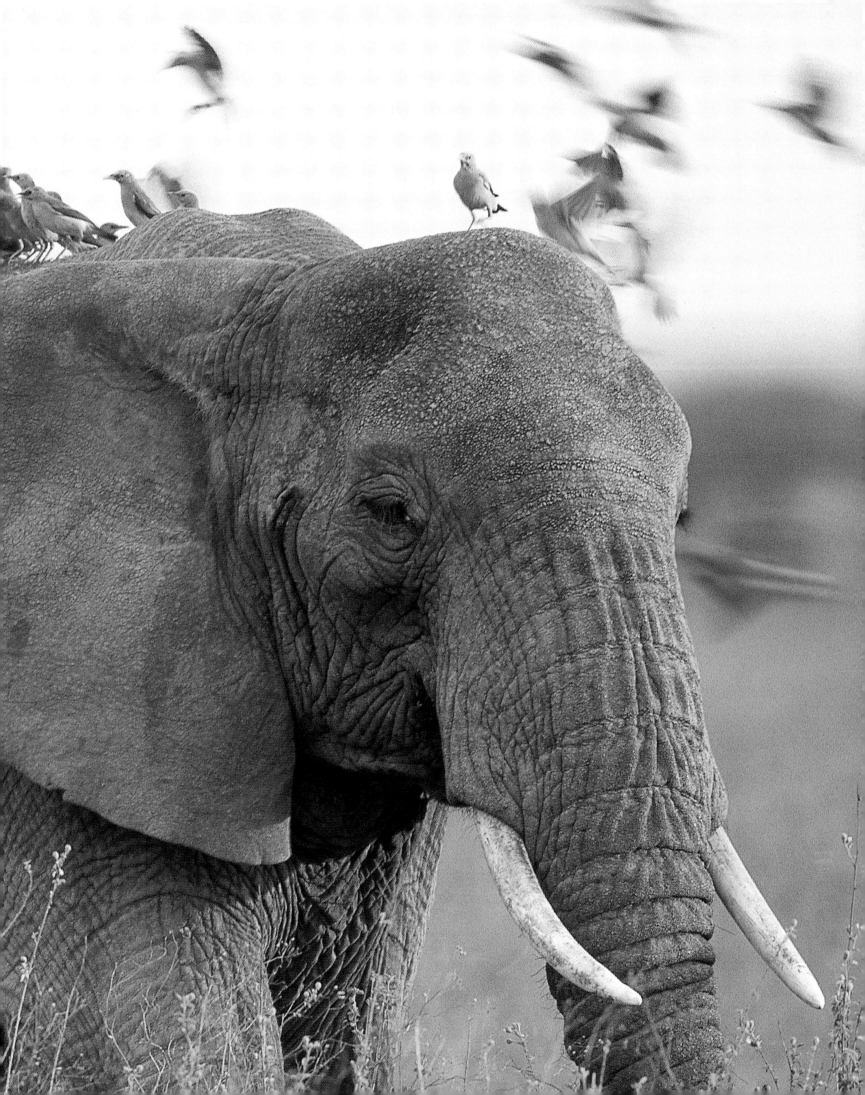

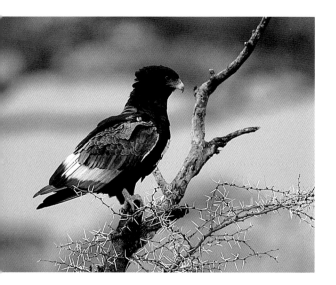

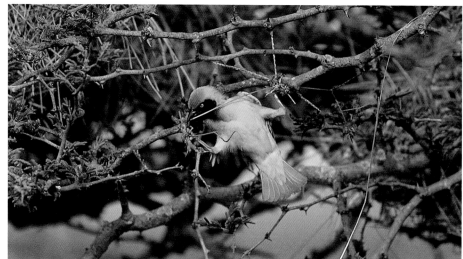

ABOVE Attractively trimmed with touches of red, the Bateleur is one of the most handsome of the park's 49 raptor species. It glides over open country, searching for mammals and snakes, rarely flapping its wings.

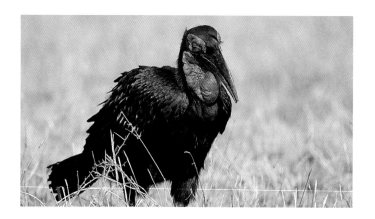

TOP A male Masked Weaver must work assiduously to attract a mate. He flies back and forth carrying lengths of grass, which he uses to weave into a ball-shaped nest. When his task is completed, he hangs beneath the nest fluttering his wings provocatively. The female inspects his handiwork, and if she approves of it, she chooses him as a mate.

ABOVE Alluring eyelashes and startling red embellishments adorn the turkey-sized Ground Hornbill. It passes its days stalking the ground for insects and small vertebrates.

OPPOSITE Starting the day early, a Yellow-billed Stork prods the muddy bottom of a small pool for frogs and other tasty morsels.

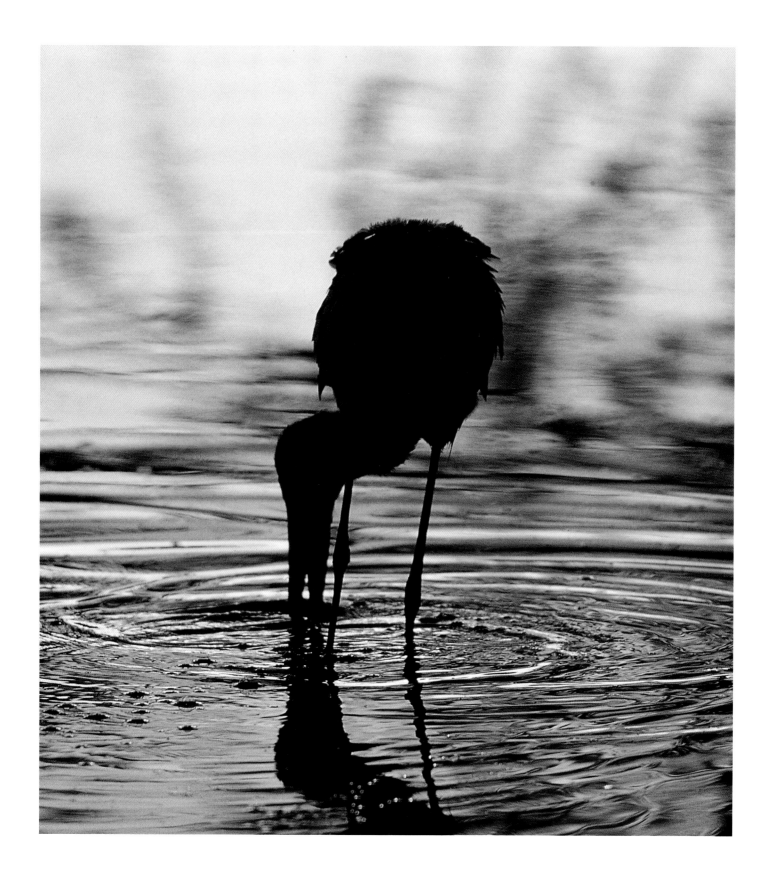

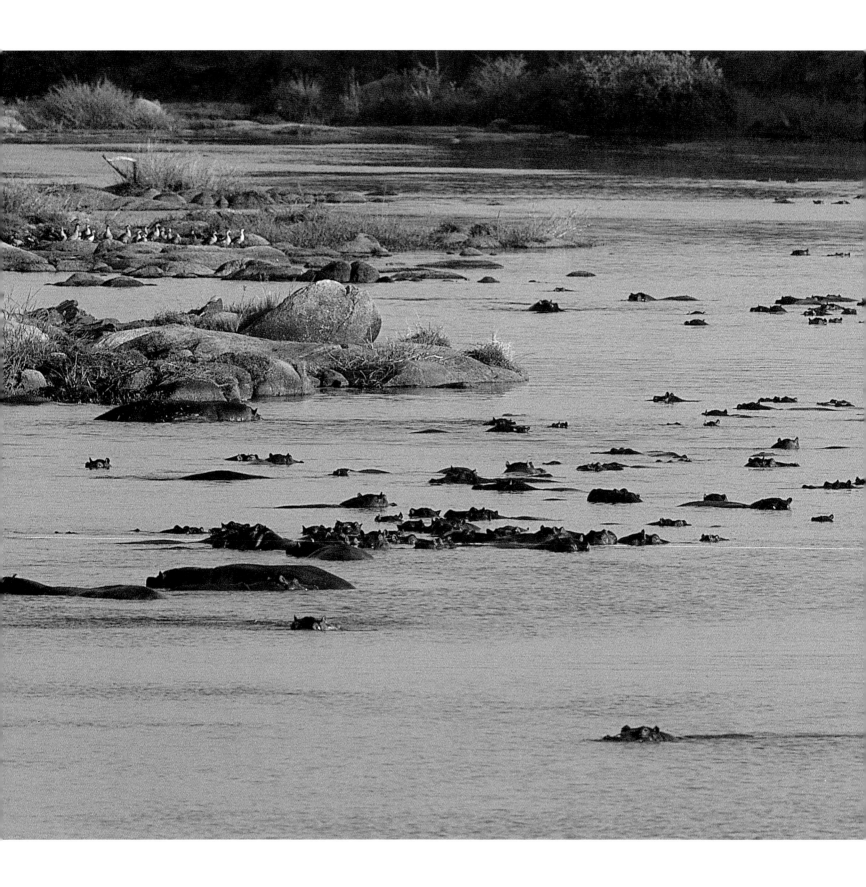

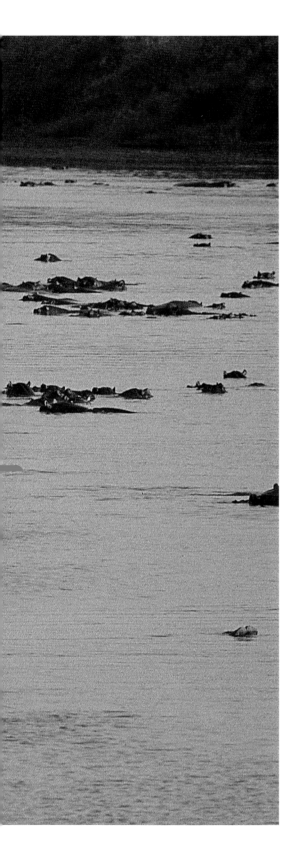

LEFT Fed by frequent rainfall in the Kenyan highlands, the Mara River flows between muddy banks and innumerable hippos.

BELOW A hippo's incisors are its battle kit. The huge open-mouthed 'yawn' that displays its dangerous armoury is one of the most aggressive of a range of postures hippos use to intimidate rivals. Territorial bulls are mutually intolerant. They frequently face off in ritualised encounters, in which they stare at each other, turn tail, and shower each other with dung and urine with rapidly paddling tails. Any disturbance in a hippo pool stirs up an outburst of honking, yawning and sometimes chasing and fighting.

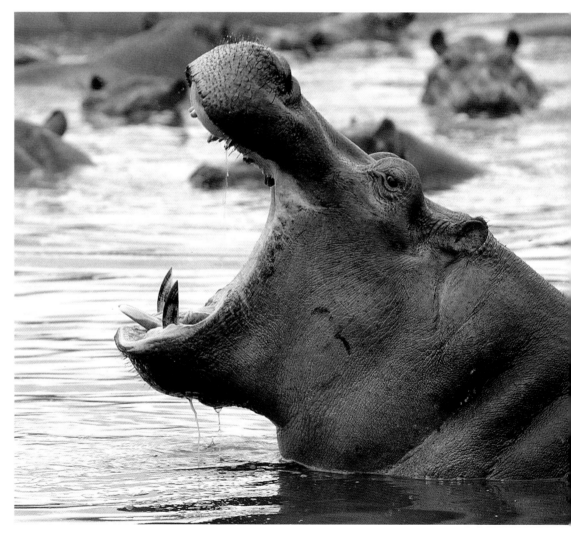

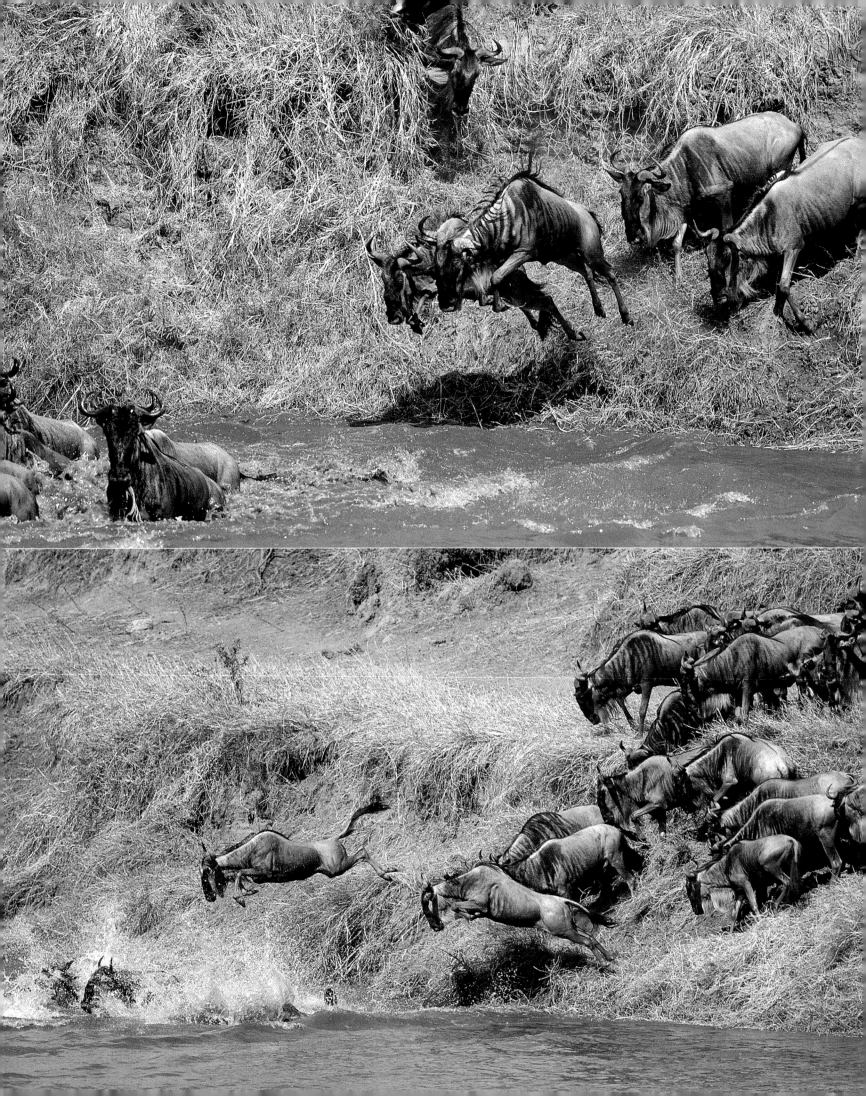

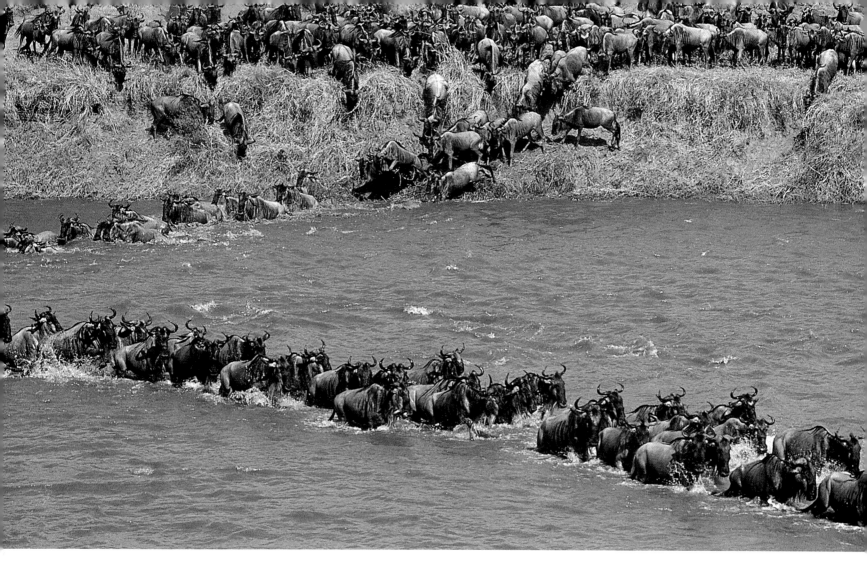

To cross the Mara River, wildebeest not only risk being swept away by the current but must also run the gauntlet of a flotilla of hungry crocodiles. Herds gradually congregate on the riverbank and vacillate, sometimes for days, before one bold animal musters the courage to plunge in. Then, in a spectacular display of *esprit de corps*, they bellyflop into the hazardous river and surge to the opposite bank.

Many animals drown in the process. Leaders of large herds can be trampled or pushed into the water by the masses following behind. Many calves, by now five months old but still much weaker than the rest of the herd, either drown or fall behind and become separated from their mothers. If the river is raging, thousands of animals may perish.

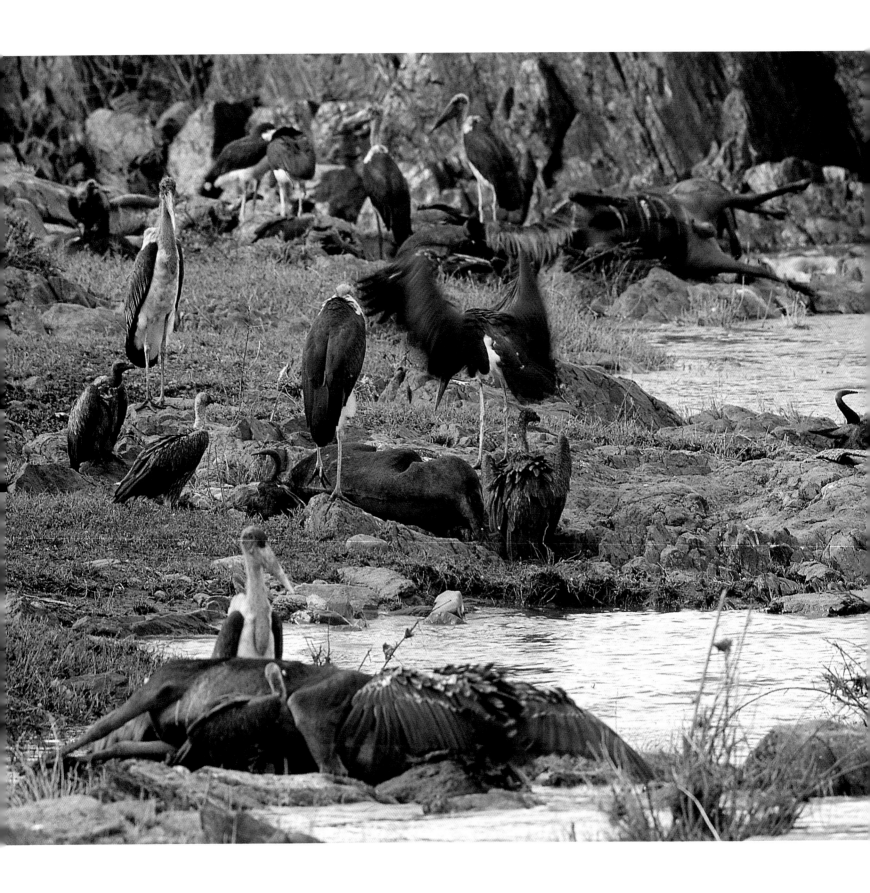

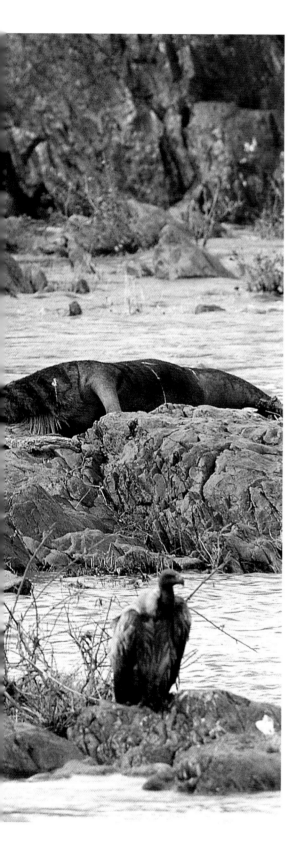

LEFT After the frenzy of the river crossing, the carcasses of drowned animals litter the riverbanks. At times like these, scavenging birds are well fed.

By capturing thermal updraughts, vultures can cover large distances quickly without expending much energy, enabling them to follow the nomads throughout the year. Wildebeest deaths, resulting from starvation, disease and accidents, provide a large food supply for scavengers. Of the six species of vulture that occur in the Serengeti, the two Griffon vultures – White-backed and Rüppell's – constitute nearly 90 per cent of the population. They are the major carnivores in the Serengeti ecosystem. Their total meat consumption is probably greater than the total food intake of all the other mammalian carnivores combined.

BELOW A Rüppell's Griffon Vulture stands satiated near the surfeit of carcasses.

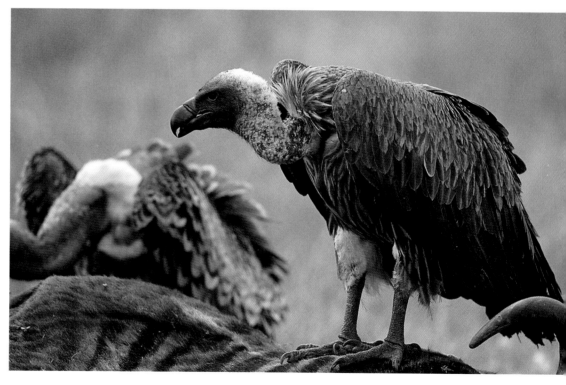

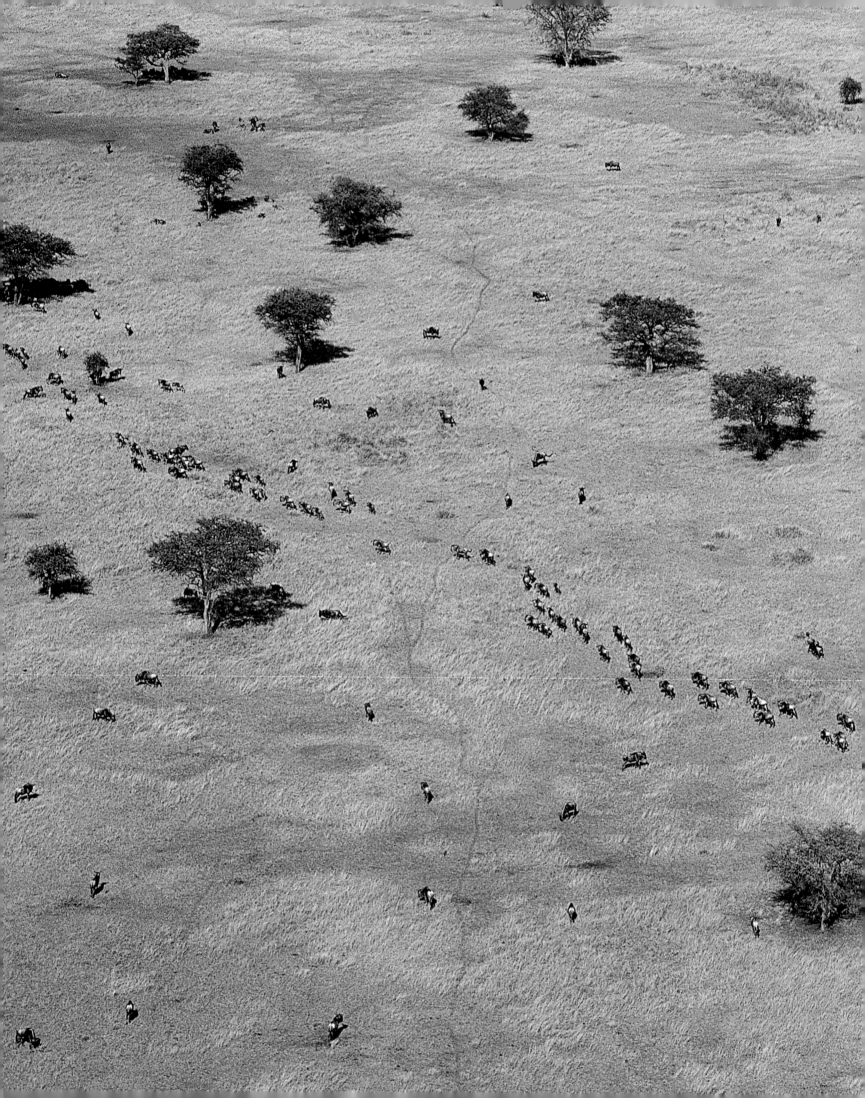

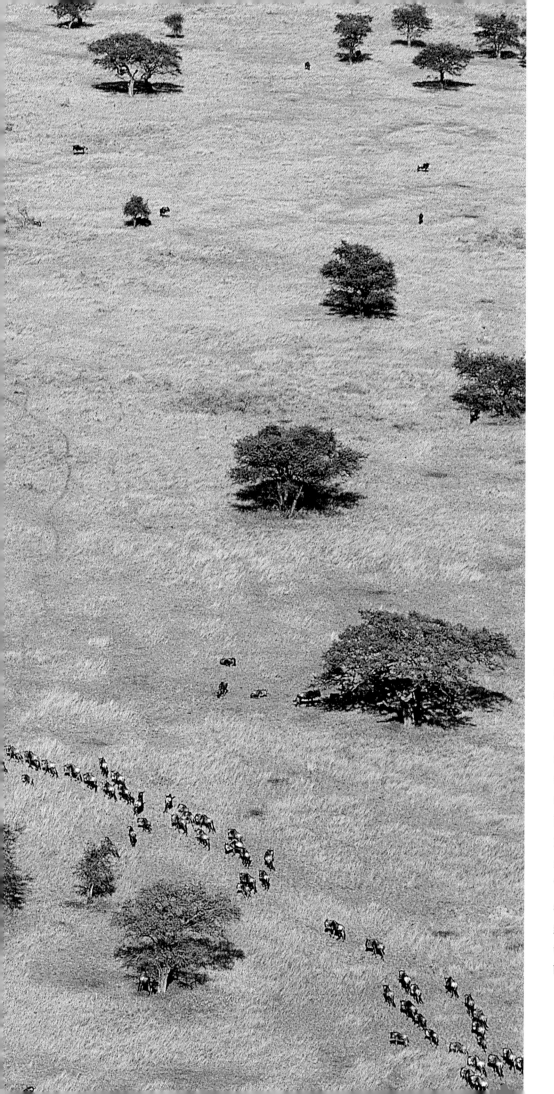

LEFT AND OVERLEAF Even before storms start to clatter across the sky in late October the pasture of the Mara is almost exhausted, and the wildebeest sense it is time to move. Most of the cows are pregnant again after the rut, and the urge to return to the plains begins an exodus. Again they brave the Mara River, now swollen with highland rain, and again the river exacts its toll. Those who reach the southern plains are rewarded with luxuriant new grass growth, and the cycle of birthing and then preparing for the long trek north begins all over again.

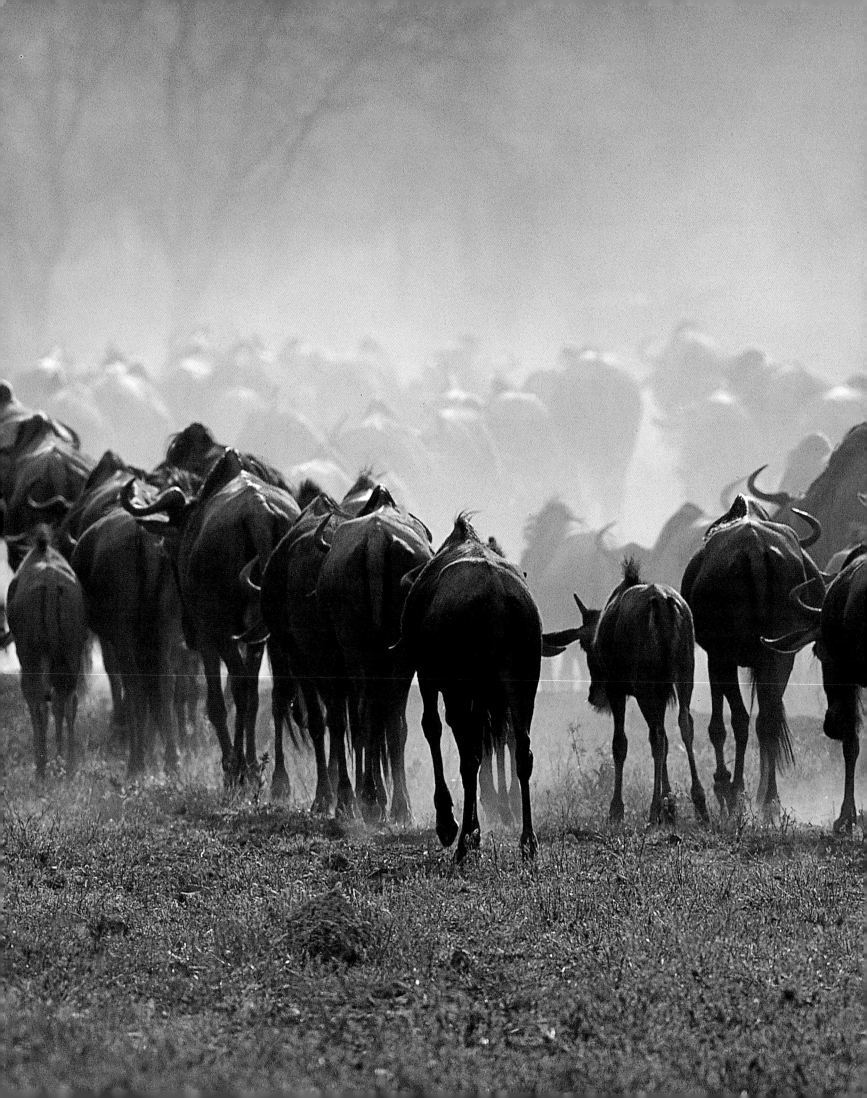

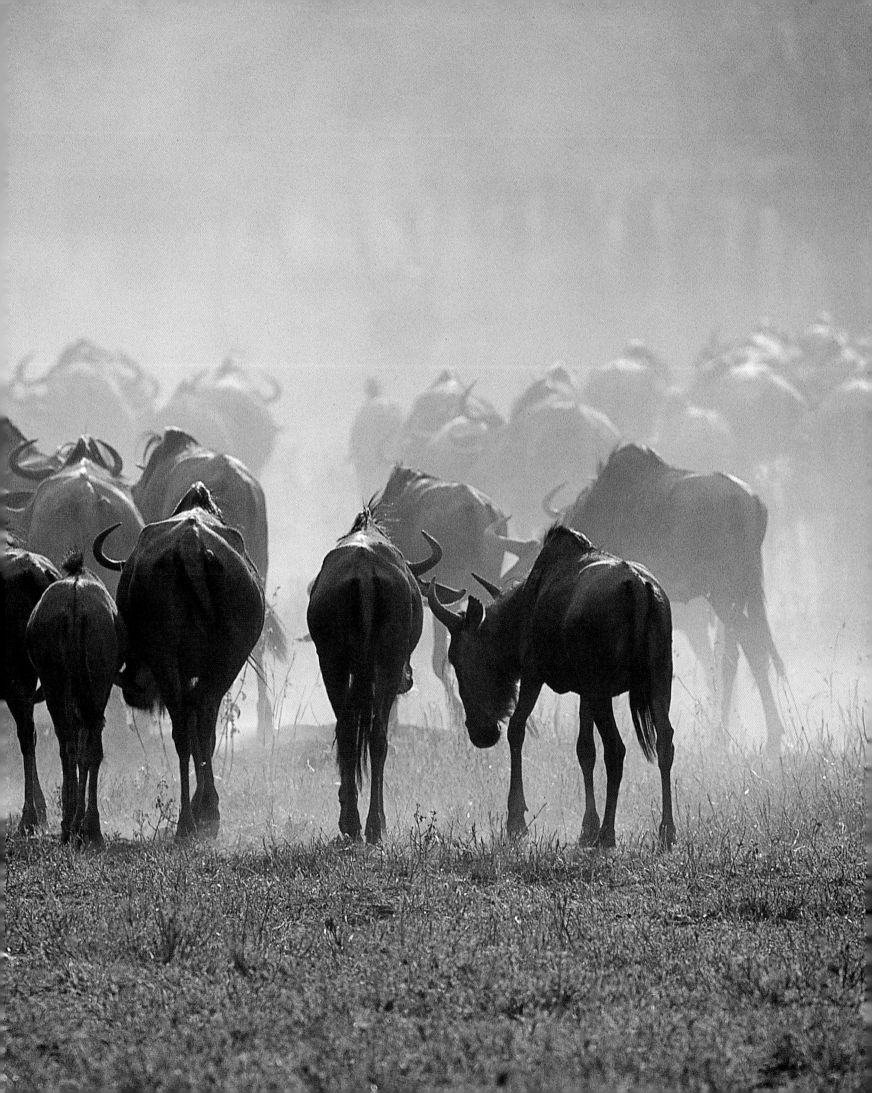

THE FUTURE

'Man and beast are interdependent on this finite planet of ours, along with other elements – soil, water and air – which all comprise the earth's outer crust we refer to as the biosphere. The continued health, welfare and survival of our parks and wildlife reflect the state of the human condition. The demands placed on our parks by increasing population pressures and exploitation now threaten their very existence.' Director-General of Tanzania National Parks – Lota Melamari.

Land-use pressures in the Serengeti region are intensifying rapidly. A massive increase in the population density outside the western boundaries of the national park over the last 20 years has eroded the integrity of the ecosystem and a large proportion of the area inside the park has been altered by poaching. Agricultural and pastoral activities have encroached on protected land, while crop-growing has swallowed former pasture land and the demand for grazing areas for domestic herds is steadily increasing. Impoverished local villages on the western boundary, populated by the Sukuma, Kurya and other traditional hunters, provide a steady source of illegal hunters and a market for poached meat.

The game reserves that are designed to act as buffer zones around the park lack the financial and material resources to manage effectively the problems of poaching, wildfires and illegal tree cutting that continue to thwart conservation strategies. Anti-poaching activities consume the most significant proportion of park resources. They require vehicles, repair workshops, aircraft, communications and road networks, as well as the efforts of more than 150 dedicated rangers. But while law enforcement is an essential element of the overall management of the park, it cannot eradicate its problems.

In the past, villagers derived no direct benefit from the protection of wildlife and its habitat. Conservation strategies excluded local communities, bringing them into conflict with the local authorities. Wild animals were perceived by villagers merely as competition for pasture and as threats to their crops. Trophy-hunting exterminated most elephants and all but two of Serengeti's rhinos as world prices for ivory and rhino horn escalated in the 1980s. To this day, illegal hunting for bushmeat by poachers from outside the western boundary remains the biggest threat to the Serengeti and continues to remove tens of thousands of animals from the park each year. Since the wildebeest migration determines the healthy functioning of the ecosystem, the collapse of the wildebeest population would threaten the viability of the entire Serengeti. Conservation

OPPOSITE AND OVERLEAF Poaching is one of the very real threats facing the wildebeest populations, and ultimately the integrity of the Serengeti ecosystem.

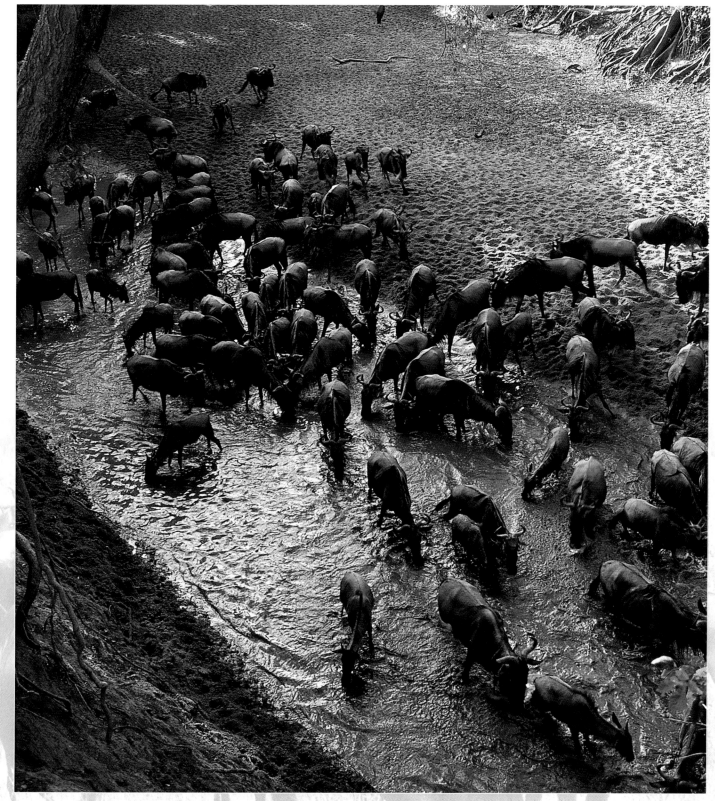

furthermore depends on maintaining a high level of inoculation in domestic animals, which are still a reservoir of tick-borne diseases, rinderpest, rabies and other canine diseases. An outbreak of canine distemper that spread from domestic dogs exterminated one third of the Serengeti's lions in 1994.

The survival of the last remnants of intact ecosystems depends on the intervention of individuals dedicated to their preservation. Researchers strive to gain a fuller understanding of the factors that mould and maintain the Serengeti ecosystem in order to shape successful future management strategies. Despite the vast body of information that has been accumulated, the picture remains incomplete.

Recognising that communities with equity in wildlife resources are motivated to protect their investment, the Tanzanian government, with the support of the Frankfurt Zoological Society, is creating four Wildlife Management Areas around the Serengeti-Ngorongoro ecosystem, in which local communities are handed management of and income from the sustainable use of wildlife resources around their villages. By enabling these communities to benefit from the profits of tourism, which already provides Tanzania with more than 50 per cent of its hard currency, it is hoped that pressures on the protected areas will decrease.

Serengeti is a priceless fragment of a rapidly disappearing world. Serengeti National Park and its vast and diverse wildlife is not just Tanzania's heritage – it should certainly be considered the heritage of the entire planet. As Bernard Grzimek so eloquently implored:

'Men are easily inspired by human ideas, but they forget them again just as quickly. Only nature is eternal, unless we senselessly destroy it. In fifty years' time nobody will be interested in the results of the conferences that fill today's headlines. But when, fifty years from now, a lion walks into the red dawn and roars resoundingly, it will mean something to people and quicken their hearts . . . They will stand in quiet awe as, for the first time in their lives, they watch twenty thousand zebras wander across the endless plains.

Is it really so stupid to work for the zebras, lions and men who will walk the earth fifty years from now? And for those in a hundred or two hundred years' time?'

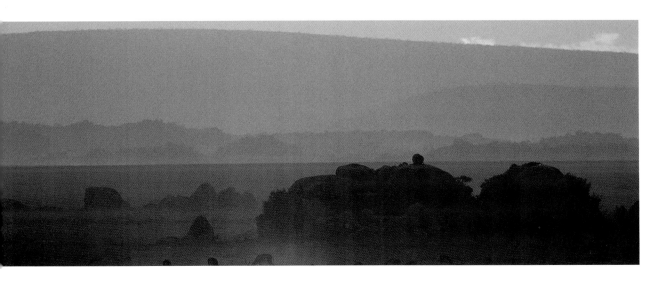

LEFT Dust and haze intensify a Serengeti sunset.

OPPOSITE Thunderclouds blacken the evening sky.

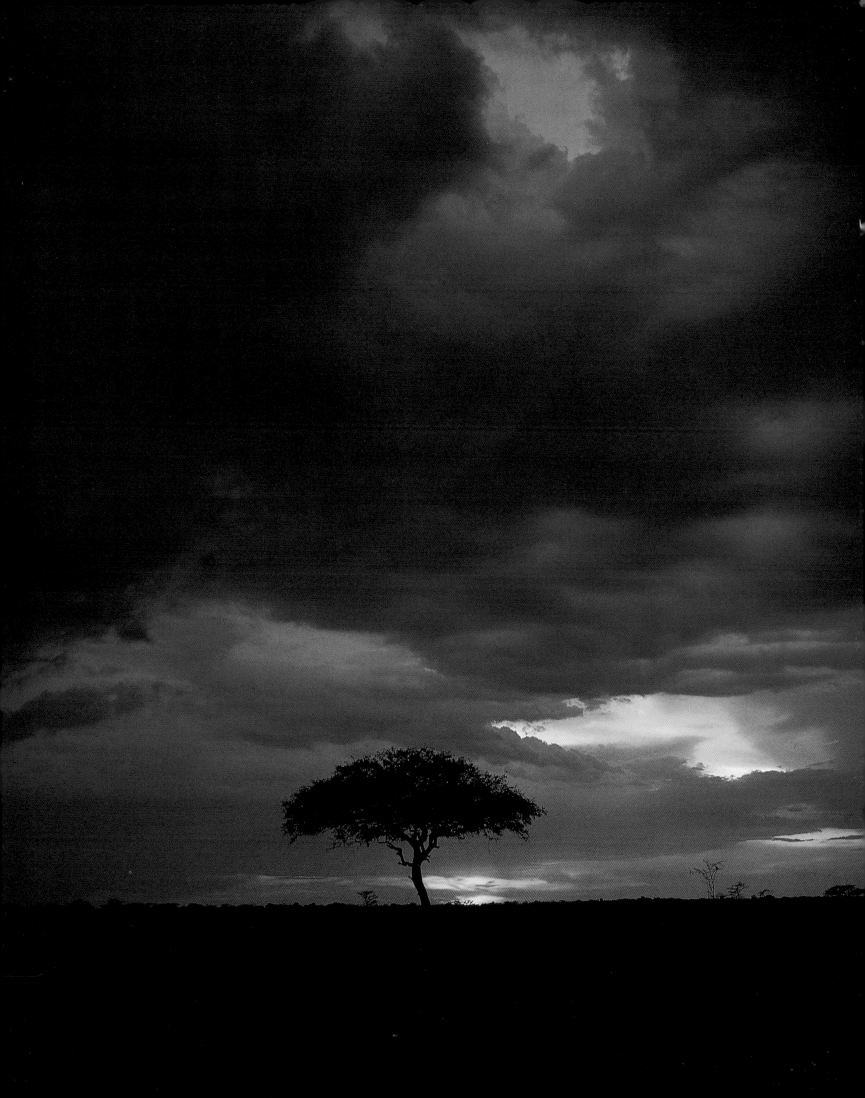

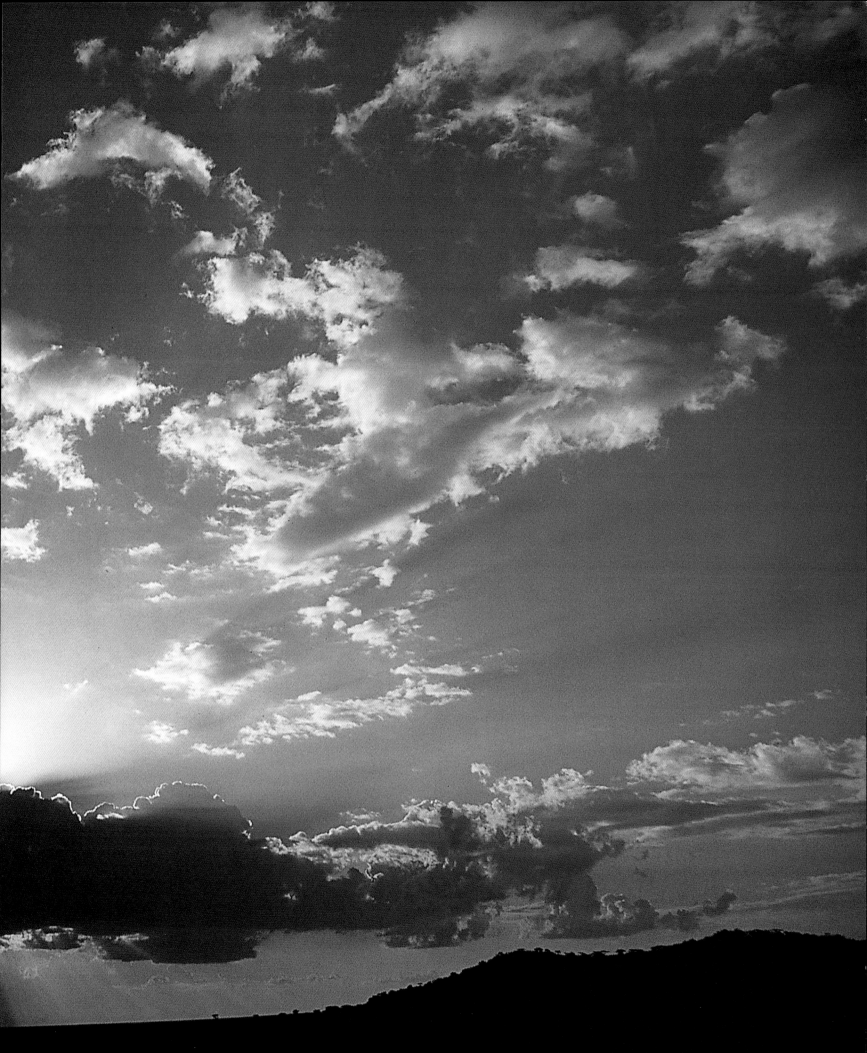

ACKNOWLEDGEMENTS

My greatest thanks go to my driver, guide, animal behaviourist, Serengeti expert, mechanic and minder, Peter Massawe, without whose driving expertise, bush skills, knowledge and encouragement most of this book would not have been possible.

I am very grateful to the Serengeti researchers who shared their knowledge (and invited me to their parties), particularly Dr Marcus Borner and Joe Ole Kuwai of the Frankfurt Zoological Society; Meggan Craft and Peyton West of the Serengeti Lion Project; Dr Sarah Durant and Tom Maddox of the Serengeti Cheetah Research Project; Dr Simon Mduma; and Kirstin Schulz of the Max Plank Institute Hyaena Research Project.

The support of Tanzania National Parks was also important for the success of this work, and for that I thank Director-General Mr Lota Melamari. I am particularly grateful to Mr James Lembeli for championing my cause. Park Warden of Tourism, Ms Eunice Msangi, eased my public relations and provided invaluable friendship and even-handed support. All the rangers I met were at all times friendly, and those at remote Kogatende were particularly helpful. Their dedication to a very difficult job is an inspiration.

Good logistical support made long stays in the bush possible, and I thank Latifa Kyaruzi for fulfilling my every request.

For all their small kindnesses I thank the many people, too numerous to name, who helped ease the difficulties of long-distance travel and lengthy stays in the bush, and who came to my rescue when I was in difficulty.

Lastly, I thank my family for uncomplainingly putting up with my long absences from home, and particularly my husband for his practical support and encouragement.

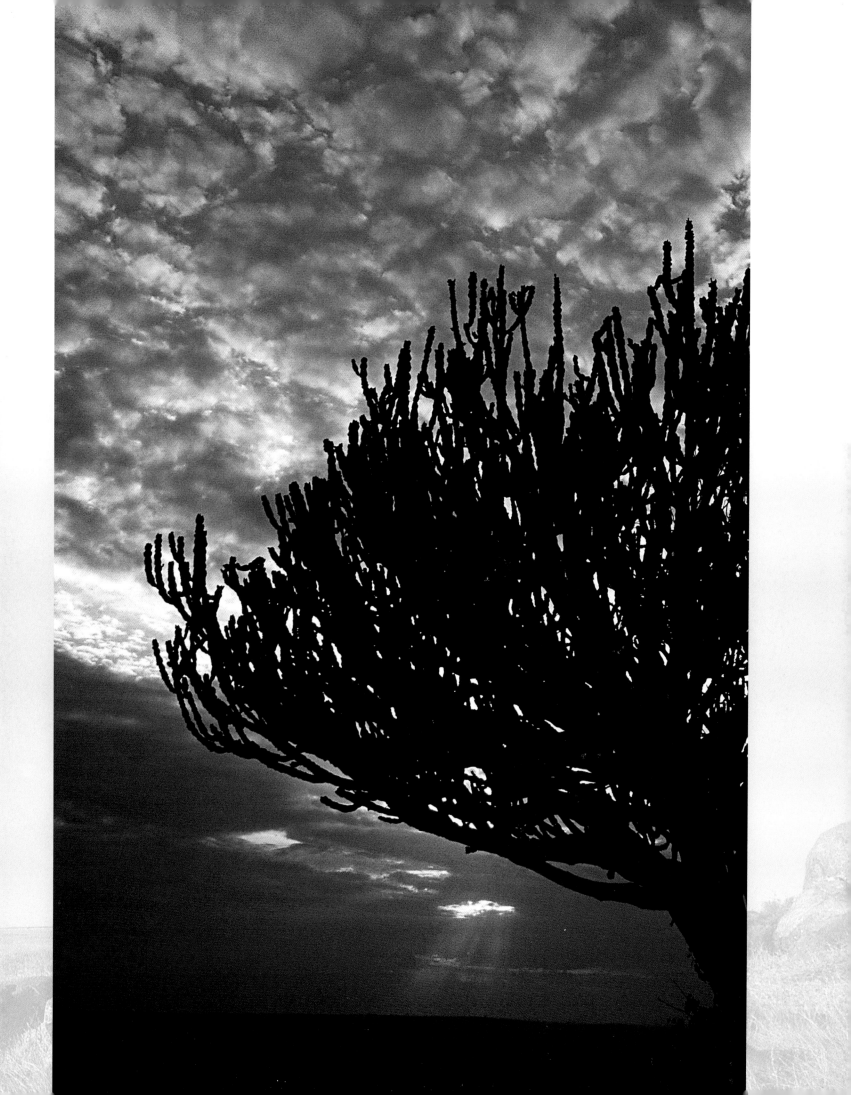

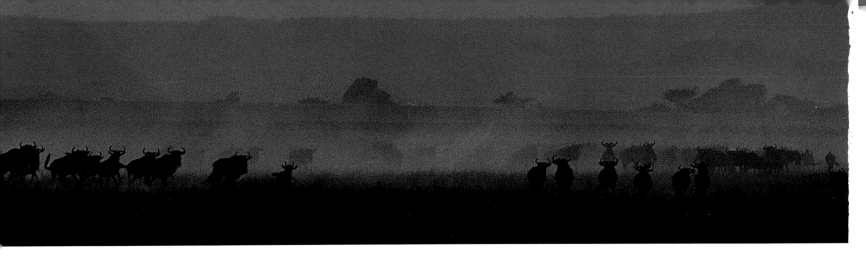

BIBLIOGRAPHY

BEHAVIOUR GUIDE TO AFRICAN MAMMALS
Richard Estes
University of California Press 1991, Berkley

BIRDS OF EAST AFRICA – COLLINS FIELD GUIDE
J.G. Williams and N. Arlott
HarperCollins 1980, London

BIRDS OF KENYA & NORTHERN TANZANIA
Dale A. Zimmerman, Donald A. Turner and David J. Pearson
Princeton University Press 1996, Princeton

CHEETAHS OF THE SERENGETI PLAINS
T.M. Caro
University of Chicago Press 1994, Chicago

COMMON BIRDS OF EAST AFRICA
Martin Withers & David Hosking
HarperCollins 1996, London

ECHO OF THE ELEPHANTS
Cynthia Moss & Martyn Colbeck
BBC Books 1992, London

HEARTS OF DARKNESS; THE EUROPEAN EXPLORATION OF AFRICA
Frank McLynn
Pimlico 1992, London

KINGDON FIELD GUIDE TO AFRICAN MAMMALS
Jonathon Kingdon
Academic Press 1997, San Diego

MAASAI
Tepilit Ole Saitoti and Carol Beckwith
Harvill 1980, London

OXFORD ENCYCLOPEDIA OF TREES OF THE WORLD
Oxford University Press 1981, Oxford

SERENGETI – DYNAMICS OF AN ECOSYSTEM
A.R.E. Sinclair and M. Norton-Griffiths
University of Chicago Press 1979, Chicago

SERENGETI II – DYNAMICS, MANAGEMENT AND CONSERVATION OF AN ECOSYSTEM
A.R.E. Sinclair and Peter Arcese
University of Chicago Press 1995, Chicago

SERENGETI SHALL NOT DIE
Bernard Grzimek
Hamish Hamilton 1960, London

THE FATE OF THE ELEPHANT
Douglas H. Chadwick
Viking 1992, London

THE GIRAFFE – ITS BIOLOGY, BEHAVIOUR AND ECOLOGY
Anne Innis Dagg and J. Bristol Foster
R.E. Krieger Pub. Co., 1976, Huntington, N.Y.

THE SERENGETI LION – A STUDY OF PREDATOR-PREY RELATIONS
George Schaller
University of Chicago Press 1972, Chicago